The
FOCALGUIDE
to
Slides

THE ⓟ FOCALGUIDES TO

The
FOCALGUIDE
to
Slides

Planning, Making and
Showing them

Graham Saxby

Focal Press · London

Focal/Hastings House · New York

🅑🅛 *British Library Cataloguing in Publication Data*

Saxby, Graham
 The Focalguide to slides.
 1. Slides (Photography)
 I. Title
 778.6 TR505

ISBN (excl. USA) 0 240 51004 6
ISBN (USA only) 0 8038 2374 6

Reproduced and printed by photolithography and bound in
Great Britain at The Pitman Press, Bath

Contents

Introduction

Until colour prints came along, the only kind of colour photography available to the amateur was the colour transparency. Now, even though the colour snapshot has become commonplace, photographic enthusiasts treat the projected slide as a pictorial medium in its own right. They are giving increasing attention to the immense creative possibilities in carefully chosen sequences of slides, as well as the values of a well-designed commentary. Many are beginning to add sound effects. Indeed, out of the simple slide show has grown the slide-sound sequence, a new aesthetic experience.

Teachers and lecturers have long used slides for illustrative purposes. Here, the quality of the slides can play a large part in putting over a topic, or demonstrating a product, effectively. Just how large a part has become evident over the past few years, when a wide variety of audiovisual aids, such as overhead projectors and videotape players, has been developed. The projected slide, with its large, sharp, brilliant image, has a unique place among other forms of technology. There can be few teachers or lecturers today who are unaware of the usefulness of slides.

This book is intended for the comparative newcomer to slides, whether photographic enthusiast, teacher, lecturer or demonstrator. It does not set out to explain how to use a camera (there are plenty of excellent books on that subject already), though it does contain a large number of tips on techniques especially applicable to slides. Our main aim is to show you how to get the best out of your slides: how to plan your slide show, how to organize the photography, and how to present the slides so that they do you credit.

Beginnings

Lantern slides — black-and-white or hand-coloured — formed an important part of early photography. Today, their place has been taken by colour transparencies, produced on modern, reliable and easy-to-use colour reversal films.

Why slides?

When compared to paper prints, projected images have a number of advantages.

Firstly, they can reproduce a much greater range of tones. On a sunny day, a normal scene may show a brightness range of over 100 to 1. That is, the brightest highlights (not specular reflections) can be over 100 times as bright as the darkest shadows. Most printing papers, and this includes colour papers, can produce a maximum tonal contrast of about 30 to 1. So a print on paper cannot always reproduce all the tones of the original.

A colour transparency, on the other hand, is capable of recording a contrast of about 100 to 1, which will cope adequately with almost any subject. This is why a print made from a transparency is so often disappointing. The usual result of compressing the tonal range is blank whites and dense discoloured shadows.

Secondly, you can make the projected image as *bright* as you like. This gives a big advantage over prints. You have to examine a print by room light; and as it reflects only a comparatively small part of the light falling on it, it looks dull by comparison.

Thirdly, the viewing conditions are better for a projected slide. If you examine a print in the ordinary way, with light and distracting objects all round you, you get nothing like the impact you get from a brilliant image on a large screen in near-darkness. You get a greater impression of realism with a slide, too, because the image is much larger, vertical, and much farther away; and there is no surface sheen and no visual distractions.

Fourthly, a properly presented slide show carries a feeling of occasion. The room is blacked out: everybody knows you've been to a fair amount of trouble to select the slides and set up the projector; and, we hope, you are giving an interesting commentary.

Finally, apart from its purely pictorial possibilities, the slide is an exceedingly versatile form of illustration. If you have to give a talk or a lecture, a few slides can be very helpful in clearing up a tricky point. Indeed, the slide has its own particular niche in the field of audiovisual aids.

Formats available

At one time, slides were fairly large affairs. In Europe the standard size was 3¼ x 3¼ inches, in the United States 3¼ x 4 inches. At present, slides of this size are uncommon (though large transparencies are still made for commercial and advertising purposes and for high-quality colour prints in magazines).

The nominal sizes of standard formats for slides currently are:

Outside dimensions of slide 70 x 70 mm (2¾ x 2¾ inches)

 60 x 60 mm (12 on 120 film)

 45 x 60 mm (16 on 120 film)

Outside dimensions of slide 50 x 50 mm (2 x 2 inches)

 40 x 40 mm

 24 x 36 mm (full frame 35 mm film)

 24 x 24 mm (square format 35 mm film)

 18 x 24 mm (half-frame 35 mm film)

 28 x 28 mm (126 film)

Outside dimensions of slide 30 x 30 mm (1¼ x 1¼ inches)

 14 x 17 mm (110 film)

Which format you choose out of all these? If you already own a camera, the answer is likely to be: the one you have already. If you are going to take slide-making seriously, though, it may be worth your while having a look at some of the advantages and disadvantages of the various formats.

Picture size

Although the smallest cameras are technically capable of producing

very high quality images, it is impossible to deny the old hands' dictum that "a good big 'un will always beat a good little 'un". The reason is simply that there is a limit to the resolving power of any given film: that is, it will record detail that is just so fine and no finer. If you halve the size of your format, you halve the size of the image too; so that now the finest detail is no longer recorded. On the smaller format cameras, the image will look grainy, especially if you use high-speed film. The largest commonly available modern cameras use 2½ inch wide roll film, size 120 or 220. They produce 6 x 4.5 cm (2¼ x 1⁵/₈ inches), 6 x 6 cm (2¼ x 2¼ inches), 6 x 7 cm (2¼ x 2½ inches) or, rarely, 6 x 9 cm (2¼ x 3¼ inches) transparencies. These can compete with the smallest sheet film sizes for some commercial uses, but only the 6 x 4.5 cm or 6 x 6 cm sizes can be considered for slide making.

Undoubtedly, they allow the highest quality images, but the cameras and accessories are heavy, bulky and mostly expensive.

The next size down, full frame 35 mm, is undoubtedly the most popular for slide work. The camera equipment available is unparallelled in versatility, and modern projectors are capable of producing brilliant images.

Smaller sizes, though, are cheaper. The 24mm square format never became very popular, but the 'half-frame' (18 x 24 mm) size has a number of adherents. You certainly get twice as many pictures per cassette as compared with a full-frame 35 mm camera, but it is not always as economical as you might think. Seventy-two, or even 48 or 40, pictures on one cassette of 35 mm film represents a lot of pictorial matter, and you may be tempted to make far more exposures than necessary, just to finish the film.

Size 126 (Instamatic) cameras are much easier to load and unload than the standard 35 mm film cassettes. The cameras themselves range from simple fixed-focus, fixed-exposure models to fully-automatic versions. They all produce 20 slides approximately 28 mm square on each cartridge. The square picture does have disadvantages. There seem to be few satisfactory compositions that fit into a square, and you will find that most of your pictures need to be masked down. At least you never need to turn the camera on its side; even though usually you have to crop the picture you will normally have room for centering the subject.

The 110 or pocket Instamatic camera uses a similar cartridge-loading system, but the format is smaller still, about 14 x 17 mm. This is only half the linear size of the standard 35 mm format; and though you can now get expensive precision cameras in this size, you can't get away from the limitations of resolving power and granularity of the film emulsion.

Projectors

The full-frame 35 mm format has been so firmly established on the market that it seems likely that projector manufacturers will continue to concentrate on this format. So, it is easier to obtain equipment that projects 50 x 50 mm slides; but the light sources are designed for 24 x 36 mm images, and are thus not efficient for smaller formats. Some of the more expensive projectors do have condenser systems which can be adapted to the smaller formats.

The largest format, 70 x 70 mm, requires a special projector. These larger projectors tend to be much more costly than their 50 x 50 mm equivalent, and few offer sophisticated features. However, there certainly is some gain in quality and maximum possible brightness. As most 35 mm projectors will actually project an image area as large as 40 x 40 mm, if you use a roll-film camera you may prefer to compose your picture slightly smaller so as to fit within these limits (you can mask off the viewfinder). Then you can use a 40 x 40 mm mask, mount your transparency in a 50 x 50 mm mount, and show it in a standard 35 mm-type projector.

Taking everything into consideration, there seems to be a fairly strong case for settling for 35 mm full-frame format. If you are thinking of taking the plunge, and buying a first-quality camera for transparencies, you should seriously consider this size in preference to larger or smaller formats.

Plan ahead !

Planning ahead will save you a great deal of time later, and will give you the chance to get that 'spontaneous' picture you might otherwise have missed.

George Bernard Shaw was moved to remark that an amateur photo-

grapher was like a codfish, laying a million eggs in the hope that one would survive. The trouble was, and is, the ease with which photographs can be taken. If taking a photograph involved as much effort as painting a picture, we would certainly think very hard and carefully before embarking on it.

This does not necessarily mean that you have to take fewer pictures: what you do need to do is to increase their survival rate. And you can go a long way towards assuring this just by giving a little thought as to what you are trying to achieve. Before you make your first exposure, before you even buy the film, there are four important questions to ask yourself.

Why?

What reasons have I for taking these photographs? Are they for entertaining other people? Are they for instructional purposes? Are they for competitions, or just so that I — and my family — can have a permanent record? Once you have established the answer, you will be in a position to sketch out a general approach to the photography.

Who?

Who, apart from yourself, will be looking at the slides? Once you have decided the answer to this, think about the people the slides are intended to entertain or inform: what their interests or needs are. That will help you to get your mind clear as to how to go about the photography. To see how this works, let us suppose you are going off by car on a European holiday. You are aware that your friends, the Robinsons, are fascinated by mountain scenery and will be very interested in any pictures of the Dolomites; the Browns, on the other hand, whose passion is Delft pottery, would be thrilled to see a series of your pictures showing where — and how — it is made. As you share these interests to some extent, and are intending to visit both areas in any case, you can start thinking about how to get a really interesting series of photographs. What sort of picture is best going to put across the feeling of the place? How many shots will you need of this or that? What sort of continuity shots will you need? Once you've answered these questions,

you will be in a position to get just the sort of shots that will recall the realism of the whole experience, and bring your holiday to life afresh every time you view the slides. You will not only have been able to afford much pleasure to your friends, but you will also have given a great deal of satisfaction to yourself.

If your journey concerns your own job or specialist interest, and you expect to use the slides in a talk or lecture to specific groups of people, then you can be specific in your planning, too. You can lay out the subject matter in detail, and consider at each point whether you need visual illustration; and, if so, exactly what form it should take. If you are thinking of putting your slides in for a competition, you should be certain what subject matter, approach and technique will be appropriate. You might well make a few rough sketches of what you intend to take: after all, you will not win first prize if the light is not right or if an awkward viewpoint results in an unbalanced composition. And even if your pictures are 'just for the record', you will save yourself a good deal of time and film by planning your photography ahead.

With what?

What are the limitations of my equipment? Under the right conditions, you can get perfectly good colour transparencies with any camera, no matter how cheap and simple. But the simpler your equipment, the more limited you will be. A fixed-focus, fixed-exposure camera will give you perfectly adequate transparencies, but only when the lighting is at exactly the right level. Most cameras of this type operate at about 1/60 second at f11, and with an average-speed film (about 64 ASA) you will get correct exposures in moderate sunlight. Cameras with variable shutter speeds and aperture settings are more versatile.

As long as you are working out-of-doors, you do not really need an exposure meter. The leaflet that comes with the film is usually pretty reliable. But you cannot work indoors unless you have an exposure meter and precise focusing too; and if you want to photograph dark interiors such as churches you need a maximum aperture of about f2 in order to keep your exposure time manageable. For such subjects you are also likely to need wide-angle and long-focus

15

lenses; and if you intend to go in really close and photograph small details such as pew ends, you need the accurate close focusing that goes with the single-lens reflex camera. You will need a tripod and a flash, too, with an extension lead to get the flash well away from the camera, and possibly a second flash for contrast control. If you want to go in for photographing architectural exteriors, you can not expect to get elegant pictures, with all the verticals parallel, unless you have a studio camera and several years' professional training. In such cases you are better off going for 'atmosphere': that is the sort of thing an amateur can often manage better than the professionals!

When?

What are my time limits for completing the photography? This seems an obvious enough question, with an equally obvious answer: the last day of the holiday, perhaps; or the day before your lecture, or before your brother leaves for Australia. But there may be complicating factors; you may have to allow a week for the film to be processed, for instance. As far as taking individual pictures is concerned, your time limit may be clear enough, but it will have to fit into the pattern of all the other things to be done. If you need a picture of the view from your hotel window, well, you can do that at any time as long as the light is right; so you can give that task a low priority. On the other hand, if you can only catch the illuminated fountains at one particular time of day, you need to give this a higher priority. The little figures that dance round the clock when it strikes midday: well, perhaps there are only, say, three occasions when you can make it, and on one of them you will have to be there, on time and with the right lens ready focused and the right exposure set. Advance planning will ensure you miss nothing. The other type of time limit is slightly different. It is the length of time you can give yourself to press the shutter release after you have seen your picture and before it is too late. If you want to photograph, say, a range of mountains, you can probably take as long as you like: after all, they have been there for millions of years, and they will wait twenty minutes for you to get the lighting or the composition exactly right, even if you do have to drive five

miles to get a better viewpoint. And if the lighting does not improve, there is always tomorrow. But if your task is a long shot of the interior of a cave, and the guide and the rest of the party are already moving on, you have very little time. And if you are in a coach, and you see that you are due for just one ideal glimpse down at a ruined castle as you pass that narrow gap just ahead, you have even less time! You can anticipate and plan for all these contingencies: you need not miss that magnificent shot.

Sequences

Slides are normally shown one after the other. Plan yours so that they go together. Whatever your subject, a logical order helps; you are unlikely to be able to produce a logical sequence from a series of random snapshots.

A Planned Approach

Your holiday pictures

Most holidays need quite a lot of advance planning, but do you really think about the photographs you are going to take? You buy half-a-dozen or more films, no doubt; and that may well be all the planning you do. It is not just beginners who do this: even quite experienced photographers tend to go off on holiday without having given any serious thought to their holiday photographs.

The crunch comes when you get out the projector to show your holiday slides to your friends. Half the pictures seem to have been taken on one day, and on the same stretch of beach or countryside. Most of the rest consist of various permutations of your family against assorted scenic backdrops.

All too often, holiday slide shows turn out to be little more than dismal catalogues of missed opportunities. There was a shot of the magnificent old railway engine that you muffed because there was no time to adjust the focus. A bullfight somewhere in the far distance because you had not got the telephoto with you at the time. The barbecue shots that are all dark and underexposed, because you did not take a flashgun; and so on. At the end of the show, the slides go back into the box, perhaps never to be looked at again.

It is a depressing story. Perhaps you may draw some consolation from the fact that almost everyone else's holiday slides are just as disappointing. But what a pity, what a waste it is! Once you have finished the duty-free sherry and thrown the rope-soled sandals in the dustbin, and your suntan is beginning to fade, the only thing left to remind you that the holiday ever happened is your set of slides. Surely it would have been worthwhile planning the photography in advance, along with all the other essentials?

Sorting out the subject matter

Let us see how you can go about it. Suppose you are going on a package trip to a waterside hotel and making a number of day coach trips, as well as going to some organized evening entertainments.

The first thing you need is a list of the main subjects you are likely to be interested in, and a note of your overall approach to them. Do you want to record the local people and their customs? Are you interested mainly in the scenery? Is there any locality or building you particularly want to take pictures of? Is there a special event you want to record? You may not, of course, know all the answers at an early stage; but write down what you do know. You can fill in the missing bits later. Some of them may have to wait until you actually get to your destination; but if you sort out all you can early on, it takes less time later.

At this early stage, the most useful thing you can do is to get hold of a map of the district you are visiting. Make sure the scale is large enough. For the local area, say ten miles across, a good scale is 1:75,000 (a little less than 1 inch to 1 mile). For larger areas you will want 1:200,000 (about 1 inch to 3 miles). You can find maps easily enough once you get to your destination: but it is *before* your holiday that you really need them. Such maps usually indicate all the places of interest, and the best scenic routes, as well as vantage points with an especially spectacular view. Some maps also have street plans of the major towns in the area, and these can be very useful.

At the same time as you get the map, buy an up-to-date guidebook for the area. This will give you the details of all the local places of interest. It will also tell you about the local history and customs, and will give the dates of any traditional events — something you will certainly want to get pictures of, if your visit happens to coincide with one. Most package tour operators run day trips by coach to places of interest, and organize things like barbecues and visits to local sporting events. The tourist office will be able to tell you about these. Do not trust your memory: write the information down. If possible find out the routes for the day trips and mark them on your map. You will be able to see if there is likely to be anything worth photographing en route. Your guidebook will help here, too.

What equipment do you need?

Now you know more or less what you are going to photograph, you can start listing the equipment you need. If your camera is one of the most basic, there is not much to select. But we will assume, for the moment, that you own a single-lens reflex camera with an *f*1.7 lens, and you also have a 28 mm lens and a 200 mm telephoto. You do not possess a tripod or a flashgun, nor any filters, but you have been thinking of buying these for the holiday. You are also not sure whether you may need a really wide-angle lens.

Take a list of the subject you have jotted down, and for each subject make a full list of all the shots you will need in order to cover each one adequately. Alongside each shot, write down the equipment that is essential. In the next column, put down any additional equipment that would be useful. In the last column, put down anything that might be handy if you owned it or could find room for it. Part of your list might look something like the following table.

Subject	Essential	Useful	Optional
Cathedral			
Panorama of town from harbour, showing cathedral	28 mm lens	20 mm lens	200 mm lens
Street leading to cathedral	28 mm lens	—	—
Views of cathedral exterior	28 mm lens	20 mm lens	—
People on steps	50 mm lens	200 mm lens	—
Figures, tracery on exterior	50 mm lens 200 mm lens	Polarizing filter	Flash
Interior from door	28 mm lens	20 mm lens	Tripod
Altarpiece, chapels	28 mm lens	Tripod	—
Roof	28 mm lens	200 mm lens	—
Small details	50 mm lens Tripod	Flash Extn lead	Extn tubes
Launch trip along coast			
Embarking	50 mm lens Polarizing filter	20 mm lens	—
Coastline	28 mm lens Telephoto Polarizing filter	—	—

Subject	Essential	Useful	Optional
Interior of launch	28 mm lens	20 mm lens	Flash
Call at fishing village	28 mm lens	50 mm lens	Flash
Sunset (?)	50 mm lens	Yellow filter	—

You are probably thinking 'What a lot of trouble to go to'; but the effort pays dividends. For example, if you go through the entire list, and find, perhaps, that the tripod is listed as essential only once, and for a picture that is not very important — well, you might as well not bother with it. On the other hand, you might notice that although the wide-angle lens and the flash are not listed under 'essential' at all, they both crop up under 'useful' so regularly that it will certainly pay you to take both of them along. If you do not feel like paying out for a 17 or 20 mm lens, you can hire one for quite a small sum. Many large photographic dealers run a hire service for almost any item of equipment. Often they do require a deposit of the whole value of the items you hire.

Another useful thing about your list is that when you are actually on your holiday, it will tell you what you can conveniently leave behind in the hotel. Carrying a heavy bag full of things you do not really need can take quite a lot of the fun out of a holiday.

If you do decide that you need to buy more equipment for your holiday photography, get the lightest you can. Modern moderately lightweight tripods are quite rigid enough for a small camera, provided you use a cable release to avoid vibration, or use the delayed-action mechanism if you have one. Electronic flashguns nowadays are small and light, too, sometimes little bigger than a matchbox; and if you have a lens of about f 2 they are good up to about 7 metres distance in the open air (more if you use a high-speed film).

Film

Next, you have to decide how much film to take. You already have an estimate of the minimum number of shots you want to bring home. Now add a note to your list of where you are going to need linking shots: a signpost, a town boundary sign, a view down a road, a 'You are here' map. Add up the total, and multiply the result by 2. This is your *minimum* film need. Once you get there, you are

bound to find further subjects cropping up; and you will probably want to take your most important shots more than once, to be on the safe side.

Filters

A word about filters. Many beginners use an ultraviolet (UV) absorbing filter for all their outdoor work. This is pointless: the amount of UV in sunlight is very small, so small that there is no visible (or even measurable) difference in colour balance between transparencies taken with and without the filter. A polarizing ('Polaroid') filter is another matter. You have probably seen how Polaroid sunglasses cut down the glare from sunlit horizontal surfaces. By using a polarizing filter set with its polarizing axis vertical (as with the sunglasses) you will improve the colour saturation of outdoor subjects quite noticeably. The improvement in the colour quality of grass and road surfaces is often quite dramatic. You can also use a polarizing filter to darken the sky, without affecting anything else in the picture. You can find out more about filters with colour films in *The Focalguide to Filters*, by Clyde Reynolds (Focal Press, 1976).

Buying-out

If you see any interesting transparencies for sale in souvenir shops during your holiday, go to study them. You may get some very good ideas from them. Don't be too proud to buy some of them. They will have been taken by professionals with more or less unlimited time, film and equipment, and they may well be better than you can take yourself. In some cases they may be of subject matter — festivals, illuminations, aerial views, you could not get yourself at all. A word of warning, though. Transparencies you buy in shops are copies from an original. They are quite likely to have been made from colour negatives; the colour balance will not be exactly the same as that of your own slides so you must be careful how you mix them in when you come to show them.

Local colour

You will probably want to include some human interest in your holiday pictures; and you may hope to get photographs of the local folk and their customs and crafts. If so, do try to find out what their attitude to being photographed is, first. In some parts, especially in parts of Asia and Africa, you will find that many people dislike being photographed, and will turn away at the sight of a camera. Local craftsmen, though, are often delighted to show off their skills, especially if you buy one of their products (*before* you attempt to take any photographs!) or offer a fairly generous tip.

Security checks at airports

When you leave for home, you are likely to meet a major hazard at the airport. Most baggage is X-rayed before being put onto a plane, for security reasons; and if your films are in it they may be ruined by fogging. You can normally ask for baggage to be hand-searched. So keep your films with your hand baggage, and do not let it go through the X-ray machine. You sometimes see advertisements for lead-lined protective bags to avoid X-ray fogging at airports. Do not rely on them. If the authorities cannot see what is in your lead bags, they will simply keep on turning up the voltage until they can. Keep your *unexposed* film with you when you start your holiday, too; British airport authorities also use X-rays.

There is one thing you can do that will avoid all risk of having your valuable pictures ruined: buy the film while you are on holiday, and send it for processing before you leave for home. The larger photographic firms have processing stations in practically every country in the world. They all operate a postal service, so you can put your home address on the return slip. They will post the processed transparencies direct to your home for no extra charge, and without danger of fogging.

A final word on holiday photographs

No matter how much of an enthusiast you may be, do not forget your companions. It is their holiday as much as yours; and they

may not be as ready as you are to wait on a draughty street corner until the light is exactly right. Include *them* in your planning, too. Estimate how many hours they will be prepared to stand patiently while you get the composition sorted out, and how many kilometres they will be prepared to trudge with you to your ideal vantage point. Then halve the figures; and everyone should be happy. Why not take along a pocket-Instamatic (110) camera, and let your friends use it? They will then have their own record of the holiday, in prints they can pass round; they will not complain that you did not take any pictures of them; and they may become interested in pictorial photography themselves!

Slide Sequences on a Theme

If you take all your holiday photographs without any advance planning, your only real costs will have been in wasted film and opportunities. If your photography has a serious aim — for example if you are setting out to cover some specific topic, you have only to miss out (or mess up) one shot, and you will have spoilt the effect of the whole sequence. This applies whatever your original purpose was in taking the pictures. If a sequence is going to be effective it needs careful and thorough planning.

How will you use the sequence?

As in the planning of your holiday photographs, you must first be clear about your purpose in making your slide sequence. What is it going to do? Is it going to help to teach something? Or is it primarily for entertainment? Is it to be self-contained and complete in itself, or are you going to use it as a set of pictorial illustrations for a talk? Which is more important, the artistic merit of the pictures or their subject matter? The answers to these questions dictate your approach. If you have some kind of instructional purpose in mind, you will probably need to include slides that consist partly of words and drawings. If you want the set to be a self-contained package, that is, something you can lend people to look at on their own, you will probably need some kind of script to go with it, to explain or describe the slides. Nowadays it is quite usual to put such scripts on a tape cassette, and the whole thing is then called a 'tape-slide package' (see p. 201).

Once you have sorted out *who* is going to be entertained, or instructed, by your sequence, your general approach should become clearer. You know how many slides you need, and you should be able to balance clarity and pictorialism for the audience you have in mind. In you are thinking of making sound an integral part of

the sequence (see p. 169), you will have to plan the pictorial and sound elements together, so that they complement one another.

A shooting script

Once you have established the purpose and general approach of your sequence, you need a detailed plan of action: a 'shooting script'. Take a sheet of paper, and mark out a set of frames down one side, the same shape as your camera format. Use these for rough sketches or descriptions of your subjects, in the order you are going to show them. Use the right half of the sheet for notes on lighting and exposure. and for the commentary if you intend to have one. If you have the use of a duplicating machine, make a master of the form, and run off several dozen copies. Try to keep the precise purpose of your slide sequence firmly in mind. Your aim may be fairly general: say, the splendour of New England in the fall. Alternatively, you may want to entertain a circle of enthusiasts with a record of a visit to a traction-engine rally. You may have a more specific aim: for example, to show how you built a water garden. If your sequence is to be purely instructional, you can be very precise indeed, because you know exactly what you intend to achieve by showing the slides. Whatever your purpose, once you have it firmly established, the task of planning the photography will have become a lot simpler.

Categories of themes

The subject matter of your theme will probably fall into one of a number of distinct categories, each needing a somewhat different approach. They are:
1. Skills and crafts.
2. Locations.
3. Growth and development themes.
4. Events.
5. Collections.
Each category has its own approach, so we will consider them separately.

Subject: Building a 5-metre dinghy		Page: 1
Layout	**Exp No**	**Commentary or Notes**

Layout	Exp No	Commentary or Notes
BUILDING A DINGHY *(sailboat illustration)*	1	Title in yellow poster paint, rough caps. Paper cutouts. Ok grey sky, blue sea, yellow boat, white sails, red buoy. Introductory comments.
(sailboats on water illustration)	2	Actual race – photo or copy. List different types – define one type chosen for illustration.
(boatbuilder's yard illustration)	3	Boatbuilder's yard - W/A shot? two or three boats at anchor in foreground. Timber etc. Comments on how heap of timber will become a hull, etc.
(tools on bench illustration)	4	Bench with selection of tools - plane, handsaw, powertool, chisels, sash cramp O.O.F. timber background. 'A few of the tools he will use for the job'.
(craftsman holding model dinghy illustration)	5	Craftsman holding model dinghy, 'This is the kind of dinghy he is going to build'. Describe. Explain about working drawings.
LAYING THE KEEL	6	White poster paint on deep blue, rough caps, diag. layout 'Backbone of every timber vessel.' Entire behaviour of finished craft depends etc.

Observations: Check which tools most important, e emphasise. Check builder has model. Include shot of drawings (?) in case needed. Ask K.B. if he has suitable shot for 2 (check colour balance.).

An example of a shooting script for a slide sequence.

Skills and crafts

The kind of sequence that comes into this category is usually fairly short, and deals with just one comparatively restricted subject. Examples of subjects in this category might be fly-tying for anglers, throwing a pot, or setting up a lathe tool; in fact, any operation that can be broken down into stages.

The first thing you need to do is to sketch out the pattern of development. This is easy enough if the skill is your own: all you need to do is to break it down into stages. If it is someone else's skill, have a talk with the craftsman concerned so that you can identify all the stages you need to record. Once you have got a shooting script roughed out, you can start thinking about how to arrange the viewpoint and lighting for each shot so that the most important points stand out. Now you can prepare your final version of the shooting script, with sketches of the layout for each picture and descriptions alongside of exactly what you are aiming to show.

In preparing a sequence of slides on virtually any subject, always progress from the 'general' to the 'particular', and from the 'known' to the 'unknown'. For example, consider a sequence showing a craftsman building a dinghy. You might begin with a shot of a group of dinghies on the water, with a title superimposed. You would follow this with a single dinghy, beached. Next you would have several close-ups of the main features of the construction. You would then show each stage in the building of the hull, starting with the timber laid out in the yard, continuing step by step until the dinghy is complete. You may then end with a last very general shot, say of the dinghy under full sail.

Within this general format you will have a number of short sub-sequences for each separate operation in the building. Most of these will start with a general 'orientation shot', before you move in close to show the particular manual skill you are discussing. Sometimes you may need more than one shot for this: first, a 'general' one showing the whole boat to identify the area concerned; then a second, showing the posture of the craftsman; then a close-up of his hands carrying out the work; then the work itself, partly finished, showing the tools; and finally, the completed task. You may decide to show the *wrong* way to go about something, too. If so, it is good

policy to show first the *right* way, then the wrong way, then the right way again for comparison. Keep the lighting and viewpoint exactly the same for these shots, so as to allow a fair comparison.

Photograph each stage from several different angles and viewpoints. When you are composing a picture in the viewfinder, remember to allow space for any titling you may want to include in the slide (see pp. 111-114). Try to arrange your composition so that the eye will be led to the important detail. The easiest way to go about this is simply to get someone to point to the detail concerned. A brightly coloured pointer is often useful. To indicate very small detail, use a small dart-shaped pointer cut from card and temporarily fixed in position.

Once you start shooting, try to complete the job as quickly as you can, especially if it is out-of-doors. If the lighting varies between shots, you lose a lot of the continuity and smoothness you need for a sequence of this type. Always record the lighting, so that you can repeat it later if necessary. If possible, use the same sort of light for every shot. That is much better than changing from daylight to flash, to photofloods and back again.

Selecting the slides

Your next task is to go through all the processed slides and decide which of them are to go into the set. Examine them properly: you cannot judge the effectiveness or colour balance of a slide by holding it up to the light, and a magnifying viewer is not much better. Put all the slides through a projector, under the lighting conditions they will eventually be viewed by. Run through them fairly quickly twice. This will give you a fairly clear idea of which shots do have a contribution to make. Start by weeding out the ones you can definitely manage without, but keep them to one side. Now go through the slides again, this time putting aside as many slides as you can, until you are satisfied that you now have the absolute bare minimum that will tell the whole story. If you prepared your shooting script carefully, it will probably match it fairly closely.

Now you need a bit of outside help. Go through your final set with a couple of friends, and see if there are any missing links in

the chain. Either fill them from the material you set aside, or make a careful note of exactly what information is missing and work out the best way of supplying it. You may need a further photographic session on site; or you may need a drawing. For a technological theme, it is more than likely that you need some form of graphics in at least one part of the sequence. You may in fact have already noted this in the script. When you have decided the form it should take, you can then design, draw up and photograph them (see pages 190 and 192).

Locations

'Location' sequences are concerned with a specific geographical area. You might, for example, choose to produce a sequence on the white cliffs of Dover, the ruins in Southern Turkey, or the Baja Peninsula. Some sequences of this kind might well be among your holiday photographs. However, let us suppose that your sequence is to be built around a place you know intimately; and that you have more or less unlimited time, so that there is no doubt that you can do full justice to it.

Your first job is to decide *how* you are going to treat the theme. There are several ways you might perhaps choose to develop it:

1. Historically.
2. As a continuous journey.
3. By structure.
4. By literary association.
5. Temporally.

Historically. This approach would be suitable for an old town or for a building such as a cathedral, with a long history. For this, you would need quite a lot of documents and archive material, as well as your photographs of the place as it is today.

As a continuous journey. This approach is best where an actual journey is involved — land, sea or air. Your photographs simply follow the route, including all the interesting things, large and small, that you can see on the journey.

By structure. This treatment would be suitable, say, to show the process of urban growth by comparing two towns. Here you certainly need explanatory diagrams to illustrate the general theory,

and real photographs to bring the theory to life. By using two projectors, you can even superimpose a diagram of structure on a photograph of the place itself. You can find out more about this type of technique on pp. 175-6.

By literary association. Many districts are associated with literary or artistic figures, e.g. Shropshire with Housman, the Mississippi with Mark Twain, or Arles with Van Gogh. You can use such associations to link sequences of slides of areas which might otherwise be difficult to present as a coherent whole. If you adopt this approach, you will find it fits in well with the principles of a slide-sound sequence (see p. 168).

Temporally. Another possible approach is to show a locality through the seasons, or even through the years. There are pitfalls for the unwary in this approach: for example, the problem of maintaining the same colour balance over a long period of photography. They are discussed in more detail on p. 34.

Just because you have lived somewhere for many years, and carried your camera everywhere, do not assume that you already have the basis of a suitable sequence. The lighting quality and colour balance may vary from one slide to the next. Many of the viewpoints are not really satisfactory; and coverage is patchy, so that although there are many pictures of apple blossom, there are none of the asparagus beds; plenty of shots of one side of the valley but none of the other; there is scarcely a human being to be seen; and those that are, are wearing fashions years out of date, and even worse, there is no continuity material at all. So whatever you may already have, start planning your photography from scratch, and ignore your existing slides until you have completed shooting. Then anything you *can* use is a bonus.

Having decided on your general approach to the theme, you can start planning the overall structure. Get a guidebook or an official information sheet: even if you do know everything about the location (which is unlikely) it will help you to get the sequence into some sort of logical order. Plan the viewpoints, with the aid of a map if necessary. Visit the location and give yourself the whole day to do so. Your bike is the most useful form of transport — fast enough to cover a reasonable distance, and slow enough to allow you to have a good look at the scenery.

Check all the vantage points against the ones you have marked on the map, and change them if necessary. Note the lighting, time of day, and the best direction from which to take the photograph. If the light is particularly good take a photograph there and then: if not, estimate when it is likely to be at its best. Note any small details such as nameplates and signs that you can to use as continuity shots: photograph these, too, if the light is reasonable. Look for human interest, and if you find any, take a photograph at once — you may not get a second chance.

Examine your processed slides carefully. Check the notes you made at the time, and amend them as necessary. You may be able to complete the photography on your next visit, though you will probably need a third or even a fourth.

The quality of lighting has a great effect on both the modelling of your subject and its contrast, colour balance and colour saturation. This quality varies from day to day, and throughout each single day; and that is why it is so important to keep detailed exposure records. The ideal outdoor lighting is unobscured sun, with white cumulus clouds to illuminate the shadows. If you take your pictures under a completely cloudless sky, your transparencies will have deep blue-violet shadows and unnaturally high contrast. White clouds prevent this effect, and at the same time make the sky more interesting. Overcast sky gives results of low contrast and an overall bluish cast, with low colour saturation.

Growth and development themes

These are sequences where you photograph the same subject over a period of time. It might only be a matter of a few days or weeks: for example, you might choose to record the development of a Christmas cactus from the first appearance of the buds to full flower (an ideal subject for the 'dissolve' technique with two projectors described on p. 168). You may have to spread the photography over a full year: for example, the story of cider, or the making of a water garden. You might even take ten or more years to record the life of a birch tree from seedling to maturity. When you embark on this type of sequence you need to lay your plans particularly thoroughly, as there is unlikely to be an opportunity for a repeat.

Subject	Date	Time	Distance (metres)	Position Cam	Position Sun	Lens Fl (mm)	Exp	F/no
Plan of garden showing position (copy)	3 Jan.	—	(2 floods, 30 cm.)			50	8	8
Garden area chosen (hazy sun)	1 Feb.	1400	4	S	SW	35	125	5.6 / 8
Ground cleared	15 Feb.	1400	4	S	SW	35	125	8
Begining excavation (self from rear)	22 Mar.	1000	3	SW	SE	50	60	11
Ditto (close up of spade)	—″—	—″—	1	SW	SE	50	60	11
Completed excavation (high view point)	12 Apr.	1200	2	SW	S	35	60	11
Ditto from house side (+ fill-in flash)	—″—	—″—	2	NE	S	35		16

Sequence on: Water garden

Emulsion & Batch: Ektachrome 64/501122

Exposure records. You should try to keep an exposure record for everything you take that may come in useful for a sequence. You may buy pocket exposure record books from photographic shops and larger stationers. If you are planning a sequence that may extend over some time, it is better to keep a single record sheet for the whole sequence, so that you can fit in any retakes without having jarring changes in lighting or colour balance.

Decide first how much film you need for the whole sequence; and if it is not going to be more than a year in the taking, buy the whole lot fresh from a professional supplier. Make sure it is all the same emulsion batch number. If you keep it in a freezer it will not deteriorate and the colour balance will not alter. However, if your shots are going to be spaced a long way apart, buy 20-exposure lengths of film not 36. You want to use the camera for other things in between times, and you should not leave exposed film for more than a few weeks before you have it processed. So, each time you have completed a set of shots for the series, finish off the film and send it for processing without too much delay. You will have to budget for this, buying one film for each occasion, so that if your shooting plan requires, say, eight separate occasions, you will need at least eight films. When planning the photography, be sure to include very full details of exact viewpoint lighting and time of day. This is important for smooth continuity, particularly if you have ambitions to use the sequence in a two-projector set-up, with dissolves from one slide to the next. If you do this carefully, your birch tree will almost appear to grow before your eyes. For this effect, you must take all your shots from exactly the same viewpoint, with exactly the same lighting, so your exposure record is particularly valuable. Do not forget that what is a small sapling will eventually become a large tree, so start far enough away! Of course, the actual growth of the tree is not the only aspect you would want to have in the sequence; you would want to intersperse it with shots of catkins, leaves, bark texture, and perhaps insects, birds and other related things. Here you can let your creative ideas have full rein.

The kind of sequence described above is a very long-term business. Many development sequences are much shorter-term, for example, the Christmas cactus mentioned earlier. However, many of the rules are the same. You will still have to keep accurate records of position, camera viewpoint, lighting and time of day (if you are using daylight as illumination). Leave plenty of room in your first shots, because plants grow. A sequence of this simple type may seem a bit dull on its own. There may be only six or seven slides altogether. Where it comes into its own is as a backdrop to another story, for example, the family preparations for Christmas. You can use the more extended themes for longer stories: even the birch tree could

fit into a story of your children growing up, as a kind of symbolic background. A collection of development themes of various lengths can be very useful in this way, whenever you are planning to tell a story in slides.

Some development themes, of course, are self-sufficient: the record of how you built your water garden, for instance. This type of theme often goes well with appropriate background music, which you can put on tape: you can have a lot of fun selecting the music so that it is really apt. If you want to do this you need a licence from the Mechanical Copyright Protection Society, and permission from both the Performing Right Society and Phonographic Performances Ltd, to cover yourself legally. This is particularly important if you intend entering your sequence for a competition, or showing it at a club. Details about how to get a licence are given in the section on copyright, at the end of the book.

Events

Photographing events poses two problems. Firstly, most events involve movement. How do you give the impression of movement in a series of still pictures? Secondly, and this applies even if the event is a completely static display — how do you get variety into the sequence? If you photograph everything in exactly the same way, the result will be no more than a dreary catalogue, but if you overdo the variety of viewpoints you may fail to do justice to some of the items.

Let us deal with the movement problem first. When you are photographing moving objects, you have to use the right kind of technique, such as 'zone' focusing (keeping the object within a predetermined depth of field) and 'panning' (following the moving object with the camera as you expose). If you want to know more about the techniques of photographing moving objects, you will find them described in *The Focalguide to Action Photography*, by Don Morley (Focal Press, 1978).

You want a slide of action to really put across the action. One way of giving the impression of movement is to use an exposure that gets the moving object, or the spectators, slightly blurred. But much more important than any trick of this type is the ability to

capture exactly the right instant to make your exposure. Quite often, this all-important instant is not when you might have expected it. In fact, it is hardly ever the point where the subject is moving fastest. To get a good action picture of, say, a discus thrower, you do not take it as the discus leaves his hand. Such a picture looks like a single 'frozen' frame from a TV sports programme. For this subject, the right instant is *before* the throw itself, when the athlete is wound up like a spring, and stationary.

You also need to choose your viewpoint carefully; for example, in show jumping, a low viewpoint catches horse and rider at the highest point of a jump; or motor racing, where your best viewpoint is probably at a sharp corner. Even slow-moving events such as carnival processions need a careful choice of vantage point. If you can, visit the area in advance (or at least arrive as early as you can). Bring enough film for at least three times as many exposures as you think you are likely to want to use. Choose your viewpoints, about three if you are going to be able to move around freely: two for comparatively close-up action shots and one for a wider view.

If you are unlucky enough to be hemmed in by a dense crowd, unable to move you may even find it difficult to get any photographs at all. If you use a waist-level viewfinder, or a twin-lens reflex, or a single-lens reflex with removable pentaprism, you can hold your camera upside-down above your head (with a little practice).

Even with an eye-level finder, you can still gain a few centimetres in height by holding the camera upside-down. You will need to find a new grip, otherwise you will not be able to reach the shutter release or hold the camera steady. It is also possible to teach yourself to aim 'blind' with the camera held above your head. There is nothing new about this trick, of course: many of the old plate cameras had no separate viewfinder. Alexander Keighley, one of the earliest (and greatest) 'candid' photographers, did most of his best work among the ordinary people of Morocco, who were very shy and suspicious of photographers. So Keighley disguised his camera as a brown-paper parcel, and operated it while carrying it under his arm. His composition was invariably flawless.

Composition is probably the trickiest thing about photographing events, especially sporting events, where things tend to happen pretty quickly. When you use print film, you can deliberately

include more in the negative than you are going to use in the print. You cannot afford to do this with colour transparencies. You can, certainly, mask off any unwanted detail using black gummed strip. In fact, you will probably have to do so quite often, to produce the picture shape you want. But if you have to mask out unwanted material all round your subject, then the image will be noticeably smaller than an unmasked slide. The best technique, then, is to try to compose your picture as far as possible so that it uses the whole of your format. This is certainly easier to do with the full-frame 35 mm format than with square pictures. It is also preferable to try to have all the pictures in a slide sequence the same way, usually horizontal ('view'). A single vertical slide mixed in with a sequence that is otherwise horizontal is a bit jarring.

This means that you have to choose your viewpoint and distance carefully. Of course, if you are in a fixed position there is nothing you can do about the distance problem, and there is no alternative to having several lenses of different focal lengths. An excellent solution to the problem is the 'zoom' lens, preferably one with a range of focal length between about 35 mm and 135 mm. Zoom lenses are expensive items, and they are rather large and heavy, too. So think about hiring one for the day.

Two camera bodies can make life easier. You can then always have a camera with the right lens handy, and you will not have the embarrassing experience of being in the middle of rewinding the film just as the high spot of the show is about to happen.

Never just concentrate on the event itself. There will be plenty of human interest away from it. Indeed, some of your best pictures may well turn out to be of the spectators. So keep an eye on them, too. In any case, such pictures are useful in a sequence, to provide variety.

Many events feature a static exhibition, too: old vehicles are particularly appealing. Never photograph everything from the same angle. To avoid monotony, vary the angle between shots. In any case, you will often find that you need to vary the viewpoint in order to bring out the best in your subject. But do not use such bizarre 'angles' that you cannot see the subject properly: this is very frustrating to any enthusiasts you may show your sequence to. For example, at a veteran car rally, a group of slides within the

sequence might be of a Rolls Royce Silver Ghost. The group would start with a general shot showing the car amongst a number of others. The next slide would be of the car itself; any others would show various details such as the radiator, the engine and the dashboard (assuming you want this kind of detail). Of course, you need not take the pictures in that order, though it is usually a good idea to do so. Slides of old machinery generally look better if you can include some human interest. Usually the owner is never far away; and he (or she) will probably be more than willing to be photographed with it. Keep a sharp look-out for humorous moments, too: you can often manage to intersperse your show with pictorial 'asides' such as the apprehensive expression of the traction-engine owner as a little dog examines his gleaming wheel; the two middle-aged ladies vainly trying to start their model T; the four young enthusiasts standing on the roof of their battered old London taxi covered in slogans, to get a better view. But don't go overboard for atmosphere at the expense of the event itself. Keep your prospective audience in mind all the time.

Collections

The last category of slide sequences is the pure record of a collection. This is strictly by a specialist for specialists. That does not mean, of course, that your pictures should be arid and devoid of aesthetic appeal, but it does mean that they must be technically as good as possible. This is not always easy: it depends largely on your chosen subject.

If it is Victorian lace, you may not need much more than some plain dark velvet and a single lamp; but if it is Georgian silverware, you are going to need a studio equipped to something like professional standards, and a good deal of experience in lighting to go with it. Pottery and ceramics are more straightforward; but every subject, whether dolls in national costume, historic aircraft or nineteenth-century manhole covers, presents its own problems.

A slide is the nearest possible substitute for the real thing; and it is portable, and always available, something the real thing may not be. Your collection may be of archaeological material, much of it tucked away in Cairo museum or somewhere equally inaccessible,

some perhaps lost or destroyed. A slide can preserve the most beautiful flowers in a collection of houseplants, where some, like the Selenocereus group ('Queen of the Night') open during the night and are past their best by morning. And slides make it possible to 'collect' even such intractable objects as sixteenth-century stone bridges, Indian settlements or radiotelescopes.

Sometimes you may have to be content with a bought-out or inferior slide, or a copy from a photograph (see pp.82-101). Never mind, with luck you may one day be able to make a slide of the real thing. When you do, you will naturally want it to be technically as nearly perfect as possible; this is not always easy, especially if the object is locked away in a glass case in a museum.

Of course, full records of lighting, exposure, scale, date of photography, and details of the object itself are important. You also need to decide, early on, whether to aim at a standard background or to vary it; whether to adopt a standard lighting set-up for all the slides; whether you need a scale of millimetres (or inches) in the picture, or a title in the picture area. What you decide depends a good deal on the nature of your material, and on whether you are likely to have to photograph much of it 'in situ'.

There are some general guidelines, however. A white background hardly ever looks good on a projected slide, even if you are photographing something as unexciting as a collection of laboratory glassware. The general effect is always somewhat weak and washed-out. At the other extreme, you do not want to use draped purple velvet for everything. It may look fine for a single shot of, say, silverware; but it will soon become monotonous if you use it for every shot. Black or dark blue are possibly a little severe, but they both work well for light-coloured ceramics and for flowers. They are not very suitable for dark objects or glassware, which look better on grey or a pastel shade. For almost any object, though, you will not go far wrong with an unassuming mid-greyish blue. Avoid using red backgrounds, especially bright red. If you do use red, you will find that when the slide is projected, the red stands out so strongly that the object appears to be sunk into it. Blue and subdued (desaturated) colours have the opposite effect, and cause the object to stand out. That is why blue is a safe bet in cases of doubt.

If your camera has a fixed lens, you probably cannot focus closer than about 0.9 metres (3 feet). At this distance any object smaller than 0.5 metres (20 inches) in length will be too small to fill the frame adequately. Most 35 mm single-lens reflex cameras focus rather closer, about 0.35 metres (14 inches), corresponding to an object of about 0.2 metres (8 inches) in length. For smaller subjects, you need close-up equipment (see pp. 92-4).

Lighting

If the subject matter of your collection is all rather similar in size, shape and general appearance, you may find that using a standard lighting set-up helps you to get consistent results. Once you have found the optimum arrangement of lights, stick to it, except for very minor adjustments to avoid obtrusive reflections or shadow areas. You can use either floodlamps or flash. Floodlamps are easier because you can see the lighting through the viewfinder, and judge its quality; but they are cumbersome and require a mains supply, so you cannot use them on location. Flash, on the other hand, is very portable; but if you want to judge the lighting quality in advance, you must carry a couple of torches to try out the different positions of the lights first, replacing them with the flash units for the actual exposure.

Except for silverware, and possibly glassware, the simplest lighting is usually the most effective. You hardly ever need more than two light sources — the 'modelling' light and the 'fill-in' light. The modelling light provides the highlights, shadows and texture, and gives the general impression of solidity, of three dimensions. Start with this lamp only. Put it about halfway round from the camera axis, and about 45° above the object. If the object has a 'face' put the lamp on the 'face' side. Now get someone to move the lamp around, while you watch through the viewfinder. Once you have found the place that gives the best modelling, fix the lamp in that position. Now bring in your second lamp, the fill-in light. Its purpose is to illuminate the shadows and control the contrast. It should not throw any visible shadow. That means you need to have it close to the camera axis, so that any shadows are directly behind

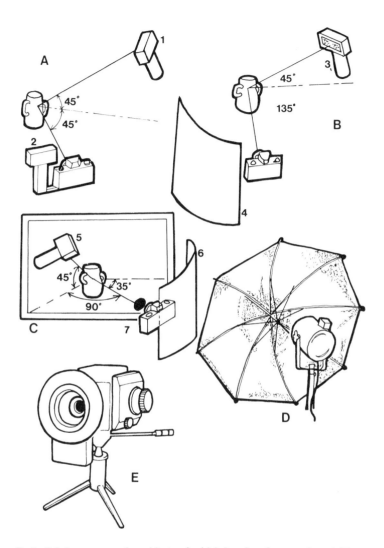

Basic lighting systems for objects. A, Lighting for shape and modelling. 1, Modelling light (1 metre). 2, Fill-in light (1½ metres). B, Lighting for contrast and texture. 3, Modelling light (1 metre). 4, White card reflector (0.5 metres). C, Objects behind glass. 5, Modelling light (11 metres). 6, White card (1 metre). 7, Polarizing filter, axis horizontal. D, Brolly-flash extended light source. E, Ring-flash for 100% on-axis illumination.

the object, and not visible from the camera. Put it on the opposite side of the camera to the modelling lamp. To start with, put it at a distance from the object that is about 1½ times that of the modelling light (e.g. if the modelling light is at 1 metre from the object, the fill-in light should be at 1½ metres). Study the effect of covering and uncovering the fill-in light, and alter its distance as necessary until the contrast appears to be just a little on the low side. This will be approximately correct for the average colour film. This simple lighting works nine times out of ten — because it is very much the same kind of effect you get from natural sunlight (modelling) and white clouds (fill-in).

Daylight-type transparency films are suitable for blue flash-bulbs, or electronic flash. If you use them with tungsten filament lighting, such as Photoflood lamps, the resulting transparencies will have a fairly strong orange cast because of the different colour of the lamps from daylight. To correct this you need to fit a bluish filter (a Wratten 80B, a D/A, a B12 or CB12 for Photoflood lamps). This filter absorbs some of the light, as do all filters, and reduces the effective speed of your film by 2½ times. What this means is that you have to re-rate your film speed by that amount. Thus a 50 ASA (18 DIN) film becomes effectively 20 ASA (13 DIN). Note that this does *not* apply if you have through-the-lens (TTL) metering: in this case, as the meter is reading through the filter, it takes the reduction in light into account. It is much more satisfactory to use a tungsten-light film, although this may need a pale filter to give you just the results you want in your illumination. Whenever possible, make tests first on film of the *batch* that you intend to use. You do not normally need any filter for electronic flash. However, if you want very accurate colour, you may have to experiment with combinations of Kodak colour-printing filters taped to the flash head. These filters are made of acetate material, and are quite inexpensive.

With most objects, measuring the exposure is simply a matter of pointing the exposure meter at the object and taking a reading. If your camera has a built-in meter, then you use it in the usual manner. However, if your subject matter or its background is much darker, or much lighter, than a mid-grey, you may need to make adjustments to the measured exposure to get it correct. There are

more accurate ways of estimating the exposure, and these are discussed on pp. 88-90.

With museum collections you may be allowed to move the exhibits you want to photograph from their cases. The Curator will probably be prepared to go a long way to help you; and you may be able to take your equipment along and set it up as you would in your own home. On the other hand, you may have to photograph the exhibits behind glass, using flash. You will need a polarizing filter for this.

Set up the camera at an angle to the glass, and adjust the polarizing filter until the reflections are at a minimum. By careful adjustment of both camera position and filter you will probably be able to eliminate them entirely. Use a single flash as modelling light, and a sheet of white card as fill-in, using reflected light from the flash. Use a pocket torch to find the position of the modelling light that gives the best modelling, watching through the viewfinder to ensure you cannot see any direct reflection on the glass from the torch. Get someone to hold the flash for you, and arrange your card near the camera (but behind the lens) so that it catches some of the light from the flash. Work out the correct aperture for the flash distance and then take several shots with slightly varying flash distances and positions. Don't be afraid of wasting film; you may not get a second chance.

Finally remember that you need to keep your slides up to date. If a painting has been recently cleaned, it is misleading to show a slide of it in its former grimy condition (except for comparison). You are probably safe enough with antiquities, but be careful if you are considering putting people into your pictures, to give a sense of scale. Fashions in clothing date very quickly!

Lighting technical subjects

Sometimes you may want to eliminate shadows altogether. If your subject is a complicated piece of electronic circuitry, or a delicate mechanism, any shadows may make details difficult to see clearly, and may possibly hide some parts altogether. You can suppress or eliminate shadows by using a single lamp and moving it right round the camera during the exposure. This technique is sometimes called 'painting with light'. Do not allow the lamp to come too close to

the camera, though, or any polished metallic surfaces will show 'glare'. Sweep the lamp in quite a wide arc over the camera. You may find this easier to do with two lamps, starting from the centre and sweeping outwards and downwards; but, unless you have a delayed-action shutter-release, you will have to get someone else to operate the shutter for you.

Shadowless lighting always results in a loss of colour saturation, and you may find you can get sufficient softening of the shadows by moving both modelling and fill-in lamps in a small circle during the exposure (you will need help for this, too).

A simpler, but more expensive method of getting a broad, comparatively shadowless light source is to use a 'brolly-flash'. This is an electronic flash accessory which is set up so that the flash is fired away from the subject into a white fabric reflector built like an umbrella. This device increases the effective diameter of the light source to 70 cm (28 inches) or so.

The ultimate in shadowless lighting is the 'ringflash'. The flashtube is circular, and actually fits around the camera lens barrel. With this set-up you can even photograph the bullet at the bottom of a rifle-barrel! However, as the light source is on the lens axis, it tends to produce powerful reflections from any surface perpendicular to the camera, and you need to take care to avoid this effect. Both brolly and ring flashes are expensive, but you can hire them from professional photographic suppliers.

There are a good many subjects that just are not amenable to simple lighting techniques, such as welding-torch flames, oscilloscope screens, microscope slides, exploded views and extreme close-ups; and in a book of this nature it would be inappropriate to try to deal with such special techniques. However, you can find some of them discussed in *Visual Aids and Photography in Education* by M.J. Langford (Focal Press, 1973).

Graphics and Artwork for Pictorial Shows

You will probably improve your slide show considerably if you include some slides of drawings and lettering at appropriate points. At the very least, it is worth making a slide for 'The End'. An introductory title slide is also very useful for setting up the projector and screen: any members of your audience who are already in the room will not get a premature viewing of your first slide. Graphics do not have to be complicated: in fact, as we shall see, the simpler they are, the better — just the necessary words and no more. Of course, you can include drawings too. Again, as we shall see, you do not need to be a good draughtsman to be able to produce effective drawings. You can even superimpose your titles on actual photographs. It may be a good idea to intersperse your pictorial slides with a few diagrams, too, particularly if your set of slides is intended to illustrate an informative talk.

Rub-down transfer lettering

Rub-down transfer lettering has for many years been synonymous with the name Letraset, though there are a number of other brands around. It is called 'rub-down' from the way you apply it. It comes in sheets backed with a protective silicone paper, and to use it you take away the protective paper, place the appropriate letter where you want it to go, and rub the surface of the support material with a blunt-ended instrument (see p. 54).

The first step is to choose a style of lettering (typeface). There are literally scores of different typefaces — the easiest to read are those which have capitals proportioned roughly 3:4 vertically, a stroke width which is constant and about one-sixth of the height of a capital letter, and are a simple sans-serif (square-ended) shape.

The lettering that comes out closest to the ideal is Helvetica Medium. It is widely used in posters, road signs, television titles, and almost everywhere that demands clear legible lettering. The typeface used for this book is a close relative of it.

Another good reason for choosing the Helvetica face is an economic one. Unlike some other faces, a 'p' upside-down is exactly the same as a 'd'. Similarly a 'u' turned upside-down becomes an 'n', and an 'l' is the same as a capital 'I'. So if you run out of a particular letter you can often find what you want elsewhere on the sheet. You can even make a 'c' from an 'o' or a 'w' from two 'v's.

Two others worth mentioning are Folio Bold and Futura Bold Italic. You can get all these in rub-down transfer lettering. Folio Bold has somewhat broader letters than Helvetica, and Futura Bold Italic has a thicker stroke, and is useful for giving emphasis to a single word or phrase.

The next thing to decide is the size of the lettering. All sheets cost the same regardless of the size of the individual letters, so you might conclude that the best size would be the smallest you can get. But it is not as simple as that. To begin with, you need to know how big an area your camera takes in when it is focused as close as possible. At the minimum focus distance of a simple camera (around 0.9 metres, 3 feet), your picture area will be about 40 x 60 cm (16 x 24 inches), or about 47 x 47 cm (19 x 19 inches) for a 126 format. At this size your letters will have to be about 25 mm (1 inch) high — a very expensive size. To get over this problem, you should get a close-up lens. The most useful value for this purpose is 2 diopters (focal length 0.5 metres), which will enable you to focus down to about 0.3 metres (12 inches) at which distance you will be able to use much smaller letters. If you have a single-lens reflex camera, you will probably find that it will focus down to about 0.35 metres (14 inches). This distance approximately covers a sheet of A4 size. For a title at this size you would normally need 36-point (9 mm high) letters. This is still rather large; and it is preferable to work with extension tubes(see pp.92-4). Although smaller letters undoubtedly work out cheaper, the very small ones are extremely difficult to get accurately aligned; and you must remember that any small error you make in alignment will be magnified 50 or more times on the screen! The smallest practicable letter size, even for experienced workers, is about 16 point (4 mm high); and until you have had enough practice to be quite sure of yourself, you would be well advised not to go below 24 point (6 mm high).

Card is better than paper as a base, because being rigid it is easier

to handle, and it stays flat. Quite thin card will do. You can get it in various pastel shades from shops that sell artists' or educational materials. Leave a generous border when you are laying out your work, because all camera viewfinders are pessimistic: that is to say, you actually get more into the picture than you see in the finder. For single-lens reflex cameras the extra is typically about 5% all round.

Although black letters are cheaper, you can also get white, and a selection of colours. If you enjoy playing around with colour filters, you can get perfectly good colour slides from black lettering on a white ground, though these techniques involve extra work, and you may have to process your own film to get the effect you want. However, there are a number of techniques described on pp. 102-10. Some combinations of colours work better than others. Black is probably most successful against a yellow ground, and white on deep blue. Most colours also look well on yellow. Yellow lettering looks good on any of the darker colours. Combinations to avoid are pairs of colours that are more or less equally dark, such as red and green, or green and blue.

Legibility of words and detail

Having discussed what ought to go into a slide, we now need to sort out whether everyone at the back of the room is going to be able to see it! Normal vision is designated 6/6, which is very roughly equivalent to being able to distinguish details 6 mm high at a distance of 6 metres, or a capital letter some 12 mm high. This is a statistical norm, so that if you have 6/6 vision you have eyesight that is poorer than that of half the population but better than that of the other half. The great majority of people have roughly 6/6 vision (with glasses if they need them), and in fact the depth-of-field scales on camera lenses are worked out on this assumption; but it is a fact that a large number of people do not have 6/6 vision. You may take it as a virtual certainty that several of them will be sitting in the very back row.

You have to bear this in mind when you are working out the size of detail you can show in your slide. You also need to remember that quite a lot of definition gets lost in the optical systems of the

camera and projector, and in the granular structure of the film. So in practice we settle for a rather lower standard, more like 6/12, that is 24 mm (1 inch) high letters at 6 metres (20 feet).

For a 35 mm horizontal format, the height of your capital letters should be not less than about 1/40th of the height of the frame, provided the picture is reasonably bright and viewed under standard conditions, that is, from not more than six screen-widths away. The thickness of lines in a drawing should be not less than one-fifth of this, i.e. 1/200 of the frame height; and the smallest details it is necessary to see should be not less than 1/100 of the frame height.

On A4 size card, your lines should be 1 mm to 2mm thick, and your smallest detail should under no circumstances be smaller than 2mm in size. Notice that this is a good deal coarser than detail in textbook illustrations; and this is one reason that these are so seldom effective when copied directly as slides.

There is another reason textbook diagrams and text are not very suitable as graphics for slides. Apart from being too small to be legible, the style of lettering is usually unsuitable for projection. Most textbooks (*Focalguides* are an exception) use a typeface based on Times Roman or a similar face. The letters have feet (serifs) at the ends of the strokes; and the strokes themselves vary in width, depending on whether they are horizontal, vertical or sloping. Although this gives print that is easy to read in a book, the projected image is quite hard to read compared with simpler faces such as Helvetica.

Layout of titles

Before you rush into things, give a little thought to the layout of your title. Try out several arrangements of it with pencil and paper, and decide which is the most attractive. It may help to do the words, then cut them out, and keep rearranging them until they look right.

Most lettering sheets have both capital and lower-case letters. Which should you use? Lower-case lettering takes up less room and is easier to read — at least as letters or phrases. On the other hand, there seems to be a tradition that titles should be in capitals; and

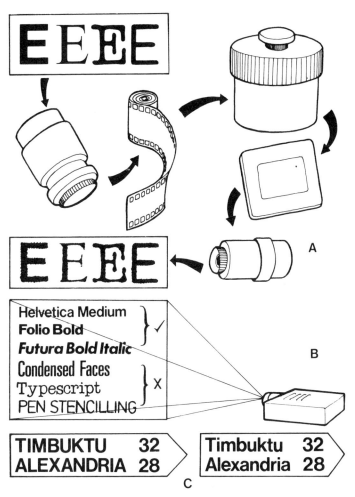

Choosing a suitable typeface. A, By the time letters of the alphabet have been through the camera optics, film emulsion, processing chemistry and projector optics, their legibility can be seriously impaired. The faces shown are Helvetica Medium, Times New Roman, Elite Typescript and pen stencil lettering. B, A selection of suitable and unsuitable faces for projection. C, In general, lower-case print is easier to read than capitals when viewed from a distance, as well as taking up less room.

as they are usually only a few words long.

There are three conventional ways of laying out titles: blocked, centred and diagonal. In the 'blocked' layout, each line begins vertically under the previous one. It is the simplest of the three to do, though there is one pitfall to beware of. The result looks uneven if you align each letter exactly with a vertical line. Certain letters need to be placed slightly farther to the left than others for the result to look right. If you take as standard the square letters like 'E' and 'H', then rounded ones like 'O' and diagonal ones like 'A' and 'W' need to be slightly more to the left. Up to about a quarter of the letter's width is about right. This means that if you have drawn your guideline as a continuous line, you cannot rub it out without damaging the letters. So mark it in only above and below where the letters are to go.

In the 'centred' layout each line is symmetrical about a vertical centre-line, like a menu card. To lay out your lettering in this way, draw a broken line as described above, but symmetrically down the middle of the title area. To get all your lines centred in this guideline, you need to count the letters in each line and divide by 2. However, you need to allow for some letters being a different width from others. Allow a count of 1½ for 'M', 'W' and spaces, and ½ for 'I' and the figure '1'. Having found the centre of your line of print, work from the centre outwards. If you have a handwritten pattern in front of you, this should help to avoid spelling mistakes.

In the 'diagonal' layout each line starts later than its predecessor, so that the lines of print go diagonally from left to right across the format. Make a mark near the left-hand edge for the beginning of the first line. Now mark the start of the next line, indented (say) 1 cm farther to the right. Continue in the same manner for the remainder of the lines. Align the initial letters of each line to these marks in the same way as described above for the blocked type of layout.

A further type of layout which can often be very effective is the 'haphazard' style, where the words seem to have been thrown down onto the format more or less carelessly (though in the right order). Lay down the words separately on card, cut out the words in 'cloud' or 'bubble' shapes, then arrange them on another piece of card of a contrasting colour, so that they form an attractive composition.

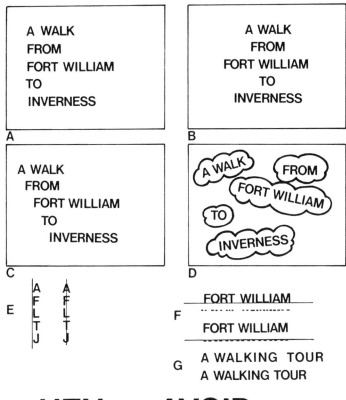

A WALK
FROM
FORT WILLIAM
TO
INVERNESS

A

A WALK
FROM
FORT WILLIAM
TO
INVERNESS

B

A WALK
FROM
FORT WILLIAM
TO
INVERNESS

C

A WALK FROM FORT WILLIAM TO INVERNESS

D

E

F

FORT WILLIAM

FORT WILLIAM

G

A WALKING TOUR
A WALKING TOUR

H

HEN AVOID

Layout of titles. A, Blocked. B, Centred. C, Diagonal. D, Haphazard. E, In blocked titles, letters should be aligned according to 'centre of gravity' (right), *not* by left-hand edge (left). F, Rub-down lettering should be aligned on the pecked lines below the letters (bottom), not on the lower edges of the letters (top). G, Spacing between letters should be based on area between letters (bottom), not on space between extreme edges of letters (top). H, Vertical letter edges should be spaced about 1½ stroke widths apart. Letters with round perimeters should be much closer, and sloping-edged combinations should overlap.

The words do not need to be horizontal. One of the advantages of this format is that you can try out a number of different arrangements and colour combinations without your having to make out a fresh title for each.

Aligning rub-down lettering

Lining up the lettering is the trickiest part, and one which usually gives away the beginner. However, it is not difficult if you follow a few simple rules, and the result fully repays the little extra care you need to take. You do need horizontal guidelines. Most people rule then with a pencil; but if they are dark enough to see they may be impossible to erase completely. A better method is to tape a piece of coloured paper to your drawing surface so that its upper edge forms the guideline. Use masking tape rather than cellulose tape, as it is easier to peel off without doing any damage. Align your letters by using the upper edge of the broken line that runs about 2 mm below the bottom of the letters. Never line up the bottoms of the letters themselves: you cannot get an even line, because letters with rounded bottoms, like 'e' and 'o' are designed to go slightly *below* the line. Place the protective silicone paper just under the guideline, and place the transfer sheet on top. It is important to use the silicone paper, otherwise you may inadvertently transfer several letters with the pressure of your hand. Now line up your first letter, and off you go.

The best tool for rubbing down the letters is a burnisher marketed by Letraset for this purpose; an old empty ballpoint pen or a pencil will do instead. Rub at first lightly, then with more pressure, until the whole of the letter has gone grey. This means that it has separated from the support material, and you can lift this carefully away. Occasionally some of the letter sticks and breaks off. If this happens, do not try to put the sheet back, as you will probably only cause further damage. Simply remove the damaged letter by lightly pressing a piece of cellulose tape on it, and very carefully peeling it away. Then try again with a fresh letter.

You should leave just enough space in between lines to fit in a capital letter; and the space between words should never be greater than the width of a capital 'M'. The spacing of letters is a little more

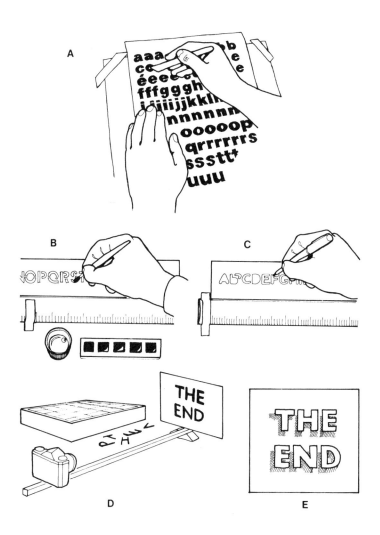

Titling methods. A, Rub-down lettering. B, Brush stencil. C, Pen stencil. D, Cine titling unit. E, PVC letters on glass against a coloured paper ground photographed with a single lamp at a steep angle gives an attractive shadow effect.

complicated. If the letters have vertical sides, like 'H' and 'N', the space should be about 1½ times the width of the strokes that form the letters. On the other hand, rounded letters like 'O' and 'D' should be almost touching their neighbours. Combinations with sloping 'envelopes', such as 'TA' or 'AW', should actually overlap slightly. It is a matter of getting the *area* between the letters, rather than the distance, equal.

Letraset letters have a crude sort of guide built into the pecked lines that serve for guidelines for letter alignment. These are in the form of pairs of dashes under each letter. The idea is that you line up the dashes with those under the preceding letter. In order to do this accurately you have to rub down the pair of dashes under the letter as well as the letter itself, which is another good reason for using a piece of coloured paper as guideline rather than a pencil line; also for aligning the *top* of the pecked guideline rather than the middle or bottom — otherwise you would have to keep removing dashes from your work. This method is not very accurate, as it takes into account only single letters rather than pairs of letters; and although it does give reasonably good spacing, the result is still rather widely spaced. All in all, it is probably better to judge the spacing by eye. A good general rule is: when in doubt, put your letters as close together as they will go.

One further word of warning. Partly used sheets are often a bit buckled. If your sheet is like this, *don't* take any notice if your letter looks as if it is going to go down out of line. As long as your guideline is correct, the letter will be, too.

When you have completed a word, you need to ensure it is firmly stuck down, otherwise a careless fingernail scratch will fetch part of it off. Place the protective silicone paper over the word, and burnish it by rubbing all over it, quite hard, with the burnisher or with something smooth and rounded, like the upper end of a ball-point.

The whole of the sheet of rub-down lettering is transferable, even the small print at the top and bottom. You may find a use for some of it, particularly the straight lines, which come in handy for underlining.

There is no doubt that rub-down lettering gives by far the neatest and most professional-looking results of any lettering method. But

it will only do so if you work precisely and carefully with it. It is not nearly as hard to do as it sounds; and the results will more than justify the care you put into it.

Movie titlers

Good movie titlers are expensive to buy; and the choice of lettering styles is rather limited. Unlike rub-down lettering, however, you can use the letters over and over again. There are two main types, magnetic and PVC (polyvinyl chloride, a plastic material which sticks to itself and to glass). The board for the magnetic type is actually a plain steel sheet. The magnets are the letters themselves, which are cut from a plastic material containing magnetic iron oxide. The PVC type has a plastic-coated board, and the letters stick to it in much the same way as your car licence holder sticks to your windscreen. To attach the letters to the board you simply smooth them down with your hand. PVC letters are cheaper than magnetic ones; but they tend to stick to one another in the box, and can get creased. The magnetic letters are easier to use, as you can easily move them about on the board and adjust the composition without having to peel them off and restick them each time. You can also buy pieces of magnetic tile, to cut up into various shapes, and magnetic 'string' for constructing diagrams and graphs.

It is not difficult to make your own PVC titling board. All you need is a piece of heavy-gauge white board, which you cover with Transpaseal or similar self-adhesive material, which you can get from large stationers or stockists of artists' materials. Alternatively, you can use surface laminate or hardboard painted with hard-gloss paint. This way you have a choice of colours. A piece of plate glass will also take PVC letters, and you can get interesting shadow effects if you light it from one side only.

Stencils

Another way of producing lettering is by means of stencils. These are of two types: brush stencils and pen stencils. Brush stencils are the kind you dab on. In their crudest form they are the stencils you see on the side of crates; but the ones used by graphic artists

are a little different. They are usually cut from resin-filled paper. You can get them from artists' material shops. They come in an assortment of sizes, complete with brushes and paints; and you can buy replacement stencils separately if any of them get damaged with use. As with rub-down lettering, the most important thing is correct alignment and spacing. To get the alignment right, tape a ruler to your piece of card and slide the stencil along it. To apply the colour, barely moisten the brush (even breathing on it may be enough); pick up a *small* quantity of colour, and dab it on the letter. Don't pull or wipe it over the stencil, or you will get ragged edges. Now, there are two types of stencil pattern. One is like the type you see on crates, with gaps at the tops and bottoms of letters: you need to fill in these gaps. Do this by aligning a horizontal piece of letter over the gap, and carefully fill in the missing space. The other type has the curved piece of the letter (say 'R') separated from the straight pieces. To do these letters you first fill in the vertical stroke, then move the curved area over to join up with it, fill in this area, then do likewise for the diagonal stroke. These stencils are generally most useful for the larger size of letter, upwards of 10 mm high. In terms of initial cost and in use they are probably the cheapest method, provided you always clean brushes and stencils immediately you have finished with them, and never leave the stencils lying around to get damaged.

Pen stencils are quite different. They are easy to use once you have been shown how; and, like brush stencils, once you have paid for the equipment, the running costs are negligible. The cheapest variety is intended to be used with a special ballpoint pen that fits the lettering slots — though a coarse fibre-tip pen works equally well. The better quality stencils are quite expensive, and require a special pen with a needle valve. These pens come in a range of sizes to fit the various lettering sizes. There are a number of makes on the market, and there is little to choose between them as far as quality and reliability are concerned. However, the 'open-reservoir' type tends to dry out and clog; and it is rather difficult to clean. The cartridge type of pen is better in this respect; but it costs more to run, because of the cost of the non-refillable ink-cartridge. The refillable fountain pen type are the most economic to use.

The different makes of pen stencil equipment differ somewhat in

the styles of lettering available. Some of these are ugly and comparatively difficult to read when projected on a screen; and in all cases the lines are rather thin in comparison with the height of the letters, so that they appear somewhat spidery. So shop around, and pick the lettering style that looks best to you.

One serious objection to pen stencil lettering is that it produces rounded ends to the letters. This is a defect which spoils the appearance of the lettering and also makes it harder to read, especially when it is projected. At least for short titles, it is worthwhile squaring off the ends of the letters with a mapping pen.

To use a pen stencil, you align the letters in the same way as with a brush stencil. To draw the letters, hold the pen upright, and follow the guides. Letters such as 'P' and 'O' are hollow: here you must trace round the inner edge of the guide. For letters with extra strokes such as 'Q' you need to put in the short stroke after you have completed the main outline of an 'O', and the same applies to 'R', which is a 'P' plus a diagonal stroke. A needle valve controls the flow of the ink: do not hold the pen down at the end of a stroke, or it may go on flowing and the result will be a blob.

Typewriters and hand-lettering

Unless you can borrow one of those very expensive electric typewriters that have variable spacing and interchangeable type, do not consider typescript for your titles. Apart from appearing ugly and ill-balanced because all the letters are the same width, the lettering is so small that when it is enlarged to fill a screen the edges of the letters are very rough. The kind of type used on traditional typewriters, known as 'Elite', is also very difficult to read when projected (see p. 48).

One kind of lettering that should not be ignored is hand-drawn lettering. Not, of course, drawn painstakingly with ruler and compasses: life is too short for that. In any case, rub-down lettering or brush stencilling make a better job, quite apart from the saving in time. The kind of lettering that is most effective *looks* hand-drawn. There are several varieties. The easiest is rough brush-drawn capitals, with slightly ragged ends. You do these by simply drawing a no. 9 brush laden with poster paint over the paper. 'Pull' the strokes: be

careful not to move the brush sideways or the edges of your lines will be ragged. Poster paint takes a little more trouble than a broad felt pen, but the result looks better, as there are no streaky joins where the strokes overlap; and you can put a light colour on a dark ground. You will improve the appearance of the lettering if you put a narrow outline of white or black round the letters: white if the letters are lighter than the ground, black if they are darker. Keep these lines as thin as you can: they are there only to make the edges of the letter sharper to the eye when the slide is projected.

The other kind of freehand lettering is with a pen. Good pen lettering is easier than you might think. One of the most effective and legible styles is Italic script. This can be either sloping or upright. To do this style you need a square-ended lettering pen. The width of the pen should be about one-sixth of the height of your capital letters, and just under one-quarter for the small letters. For lettering up to about 16 mm (⅔ inch) capitals, you can use one of the fountain pens sold by large stationers for calligraphy.

If you need a title in a hurry, and there is no time to make one photographically, you can draw directly on a plain slide. Kodak make one for this purpose, called the Ektagraphic slide. Your writing should be about the same size as ordinary typewriter type: however, it is very difficult to do really neat writing in this size. The best script for this purpose is what we may call the 'roundhand scrawl'. It has the kind of 'improvised' air that is appropriate here. But in spite of its casual appearance you need to do it quite carefully if people are going to be able to read it. Before you actually write on the slide, try out your message several times on paper. You can draw diagrams and sketches on Ektagraphic slides too, but as the format is very small, any errors are greatly magnified, and you can only have black on white.

You may, of course, like to do conventionally produced title slides in roundhand scrawl. These often look best as negatives — white on black (see p. 104). Use a *round*-ended lettering pen. Mark out your letters with a pencil first, then follow the lines with your pen, not stopping at all, but moving the pen slowly and deliberately. Don't lift the pen from the card in the middle of a word, or you will get a blob showing where you've started again.

A

Some Mediaeval Brasses

B

A journey through the Dolomites

C

Paris in the Spring

D

E *ABCDEFGHIJKLL MNOPQRSTUVW XY&Z abcddeefghhi jklmnopqqrstuvwxxyzz 1234567890*

Hand-drawn lettering styles. A, Rough capitals in poster paint are very effective for short titles. B, Half-uncial is suitable for antiquities. C, 'Round-hand scrawl' needs considerable care to make legible. D, Italic script is well-balanced and legible. E, The italic alphabet with some variants. As the pen is chisel-pointed, all letters have to be 'pulled' downwards or from left to right, as in the letter 'A' shown.

Artwork without tears

Once you have seen how effective your titles look, you will probably want to add a little artwork to them to make them more attractive still. A touch of humour often goes down well, though it has its limitations: a drawing that will make one kind of audience helpless with laughter may leave another fidgeting with embarrassment. Some subject matter is not altogether appropriate to humorous treatment, either.

Just as with your transparencies, you can look for ideas in your file of periodical cuttings. Don't just photograph them, though, that can lead to copyright problems (see p. 206).

If you are a bit diffident about your drawing ability (and who isn't?), there are a number of specially produced books of graphics which are free from copyright, so that anybody can make photographic copies from them without having to get permission first. They are produced mainly for art departments of firms, and they contain drawings of almost every conceivable subject. You can usually get them through your local library, and they are a goldmine. You can trace the drawings, or, if they are the wrong size, copy them photographically and make a print or transparency the size you need. The easiest way to trace a drawing of this kind is to use a carbon paper under it. Get a sheet of hard, flat material about the size of the page. Put a piece of white card on it, then a sheet of ordinary carbon paper, face down. Put this sandwich under the page of your book, then go over all the outlines of your drawing with an old empty ballpoint pen. Don't press hard, or you will damage the page: press just hard enough to transfer the carbon. When you have done this, remove the card and ink in the lines.

If you want to change the size of the drawing, and don't want to use an enlarger, there is a drawing instrument called a 'pantograph' which you can get from draughtsmen's suppliers, for scaling up or down. However, it takes a fair amount of skill to master the instrument, and a rather easier way is to use a ruled grid over the original, and to transfer the drawing, square by square, to a ruled-up sheet of card. You can buy acetate sheets ruled in squares from educational suppliers (they are intended for use with overhead projectors), and place these over the drawing, to avoid your having to draw pencil lines on someone else's book.

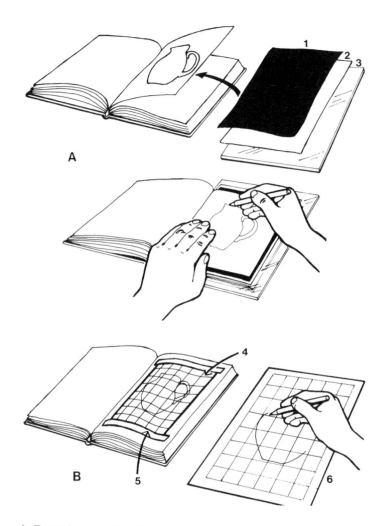

A, To produce a tracing of a picture in a book, use a carbon (1) under the page, your white card (2) under the carbon, and a firm hard surface such as glass (3), to support the card. Trace round the outline with an old empty ballpoint. B, to change the size of a drawing, use a ruled acetate sheet (4) held down by masking tape (5). Transfer your drawing square by square to your card (6).

Some makers of rub-down transfer lettering produce a range of rub-down graphics. There are sheets of trees, motor vehicles houses, men's and women's heads, hands, babies' faces, landscapes and many other subjects, all in assorted sizes. Ask to see a catalogue at your local supplier of artists' materials. A sheet of drawings of this type may save you hours of work.

Books in general, and especially textbooks, are not a very good source for graphics. Most of the drawings are too detailed, and the lines are too thin. You will usually get more impact by keeping your graphics simple, with bold lines and a minimum of detail. However, such drawings can give you a basic shape. Have a look at the drawing you want to use, and see how much you can leave out without affecting the sense of the picture. Let us suppose you are trying to evolve a little cartoon-type figure to help your continuity. Ask yourself how much detail you will need. Think of his face, for a start. Most of us are not capable of drawing faces, even simple cartoon faces. But what do you need to show his expression? Do you need a nose? Probably only to show the direction he is looking in; so if that is unimportant, you can dispense with the nose. Does he even need eyes? You can get happy or sad expressions from the mouth alone. Do his hands need fingers? How far can you simplify his clothes? The simpler he can be, the more immediate the information he conveys. Study the strip cartoons in the papers, and see how they indicate emotions. Have a go at them yourself, and ask a friend to identify the emotion you are trying to portray. Then, once you have your little figure right, stick to him.

Sometimes — and we might as well face the fact — drawings just don't come out right the first time, nor the second or third. And by the time you *have* it exactly right, the card is so scruffy that there is no hope of getting a decent photographic copy of it. And you know that you will not get it right again if you start on a clean piece of card. To avoid this, the best way to start on an awkward drawing is to use a piece of graph paper. Once you are satisfied with the drawing, you can rule up your card in squares (not necessarily the same size) and transfer your drawing, square by square. It sounds laborious, but in fact it is quite quick, especially if you have managed to get clean, simple outlines with no redundant detail. The best kind of pen to use for your final lining-in is a round-ended

A, Keep your cartoon figures simple. Leave out anything not absolutely necessary — even mouth or eyes. B, With surprisingly few lines you can put over an idea such as a distant vista, a charlady, a cowboy or a racing cyclist.

lettering or draughtsman's pen, the type with an ink reservoir, a cartridge-loading or fountain-pen type. Use Indian ink, and a nib of at least 1mm diameter. For A4 size card 1.5 mm is also suitable. For smooth curves, use a Flexicurve guide, which is much easier to fit to curves than a draughtsman's french curve, and cheaper. If you want to add colour to your drawing, don't use broad felt-tipped pens, as they almost always leave streaks. Use ordinary watercolours, and don't worry if you go over the edges. It will not be noticeable on the result.

For a change, you might try doing your drawings in white wax pencil or artists' pastels, on a deep red or blue background. Draw in the outline in ordinary pencil first. Chinagraph and pastels are both opaque, and the lines will not show through. The result is quite dramatic.

Large expanses of continuous colour are not at all easy to produce, either in watercolour or poster colour. You will probably get a much better result if you use cut-out paper shapes. There is a huge variety of different colours available but it is probably safer to keep to a few well-contrasted ones, such as the basic hues of colour photography: red, green, blue, cyan, magenta, and yellow and a few pastel shades. If you have managed to simplify your picture sufficiently, you may well be able to build up the entire picture with paper cutouts alone, so that you need to add only one or two lines and perhaps a few words.

We mentioned poster paint in connection with lettering earlier on; and, if you are a little more ambitious, you might like to try your hand at painting with it. Use the waterproof kind. You can use it on any kind of coloured card, and if you make a mistake you can simply paint over the top of it: it does not run. As with paper cut-outs, be careful not to overdo the range of colours. Never be tempted to add water unless the paint is *very* stiff. You need three brushes, a No. 3 for fine lines, No. 5 for filling in, and No. 9 for large areas. Watercolour brushes are better than the rather stiff ones sold especially for poster colour. The colours are not like watercolours, and you cannot mix blue and yellow together and expect to get bright green. You only get a dirty leaden grey.

You can, of course, combine in one drawing the techniques of line drawing, paper cut-outs and poster paint. You could start by using

Family and friends are popular subjects for slides. As well as the normal shots, take some arranged pictures with careful lighting and a plain background.

Slides of your favourite subject are a good start to a collection—or a sequence. These two are examples from the author's collection of nearly 1000 slides of cactus flowers *(above and opposite)*.

Above Traditional crafts often mean indoor locations. When they are outdoors, you have the chance of producing an interesting transparency. *Peter Stiles*

Opposite On your travels, picture the people, especially those at work. The strong lighting shows well the character of this Spanish lace maker.

Pages 68, 69 Pictorial landscapes form part of almost everybody's collection. Don't take them all with the light over your shoulder though, often you can produce more brilliant pictures with side or back lighting.

Above A carefully produced selection of transparencies can cover almost any sort of party. Take them with care and choose them with your friends in mind to ensure a convivial gathering. *Colin Ramsay*

Opposite, top Night club dancers call for at least an *f*2 lens, and a steady hand. Modern high speed materials help to reduce the exposure times, but that may take some of the sense of the movement from the scene.

Opposite, bottom Architectural night shots are easy with any camera that allows long exposures. Of course, you need a tripod and cable release to keep the camera still.

Above Negative processing produces a new range of colours on transparency film. *Top,* normal transparency; *bottom,* negative version. Note how some colours are much more satisfactory than others.

Opposite, top Slides of hand-drawn artwork can demonstrate difficult concepts— such as this topological example.

Opposite, bottom They can liven up an otherwise sleepy lecture show as well.

Development of a Klein Bottle

Organised events cry out for series treatment. Take shots of as many aspects as you can, but be very selective when you produce a sequence for projection. Make changes of size and viewpoint logically, not haphazardly. *Ken Payne*

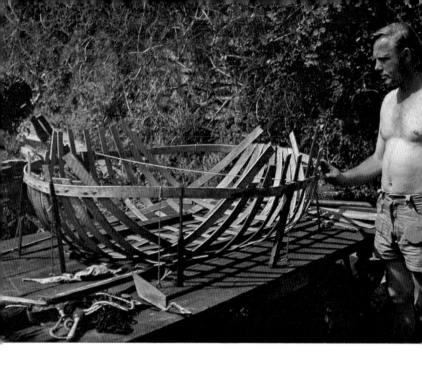

Above and opposite Construction projects call for a sequence technique. The order is simple, run from beginning to end. Once again, try to imagine the series when you shoot the pictures; and let the slides form a logical chain.

Page 80 Even simple actions can produce sequence shots, like this one of the author diving. *Christine Saxby*

All transparencies by Graham Saxby, except where indicated.

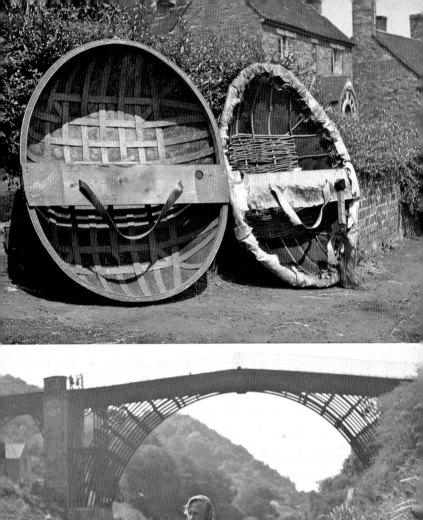

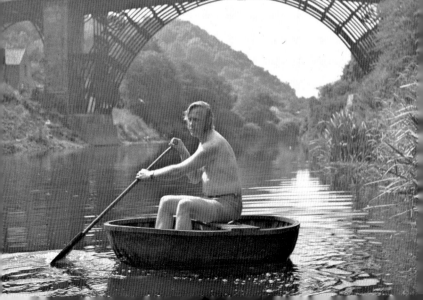

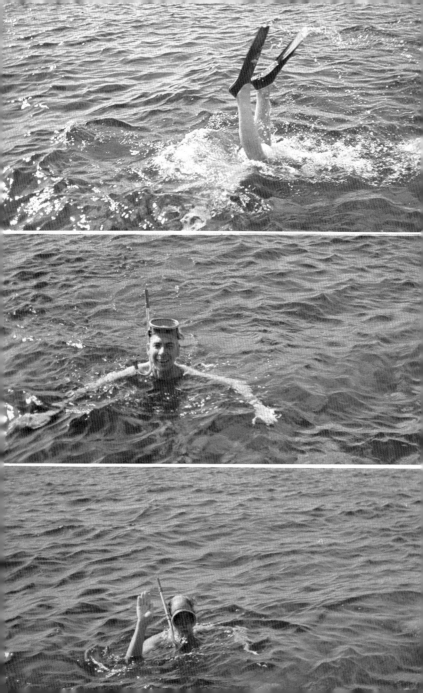

paper cut-outs for the large plain areas of colour, add outlines in Indian ink, then put in the detail with poster paint, before adding the wording in rub-down lettering. Remember that it is the appearance of the slide that counts. The main thing is to do everything in the way that involves the least work. Nobody is going to give you an 'A' for effort: they will only be interested in the results. There are no rules: the correct way is the way that gives the *best* results. Many home-made graphics may resemble collages rather than drawings; yet they produce excellent slides.

When you design your graphics, try to organize them in a balanced composition, just as you do in your pictorial photographs. Draw the shape of your format lightly in pencil on the card to start with, and leave plenty of space all round. Then sketch in the layout faintly. You may find it easier to get good balance if you try out this stage first on graph paper. However, once you are satisfied with the composition, you can start work. If you find, after it is completely finished, that the result is a little off-centre, you can adjust this when you come to make the photographic copy, and you will be glad you left plenty of room at the edges to allow for this.

Anyway, if the worst happens, so that when it is too late to do anything about it you see that the balance is hopelessly wrong, don't despair. Simply cut out the components of your work, either along their outlines, or — if these are too complicated — in 'cloud' or 'bubble' shapes. Get some background paper of another colour, put the pieces on it, and shuffle them around until you are satisfied with the composition. Then tack the components down with rubber cement. In fact, this is often a good way of designing graphics right from the start. It is an excellent method if you have to include, say, cut-outs from magazines or advertising material in your slide; and we shall be saying more about this in the chapter on slides for formal presentations and lectures. But above all, don't be diffident about doing your own artwork. A very small amount of talent, allied to a modicum of cunning, can go a long way towards adding an extra dimension to your slide sequence.

Photographic Copying

We shall take 'copying' to mean 'making a photographic transparency of a flat document'. The document may be a manuscript or printed matter, a drawing, a photograph, or even another transparency. The copy itself may have tones or colours altered to suit your needs.

It is not particularly easy to produce a really good quality copy, especially if the quality of the original itself is not too good. The angle of your illuminating lamps, their colour, and your exposure all have to be just right; otherwise you will get poor contrast and colour saturation, and possibly incorrect rendering of hues as well. However, if you take the trouble to get the lighting set up exactly right, you will probably never have to change it, no matter what the quality of your original.

Copying stands

The most useful piece of apparatus for copying is a copying stand. This is simply a baseboard with a column, a raising and lowering device with a clamp for holding the camera, and two (or four) floodlamps fixed to the baseboard or to the top of the column. If you belong to a photographic club, they probably own a copying stand which you can use. However, many commercially available copying stands have the lights fixed at an angle which is far from ideal; and unless you are very careful you may get shiny 'hotspots' at the edges of your transparency, especially with a glossy original. Some of the more expensive 35 mm enlargers have adapters for copying. The usual method is to replace the negative holder and lamphouse with a film magazine and some form of focusing device. One of the best ways of getting a copying stand — and certainly the cheapest — is to build your own, starting with an old enlarging column and baseboard. Try to get one where you can remove the head by simply unbolting it from the raising and lowering

mechanism. The column need not be a vertical one: in fact, a sloping column may be better because the camera securing bracket need not be so long.

This bracket is the first thing to make. The best material is 3 mm thick duralumin strip. You will have to find a way of fitting it to the raising and lowering mechanism, and that, of course, will depend on the kind of enlarger. The simplest kind has a single large knob with a screw thread. At the other end you will need a clearance hole for a tripod screw. Make sure your bracket is long enough for the picture area to clear the bottom of the column when the camera is at its highest point. You may be able to find a flashgun bracket that will do the job with a little modification.

If your enlarger has a removable head, you can use it as a copying stand; and if you are thinking about buying an enlarger, it may be worth while ensuring it does have a removable head, and then you can use it as a copying stand whenever you need one.

If you are likely to want to do a good deal of copying work, it may be a good idea to add the lamps as a permanent fixture. You will need to build a frame for them, and the best material for this is one of the do-it-yourself framework sets based on square cross-section steel or plastic tubing with push-in joints. You will need a horizontal piece of tubing 1.6 metres (48 inches) long, two vertical pieces 0.4 metres (16 inches) long, and two right-angled push-in connectors. Fix the horizontal tube to the underside of the enlarger baseboard, directly under where the camera lens will be at its highest position. You may need to add feet at the corners of your baseboard to give clearance. Cut two stubs 40 mm (1½ inch) long from a piece of mild steel tube that is a close fit in the square tubing, and fix them in the tops of the vertical members so that about 20 mm (¾ inch) of the tube projects. This is to take the lampholders. Most makes of lampholder require a stub of diameter about 12 mm (½ inch), and to get this to fit you may have to hammer four 'flats' on the lower part of the stubs. Hammer them into place and fill up the corner spaces with epoxy resin adhesive, or drill and bolt the stubs in place.

You now need two lampholders. Most large photographic suppliers stock portable studio lamps, which you can buy in parts. It is up to you whether or not you buy reflectors: if you do, get the smallest

ones. If you use the type of lamp that has a built-in reflector, you will save on initial outlay, but your running costs will be higher, as this type of bulb is expensive and can have a very short life. However, in either case you will need to buy the lampholder. Get the kind that fixes to its stand with a wingnut and will fit your stubs, and choose Edison screw sockets, not bayonet fittings. Photoflood lamps get very hot, and it can be known for the terminals to weld to the contacts in the socket, so that when the lamp finally gives out you cannot remove it.

Fix the lamps to the frame, and check that they are at exactly the same height, and at the same distance from the centre of the baseboard. If you got the measurements right they should be at an angle of approximately 60^o to the camera axis. Set them up so that the centre lines of the light beams cross just above the centre of the baseboard.

Correct lighting

If you already know something about copying, you may wonder why we have suggested an angle of 60^o rather than the more usual 45^o. In fact, the angle of 45^o favoured by so many textbooks seems to be founded on intuition rather than on any scientific basis. If the angle between the lamps and the camera axis is too small, the scattered reflection from the surface of the document will result in lowering of contrast and colour saturation. There is also a risk of specular reflection or 'hot spots' with glossy originals, especially if the copy is to be of a picture going right across the middle of a book. The best way to avoid both these effects is to have the angle as large as possible. However, at too glancing an angle the surface irregularities and the texture of the original begin to show up. Tests show that for most surfaces and pigments the optimum angle is about 60^o, and that at this angle you get the best contrast and colour saturation. Crossing the light beams slightly gives uniform illumination over the greatest possible area.

For occasional work, you may prefer to use separate lights. All you need to set up the lamps at the correct distance and angle is a piece of string 80 cm (32 inches) long. Bring up the lamps close to the baseboard. Fold the string in half, and use this length to set the

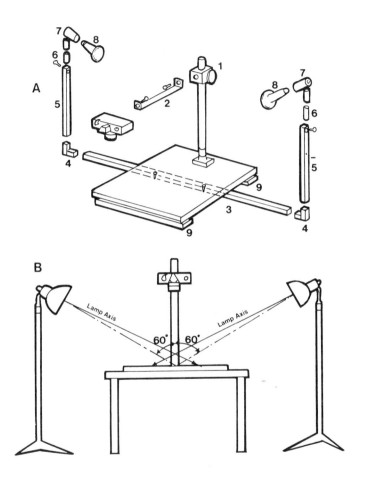

Copying on a stand. A, Building a copy stand from an old enlarger. 1, Raising and lowering mechanism. 2, Duralumin bracket with screws for fixing to post and camera. 3, Horizontal square-section tube. 4, Angle pieces. 5, Vertical tubes. 6, Stubs for lamp fixings. 7, Lamp fixings (ES). 8, Lamps (reflector optional). 9, Feet to give clearance. B, Set up the lamps 60° out from the camera axis and at least 80 cm (32 inches) from the copy. Align lamp axes to cross just above centre line.

height of the lamps above the baseboard. When you have their height right, open out the string, put one end at the centre of the baseboard and move each lamp back in turn until the other end of the string just touches the bulb. This will give a height of 40 cm and a slant distance of 80 cm, so that your lamps will now be set at 60° to the vertical axis. Check that the line joining the two lamps passes through the axis of the camera lens, and, finally, adjust the direction of the lamp axes so that they cross just above the centre of the baseboard.

If you have an exposure meter separate from your camera, use it to check that the light from both lamps is the same. Use an incident-light attachment if you have one. If the intensities do not quite match, move the brighter lamp away until your meter readings are the same for both lamps. If your meter is fixed in the camera, take a reading on a large sheet of white paper, with each lamp switched on in turn. Now, with both lamps switched on, move the meter all over the baseboard and check that the lighting is uniform.

Colour balance

The best choice of material is one balanced for the lighting you are· using: type A film for photofloods, or type B films for studio lamps 3200 K). You can use daylight film with a suitable (80A or 80B) filter, but this can be less satisfactory. Even with correctly balanced film, you may need to use colour compensating (CC) filters to give you the exact colour that you want.

The best target for deciding on correct colour balance is a colour test chart. All the major film manufacturers produce these, as well as other firms with photographic interests. When you have your slide of the test chart, project it on a white screen in a well-blacked-out room, and at the same time hold the original where the white part of the projected slide falls on it, Don't expect perfection: no colour emulsion is perfect. You will always get small errors in hue and saturation.

One common cause of poor quality is using old lamp bulbs. The light from a tungsten filament lamp becomes progressively dimmer and changes colour with use. As soon as your bulbs begin to show brown smokey patches on the surface above the filament, change

A, Series-parallel dimmer switch for two lamps. B, Diode switch for two or more independent lamps. C, Copying on a wall. The slant distance to the lamps is twice the distance of the lamps from the wall, and must be not less than twice the horizontal width of the original.

them. The old bulbs will still be satisfactory for black and white work, of course.

You can prolong the life of floodlamp bulbs greatly by using a dimmer in the lamp circuit or running them in series when you are not actually making an exposure. The voltage across each lamp is halved; and though the light is still bright enough for setting up and focusing, the lamp filaments are not ageing at all. An added benefit is that as the filament remains warm you will not have the same sudden stress on the filament at the instant of switching on — which is when most filaments 'go'.

Exposure

Once you have set up your copying lights, do not move them again, even when you change the size of your originals. Except for extreme close-ups (see p. 93) the exposure will remain constant no matter what size your original is, and no matter how light or dark it may be. So it is worth going to a little trouble to get an accurate estimate of the exposure, right at the start.

First, set the film speed on the meter. Unless the meter operates through the lens of your camera (TTL), you need to make allowance for the filter factor. The blue tungsten-to-daylight filter passes only 40% of the light falling on it; so, unless you have a TTL meter you need to divide the ASA/ISO film speed by 2½. If you prefer to work in the DIN speed system, subtract 5 from it.

A normal reflected-light meter reading is unsuitable for copying, because the subject is seldom a normal tone. If it is unusually light, the meter reading will be too high, and following it will result in underexposure. If it is exceptionally dark, the meter reading will be too low, and will result in overexposure. The easiest way to the right exposure is to take an incident-light reading.

If your meter has no incident-light attachment, take your exposure reading from a correct-toned grey card — as supplied with most copy stands, or by photographic suppliers. If you do not have one, instead use a large sheet of white card placed on the baseboard. Whatever exposure it indicates, multiply it by four (or open up the aperture two stops from the *f* number indicated). The reason you have to do this is that you are using white rather than the

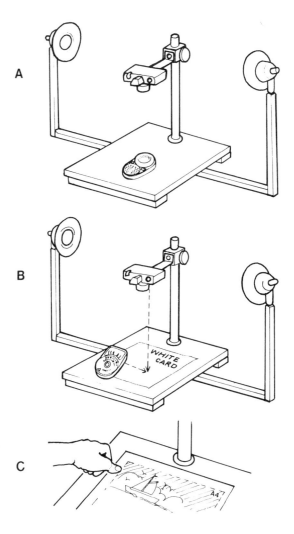

A, When you measure exposure for copying, use an incident-light attachment if you have one. B, If you have no incident-light attachment, or if your meter is built into the camera, take a reading on a piece of white card and multiply the indicated exposure by 4. When using an SLR viewfinder on A4 size originals, you actually get a thumbnail's length more all round than you see in the finder.

standard grey, which is approximately four times as dark. With TTL metering, set the film speed to a quarter of its indicated ASA value, or subtract 5 from the DIN speed.

When copying, use a normal focal-length lens, and a medium aperture such as f 8 or f 11. This aperture will give good definition with even a cheap lens, and will give sufficient tolerance in focusing to take care of any small errors you may make. With two Photo-flood lamps at 80 cm distance, your exposure with a medium-speed colour reversal film will be of the order of $\frac{1}{8}$ second. It is most important to use a cable release when making the exposure. No matter how solidly a copying stand may be built, it will still be capable of vibration.

Lining up

You are now ready to start exposing. If your originals are of differing sizes, put them in order of size, the largest first. This will save you a lot of winding up and down the column. Remember what we said earlier, that the picture area is about 5% more all round than you see in the viewfinder. A useful rule for this is, quite literally, a rule of thumb. If your original is about A4 size (horizontal), you will get into your picture, top and bottom, just about the depth of a thumbnail more than you can see in the finder. So, to find the true edge of your transparency, move your thumb in through the edge of the picture until the tip of it is just visible through the finder. Sizes other than A4 will, of course, be in proportion.

Try to get your subject matter to fill the frame as far as you can without it being cramped. If you have followed the suggestions about layout, and composed your graphics into a 3:2 horizontal area, you should have no problems in this direction; but if you are copying a drawing or diagram from a book or periodical, the pro-portions of the original may not fit your format. You will then have unwanted material showing at the edges. There are two ways of dealing with this. One is to frame the original with coloured background paper by cutting out the picture and laying it on the paper. You may be able to improve the effect by cutting the picture out in an irregular cloud or bubble shape, as we suggested as a

variant for titles. However, if the original cannot be cut, then simply photograph it edges and all, and mask off the unwanted part in the finishing process. You may even find it preferable to take upright pictures in the horizontal format and mask them off, if all the other slides in the series are horizontal. If you do, you will get a better feeling of pictorial continuity; the top or bottom of your picture will not be lost off the screen.

We have assumed, for the purposes of this chapter, that your camera is a single-lens reflex. You can, of course, use any camera for copying, provided you have some way (such as close-up lenses) of focusing close enough, but there are serious problems. The biggest difficulty is to be quite certain as to what you are going to get into the picture. For one thing, the viewfinder does not focus (except on twin-lens reflex cameras), and at one distance you will get more in the picture than you can see, and at another distance less. A more serious snag is what is called parallax. The viewfinder is displaced from the lens; and its centre point is displaced from the centre point of the picture. By careful measurement of this displacement (and a few practical tests) you can mark out your copyboard with indicator marks for each size, and once you have these right, you can go ahead with confidence. It is possible to get parallax-correcting attachments that go with the close-up supplementary lenses for certain makes of twin-lens reflex cameras; and these seem to work well in practice.

A checklist

There are a number of precautions you must take when making copies. In particular, there are several checks you should make before each exposure. It is a good idea to keep a checklist:

1. Have I set the shutter? Always set the shutter *before* you focus. Otherwise you may move the camera as you set it, and the picture will be incorrectly framed.
2. Is the camera axis exactly vertical? If not, lines of print will taper, and rectangles will be 'keystone'-shaped.
3. Is the original steady? Sometimes the original can begin to curl up in the heat of the lamps, and your picture will show curved and possibly unsharp edges. Sometimes books with very firm

spines begin to close while you are getting ready to expose. Get somebody to hold them down for you, or use Blu-tack.

4. Have I got both lamps on full power? If not, your picture will be underexposed, and will have an orange cast.

5. Is the iris diaphragm still on the right setting? With some cameras it is all too easy to move the aperture setting while you are adjusting the focus. If you have this trouble, fix the aperture ring in place with masking tape.

6. Have I got the blue filter on? You may have removed it for a special effect (see pp. 102-4) and forgotten to refit it.

7. Have I got the right exposure? If you have just removed or refitted the filter, you need to adjust the exposure to take care of this.

Close-up focusing

You will be able to manage well enough until you get down to somewhere around A5 size originals. For smaller originals than this, most single-lens reflex cameras will not focus close enough for the picture to fill the frame. This is where you need the set of extension tubes. The first (shortest) tube normally starts off exactly where your basic standard lens focusing system finished: that is, if you fit the tube between the camera body and the lens and refocus the lens back to the 'infinity' mark, the focus will be the same as your previous 'nearest' distance. You can now start on the smaller pictures. Eventually you run up against the same problem again, and you now need to substitute the second, medium tube. For smaller originals still you need the third tube. The smallest you can get with all three tubes used together is about postage stamp size.

Using extension tubes carries a penalty in terms of both focusing and exposure. As your focus gets closer it has to be more accurate: by the time you get to the smallest size your depth of field at f 8 will be little more than 1 mm. The exposure penalty stems from the fact that when the iris diaphragm is much farther from the film than the focal length of the lens, the marked f number becomes incorrect, and you need to increase the exposure. You can neglect the effect for the shortest tube. The second tube requires about half a stop extra exposure, and the third a whole stop extra. All

A

All three tubes
24x36 mm. 1½ 2 stops

33x50mm. 3rd tube 1-1½ stops

48x72mm. 2nd tube ½-1 stop extra

72x110mm. First extension tube 0-½ stop extra

B

A, Effect of extension tubes. A typical SLR camera takes in an area about
145 x 220 mm (7 x 11 inches) when focused as close as possible (0.35
metres or 14 inches). Adding extension tubes allows successively smaller
fomats to be copied. The increases shown are for the farthest and nearest
points of focus for each extension tube, and the sizes are all for the closest
focus. B, To copy a rough-surface photographic print, lay it on a glass and
flood with glycerine. Water will do for black-and-white prints. Cut out stray
reflections by means of a large sheet of black card with a hole cut out for
the lens.

three tubes together demand an increase of two stops (i.e. multiply the measured exposure by four).

These nominal exposure increases are accurate enough for most purposes. However, if it is important to get your exposure exactly correct, you need to do a little arithmetic:

1. Write down the scale of your picture (i.e. length of format ÷ length of original).
2. Add 1 to this figure.
3. Square the result, i.e. multiply the result by itself.

This is your exposure factor.

As an example, suppose the original measures 72 mm long. Your format is 36 mm long. This gives a scale of ½ or 0.5. Adding 1 to this gives 1.5 Now 1.5 x 1.5 = 2.25 or 2¼, and this (just over 1 stop) is the factor you need.

As a further example, suppose you want to copy something actual size. Your scale is 1.0, and adding 1 to this gives 2.0. 2.0 x 2.0 is 4.0, or two stops (which bears out what we said earlier about photographing postage stamps).

Difficult surfaces

You may at some time have to copy a photographic print made on a rough or textured-surface paper; and no matter where you put the lights, you cannot avoid a speckly appearance. You *can* avoid this if you cover the print with a layer of clear liquid. Glycerin is best. Place a sheet of glass of glossy laminate on the baseboard of the copying stand, lay the print on it, and pour a layer of glycerin over it. Now copy it in the usual way. This method is also useful for improving the quality of copies of matt-surface prints. There is one important precaution, however. You have to make quite sure no light is reflected from the ceiling onto the surface of the liquid. Black out the room as best you can, and get someone to hold a large piece of black card, with a hole cut out for the lens, just underneath the camera. If you cannot get hold of glycerin, water will do just as well for black-and-white prints. However, it causes some makes of colour print to go milky, so try a spot of water on a corner first. If it does go milky, you cannot use water. Do not worry about the milky patch, by the way: it will dry out all right.

Copying on a wall

If your original is very large, or immovable, or if you have no access to a copying stand, you can copy it on a wall using your camera on a tripod. Assuming your original *is* movable, choose a wall where little direct daylight falls, and, if possible, draw the curtains. Set up the camera first, and check the height of the camera from the floor with a piece of string. Mark the height on the wall. This is where the centre of the original is to go. Now fix the original to the wall with putty glue. Ensure the camera is absolutely square on to the wall when you are setting it up. Now set up the lamps. Use your piece of string in the same way as described earlier for vertical copying with studio lamps, except that the angles will be horizontal this time. The slant distance of the lamps from the centre of the original must be not less than twice the width of the original. Once you have everything set up, assess the exposure in exactly the same way as you would for vertical copies.

On a clear sunny day you can make excellent copies out of doors, provided the sun is in approximately the correct direction (i.e. roughly 60° away from the axis of the camera). *Don't* use a north-facing wall: if you do you will get a low-contrast transparency with a pronounced bluish cast. Even monochrome copies made by this highly diffuse light are poor in quality, with low contrast, especially in the shadows. For the best results in copying, you need a light source that is as small and concentrated as possible; and direct sunlight is ideal.

Copying colour transparencies

Making duplicates of slides is a somewhat tricker business than copying photographic prints or documents. It is not just a matter of accurate focusing and uniform lighting, though these are still just as important. The difficulty lies in the quality of the transparency itself, and in the nature of colour reversal emulsions. You will find a fuller account of colour emulsions in *The Focalguide to Colour,* by David Lynch (Focal Press, 1976); but here are the basic facts.

Firstly, colour transparencies have a relatively high contrast. Colour emulsions are deliberately designed with a contrast that is on the

high side, so as to compensate for the unavoidable losses in the optical systems of camera and projector. This means that when you make a copy of a slide, you get a double boost to the contrast, and the copy will look harsh by comparison with the original. In fact, if the original scene has a rather high contrast to start with your final copy will have burnt-out highlights and blocked-up bluish shadows. This is the colour equivalent of the monochrome photographer's 'soot-and-whitewash' and could be called 'ink-and-pink', as the colour balance is usually skewed in this way.

Secondly, the three dyes that produce the colour in the three emulsion layers are not as perfect as theory would suggest. In particular, the magenta dye in the middle layer absorbs some of the blue light it should transmit, which makes it slightly reddish. To compensate for this the manufacturer has to reduce the intensity in the yellow layer; and this tends to make the greens look slightly bluish. Now, when you see a slide projected in the usual way you do not notice these errors, as they are averaged out over the whole range of hues; but when you make a copy of this slide, all the errors in hue and saturation are doubled; Some subjects suffer more than others: low-contrast subjects in subdued colours often come off badly, while very high-contrast subjects show skewed casts in shadows and highlights as mentioned earlier.

As the years go by, new and better materials come on the market, and the situation steadily improves. Today's transparencies have incomparably better colour rendering than those of even a decade ago. But the advice is still: if you are going to need several copies of a slide, then if you can, make several exposures at the time, rather than having copies made. If this is impossible, consider using colour-negative film: you can have perfectly good transparencies made from colour negatives; and, of course, there is no limit on numbers. Sometimes there is no alternative to having direct copies of transparencies.

Sometimes you may even find the quality of a slide improved in the copying process. If you have a valuable and unrepeatable shot which for some reason is a couple of stops underexposed, a copy transparency made with the density corrected will certainly be an improvement. It will probably not be perfect; but it will at least be usable.

Most processing establishments run a slide-copying service, and this is certainly the least inconvenient way of having your slides duplicated. However, there is nothing inherently difficult about making copies of your slides, and you may like to try your hand at it.

If you make a lot of copies yourself, get a supply of slide-duplicating film. This material is sold in bulk. It is designed to produce the closest approximation to the original slide, being considerably lower contrast than normal camera film. Duplicating film is balanced for tungsten lighting (3200 K). Thus, if you use other light sources (daylight or electronic flash, for example) you need to use the right colour-balancing filter.

First, let us say that if you buy a simple slide-copying attachment to go on your camera, you are probably only going to have disappointment. With these simple devices there is nothing to control the colour or evenness of the light source; and the less expensive ones do not always frame the original correctly. There is little or no provision for enlargement or reduction, or for the selection of a portion of the original, and unless your camera has TTL metering, there is no way of making an accurate assessment of the exposure. The slide copiers sold to go with bellows units on SLR cameras are much more versatile. They do, though, depend on the TTL metering system to determine exposure. If you use flash, then the tests described below apply.

You can treat slide copying in exactly the same way as the copying of opaque originals — except that you need some method of illuminating the original from behind instead of from the front. Electronic flash is best for this, as there is no risk of overheating the transparency and damaging it.

You need a copying stand, a set of extension tubes or a bellows extension for your camera, a small electronic flash with an extension lead, and a jig which will hold the transparency in place.

This jig does not have to be very complicated. In fact, a cardboard box about 12 x 12 cm (5 x 5 inches), with a 45 x 45 mm hole cut in the top is perfectly adequate. Cut a further rectangular hole in one side of the box, about the size of the light aperture in the flashhead; and fix a piece of white card, concave in shape, inside the box so that the curve reflects the light of the flash up into the slide aperture. Fix the flashhead to the outside of the box with rubber bands when you make your exposure. If you focus

before you fix the flash in place, there will be enough light coming in through the aperture for you to be able to get the framing and focus correct. With this simple holder you can get perfectly acceptable copies; and the very short duration of the flash tends to result in lower contrast, so that the problems referred to above are minimized. With a medium-speed film, your aperture setting should be in the region of f 16; but if this aperture still results in overexposure, you will have to get a 0.9 neutral-density gelatin filter big enough to cover the flashhead aperture.

If you are a bit more ambitious, or are considering doing a good many copies from transparencies of varying quality, you may like to make a rather more sophisticated version which will enable you to assess the exposure for each transparency. Make your box from plywood, with a 50 x 50 mm recess to take the slide, cut round your 45 x 45 mm aperture. About 20 mm below the slide holder, fit a shelf, with a similar recess, but a little larger, say 60 x 60 mm, with a 55 x 55 mm aperture. This is for a piece of opal glass or acrylic sheet (e.g. Perspex or Lucite). Cut a slot, deep enough to get your fingers in, just above the level of the shelf, so that you can insert or remove colour-correction filters. Now fit your white card in the same way as described above.

In order to be able to assess the exposure, you need some steady illumination of the slide. The best way to obtain this is to mount a 15 watt bulb (a small festoon-bulb is best) just above the flashhead aperture. You will, of course, need to switch this off before you make the exposure to the flash.

To calibrate this system, set up the box and copying stand in a room you can darken. Select a good quality transparency with a full range of tones and colours, which you can use as a standard for calibration. Place this in the holder, switch on the filament lamp, and focus up. Now take a reading with your meter placed directly on the transparency. If you have a TTL meter, set it to the marked film speed, and write down all the shutter speeds it indicates for the range of f numbers on your camera. Keep this record carefully. Now switch off the lamp, switch on the flash, and make a set of exposures at successively smaller stops starting at full aperture and going down to the smallest stop. If you have a 0.9 neutral-density film, insert it and repeat the last three stops.

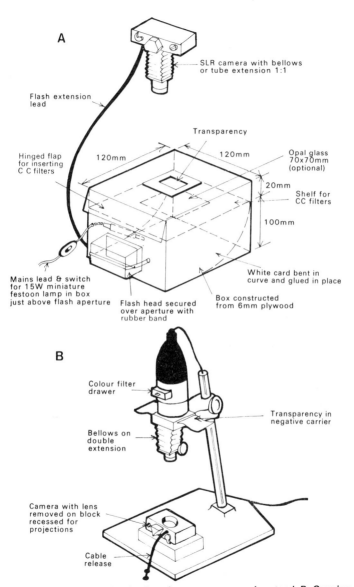

A

SLR camera with bellows
or tube extension 1:1

Flash extension
lead

Transparency

Hinged flap
for inserting
C C filters

120mm

120mm

Opal glass
70x70mm
(optional)

20mm

Shelf for
CC filters

100mm

White card bent in
curve and glued in place

Box constructed
from 6mm plywood

Mains lead & switch
for 15W miniature
festoon lamp in box
just above flash aperture

Flash head secured
over aperture with
rubber band

B

Colour filter
drawer

Transparency in
negative carrier

Bellows on
double
extension

Camera with lens
removed on block
recessed for
projections

Cable
release

Slide copying. A, Illuminating box for camera on copying stand. B, Copying
with an enlarger.

Once you can examine the finished film, you can then pick out the exposure that is nearest in quality to the original. Now compare the colour balance. You may perhaps find it slightly yellowish, or pinkish. If so, you need to add a CP colour-printing filter to your exposing light. To estimate what correction you need, examine the 'best' transparency holding one of the filters behind it, changing the filter — or adding one of another hue — until the *middle* tones are a good match for the original. Ignore highlights and shadows, which will still have a colour cast. The final choice will be the filter combination you need in future. If you don't mind waiting for another set of transparencies to come back from processing, make a further set of exposures, varying the filter combination slightly all round the selection you made. Then you can eventually select the combination that gives you the nearest to an exact match.

If the idea of waiting several weeks to get your slide copier properly calibrated seems a bit tedious, most transparency films (except Kodachrome) can be processed in a normal developing tank, see *The Focalguide to Colour Film Processing,* by Derek Watkins (Focal Press, 1978). If you want to make a good quality copy from an underexposed slide, you will have to open up one or two stops from your optimum value. However, if you recorded your meter readings as we suggested, you can use the meter to get an accurate estimate for such slides. Here is how to do it. Put your 'standard' transparency in position, with the 15 watt lamp switched on. Check the exposure time that appears against the aperture you found to be correct. Suppose, for example, it is $\frac{1}{8}$ second. Now replace the transparency with the underexposed one, and take a meter reading on this. Check the indicated *f* number that corresponds to $\frac{1}{8}$ second. This is the *f* number to set on your camera to get a perfectly exposed result. In future, you can estimate the correct aperture for any transparency you copy, by seeing what aperture your meter gives you against $\frac{1}{8}$ second. You can do the same thing with a TTL meter, if you note which exposure was opposite the aperture you eventually chose. Simply set your shutter to that speed, and thereafter use the meter to set the aperture in the usual way.

If you have a camera with a focal-plane shutter and a removable lens, and an enlarger which you can focus down to 1:1 magnification, you can make duplicate transparencies in the same way as enlarge-

ments, using the camera as your film-holder. Put the film in the camera, but don't wind on. Set the shutter to 'B', open the shutter (a locking cable release will leave your hands free) and focus on the film itself. Now switch off all the lights and wind the fogged frame out. Set the enlarging lens aperture to f 8, and make a series of exposures from 1 second to 1/30 second. You can leave the enlarger lamp on throughout. If you have a single-lens reflex camera with a removeable pentaprism, you can remove it and use the ground glass for focusing up and aligning the image. If your camera is of the rangefinder type you can line up the image on the focal plane shutter. To assess correct exposure and colour balance, you need to work the way we have described above.

The easiest way of working is to make up a jig, so that after you have removed your camera to wind on the film, you can put it back in exactly the same place again. The simplest way to make such a jig is to place the camera on a piece of 12mm plywood, dig out any necessary recesses to enable it to lie flat (such as for the film advance lever) with a chisel, then hammer in six nails to locate the camera. Cut off the heads of the nails so that you can remove and insert the camera without damaging the body.

If your enlarger has a colour filter drawer, you can use this for any colour correction filters. Otherwise you have to lay the filters across the camera lens aperture. If you do, you must use CC (optical quality) filters. They are rather more expensive than CP filters, and, being gelatin rather than acetate, are much more delicate. You must handle them only by their extreme edges, and always keep them in their protective tissue when not in use.

In fact, the process we have described above is essentially the same method as colour printers use when they make test prints from transparencies. If you are interested in this aspect, you can find out more from *The Focalguide to Colour Printing from Negatives and Slides,* by Jack H. Coote (Focal Press, 1976).

One last caution — it is often almost impossible to produce a really good copy of a slide on one make of film on a different make. The dyes that produce the colours are quite different; and if you try this kind of thing you are almost certain to finish up with pink skies or steely-blue grass. Copy Agfa on Agfa, and Kodak on Kodak; and likewise for any other make you may favour.

Special Effects in Slides

We defined a 'copy' earlier as any photograph of a document, not necessarily a replica in terms of tones and colour; and now we are going to look at some of the ways you can turn a plain original — even simple black-on-white — into something much more interesting and eye-catching.

The multiplicity of effects on TV titles owe a lot to electronic manipulation from simple graphics. Although some effects may be a little awkward to do on slides, most of them are not very difficult. Just as the TV controller can select positive or negative, so can you; and in either monochrome or colour. Just as he can control the colours electronically, so can you, with colour filters. And just as he can superimpose two pictures, so can you by double exposure, or by mounting two transparencies in the same holder. And if you can get hold of two projectors, you can produce fades and dissolves too.

Colour filters with colour-reversal material

Photograph through a strong-coloured filter, and you colour all the white (and pastel) parts that colour. So that is the first way we can get colour into a black-on-white original. An even simpler method is to use daylight-type film in tungsten lighting (or vice versa) without the normal conversion filter. The result will be a pleasant peach (or cold blue) colour. The former effect usually looks well if you use it for old drawings or lithographs, or newspaper photographs.

You can get any coloured ground you like by using filters in this manner. Your only limitation is the number of filters you own. However, not all colours are equally effective. The best seem to be yellow, yellow-green, peach and pale blue. On daylight-type film, for the yellow and yellow-green use ordinary black-and-white film filters in place of the blue tungsten filter, and rate the film at its marked speed. Don't allow for any filter factor: at most, give

half a stop extra, for the deep yellow. For a pale blue effect, use the tungsten filter and add a CC30C cyan filter, and rate the film at one-third of its marked speed. You don't need to mount the gelatin CC filter: simply hold it by one corner directly under the camera lens, taking care not to touch any other part of it with your fingers. By using combinations of CC filters you can make your ground any hue you like; but do not use more than two thicknesses of filter in front of the lens, or the image quality may suffer. Some useful combinations for daylight film are given in the table below.

CC filter combination	Tungsten filter	Filter factor	Effect
none	no	1	peach
50Y	no	1¼	yellow
20M	no	1½	pink
50Y + 20M	no	2	orange
50C	yes	4	greenish-blue
50C + 20M	yes	6	blue
50Y + 20C	yes	3½	yellow-green
30Y + 30C	yes	3½	green

All of these will give a pleasing light-coloured ground. You can get a fair impression of the effect of any filter combination simply by looking through it at your original. The effect of exposing daylight-type film to tungsten illumination is roughly similar (visually) to adding CC filters 30Y + 30M; so if you intend to leave off the tungsten filter, add this combination to your pack when you are judging the visual effect.

We mentioned earlier that you cannot use CP (colour printing) filters in front of the camera lens, because they are not optically flat, and could affect the sharpness of your picture. You can use any material you like in front of the lamps though. Theatre lighting colours are the most suitable. By putting filters of different hues over your copying lights, you can get a gradual transition across your transparency from one hue to another. Thus, a red filter on one side and green on the other will result in a transparency that is red on one side, green on the other, and yellow in the middle. Other good combinations are red and blue (magenta in the middle) and

green and blue (cyan in the middle). If you choose complementaries such as yellow and blue, cyan and red, or magenta and green, the middle of the transparency will be white. Using this technique, you can measure your exposure directly, with the filters in place on the lamps, and you do not need to make any allowance for the filtering; but if you want the colours to be correct, you need daylight balanced film (or the usual A-D filter with artificial light film).

Another way of obtaining multi-coloured effects is to use a multi-coloured filter. There are two basic types: one has the various colours in stripes, and you can have them vertical, horizontal or sloping. The other type has the colours in segments, radiating from the centre of the filter. These filters are intended to be used for special pictorial effects, and they do give spectacular pictures of certain subjects, such as fountains and floodlighting, and 'stagey' shots such as cabaret scenes; but they are very expensive to buy.

If you use coloured lines and lettering for your original, you can still use filters, provided the filter you use is not the complementary hue to your lettering (see table below).

Lettering	Filter	Factor	Result
red on white	CC50Y	1	red on yellow
green on white	CC50Y	1	green on yellow
green on white	80A + CC30C	3½	green on pale blue
blue on white	CC30M	1½	blue on pink

Lith negatives

One of the most striking ways of displaying graphics is to show them as bright lines or lettering on a completely black ground. To do this you simply need to make a high-contrast negative of your original, and use this as your transparency. It has to be really high contrast, though, with completely transparent lines and a completely opaque background. The film you require is called Kodalith Ortho Type 3, and you can get it in 35 mm width in bulk tins. Its speed to Photo-flood lighting is ASA/ISO 6; but as it has practically no latitude, you should bracket each exposure with two others, half a stop up and half a stop down. This is not as wasteful as it sounds, as the film is

comparatively cheap, and by doing this you will save a lot of repeat shots. You need to process this film yourself; and as it is insensitive to red light, you can develop it in a dish by inspection, using a red safelight. There is a special 'lith' developer, used in the printing trade; and if you anticipate doing a good deal of this type of work, it may be worthwhile getting a supply; but any universal or print developer is quite satisfactory. Use the developer at the strength recommended for prints, and develop for about 3 minutes at 20°C (68°F). The time is not critical. Use a hardening fixing bath, but don't overharden — five minutes is enough.

To test whether the exposure was correct, put the negative on a sheet of white paper, and examine the lines. They should be completely clean-edged and white. Now hold the negative up to a lamp bulb and put your finger in front of it. If the negative has been correctly exposed, you cannot see the outline of your finger through the dark parts. If you use your negative as a slide, it will appear as brilliant white lines and lettering on a black ground. However, there is no reason why you should not add a little colour to it. If you want all the image to be one colour, you can simply dip the transparency in transparent photo-tint or coloured Indian ink. Alternatively, you can wipe the image evenly all over with a broad felt-tipped pen, taking care not to overwet the film, and to keep the colour even. Kodalith film has a gelatin coating on the back, and if one application does not give a deep enough colour (this often happens with red and yellow), let the colour dry, turn the negative over, and do the other side as well. If you find that the colour is too dark, as you may with blues and purples, all you have to do is to soak the transparency in water for a minute or two, then dry it. Blues, purples and violets tend to appear much darker than you might expect, largely because the projector light has little blue in it.

Lith film has a tendency to produce tiny white specks or 'pinholes' in black areas, especially if you have used universal rather than lith developer. If your transparency has any pinholes, spot them out with a fine black fibre-tipped pen (see p. 116). You may need to do this on both sides in order to get your spot sufficiently opaque.

Negative slides of this type are often called 'dianegatives' (a positive transparency is a diapositive). They are particularly useful for slides of graphs and similar data; but for this purpose they

need to be very carefully designed. You can fill in different lines in different colours, if you use a fine fibre-tipped pen. You can also make 'frames' for trick or multiple-subject slides by making an original with black panels on a white ground and photographing this on the lith film. If you mount pictures and 'frame' together, you will have the effect of the 'framed' picture projected on the screen. We shall be saying more about this type of technique later (p. 114).

Dye-coupling development and dye-toning

It is possible to develop Kodalith and other high-contrast emulsions to a coloured image, by using a special developer containing a dye-coupler. This produces an image in dye wherever the silver image develops. After development is complete the silver image is removed by bleaching and fixing, leaving the dye image behind. This is similar in principle to the way the colours are formed in a colour negative, except that in a colour negative the dye-couplers are included in the emulsion when the film is manufactured. Dye-developers have been on and off the market for many years. At one time they were popular for producing monochrome prints in tones other than grey; but the process lost its popularity with the advent of colour-print papers, which considerably simplified the process. You can produce a range of very intense background colours by this method, but it needs a specially made-up chromogenic developer. The constituents are expensive and not easy to obtain in small quantities, and the developing solution is poisonous and can cause dermatitis. It is certainly simpler to use the colour-negative method described below. On the other hand, you can use any proprietary chemical toner to change your black-and-white image into a colour-and-white one. To get a really good colour you need to give minimum exposure and a full development. It is possible to obtain almost any conceivable colour by chemical or dye-toning. The actual method is outside the scope of this book; but you can find details of chemical and dye-toning in *The Focal Encyclopedia of Photography* (Focal Press, 1965), as well as in other advanced publications.

Negative colour transparencies

A colour negative, like a monochrome negative, shows light things

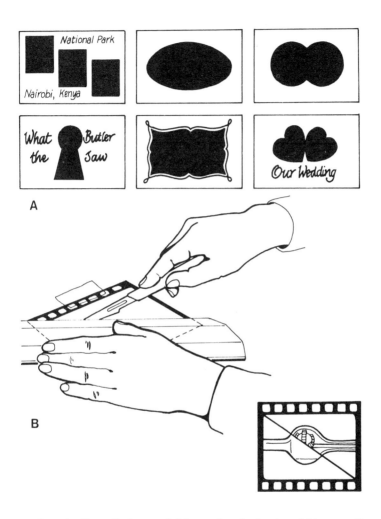

A, Masks for 'framed' pictures. A lith negative of a drawing of this type will give you an opaque frame with transparent windows and titles. For a coloured frame, use Ektachrome film with a yellow or yellow-green filter and develop to a negative. B, 'Split-frame' technique. Tape both transparencies in register to a hard surface and cut right through both with a trimming knife. Mount the halves, butt-joined with a trace of rubber cement. If edges show, rule a fine line along the cut with a black overhead projector pen.

as dark and dark things as light. But it also reverses the hues, so that they appear as their complementaries. Thus, red appears in a colour negative as cyan; similarly, green becomes magenta, and blue becomes yellow, and vice versa. This means that if, for example, you were to print your titles in black on bright yellow card, a colour negative of this would appear as white lettering on a deep blue ground. You get exactly the same result by photographing black lettering on *white* card, through a yellow filter. So this gives another way of making graphic slides.

Of course, if you have seen colour negative material such as Koda-color or Agfacolor Negative, you will have realized that it is not ideal for making slides. All colour-negative materials have very low contrast, and an overall red or orange colour caused by the colour-masking dyes. So we work with a transparency film, and process it as a negative. You can use Kodak Ektachrome; and can process it yourself. We shall be explaining how to do this later. If you are not doing your own colour processing, you can make arrangements with your local processing house to do it for you; but you will have to do this on a personal basis, and not through your local chemist. Agfa-Gevaert will not as a rule process their prepaid reversal film to a negative for you; but you can do so yourself if you wish, using Agfacolor negative processing chemicals. The results are similar to Ektachrome.

The simplest effect is to produce white lines or lettering on a coloured ground, using filters. Use the filters just as described for positives. You may, for example, make your exposure through a deep yellow filter. But when you develop the film to a colour nega-tive the result is quite different. Instead of black lettering on a yellow ground you get white lettering on a deep blue ground.

You can use other filters as well as yellow, and in each case the result will be white lettering on a ground that is roughly the com-plementary of the hue of your filter. Some of the more useful combinations for daylight film are given in the table on the next page.

Filter	Filter Factor	Colour of ground
Wratten 80A (blue)	2½	deep orange-brown
Wratten 4 (yellow)	1½	deep blue
Wratten 23A (light red)	3	blue-green
Wratten 56 (light green)	3	reddish-purple
Kodak CC50M to CC90M (magenta) 1½		dark green

You will no doubt have noticed from this list that the Wratten 80A tungsten filter is listed as producing a particular colour ground; and you may be wondering whether you need a basic colour-correction filter for tungsten light, and if so, what it is. The answer is that normally there is no need for a filter; but if you want your colour to be an *exact* reversal of the original, you will probably need some filtration. Because we are using film with a 'mismatched' processing system, it is not possible to be exact about this; but a Wratten 80D filter (B-6 or CB-6) should be approximately right. The correct filter is the one which will give you a neutral grey colour negative from a neutral grey original. However, for most purposes, you are not likely to need absolute accuracy.

White lettering on a coloured ground always stands out well: in fact, projected lettering is usually easier to read when it is lighter than the background. Your lettering need not be white, though; and if you make your original with coloured letters, they will reverse in the same way as the background. Let us take the table from p. 104 and see what the effect is when we develop the film to a colour negative instead of a positive; the results are given in the table below.

Lettering and ground	Filter	Factor	Result
Red on white	CC50Y	1	cyan on deep blue
Green on white	CC50Y	1	pink on deep blue
Green on white	CC30C	1½	pink on dark red
Blue on white	CC30M	1½	yellow on dark green

Increasing the density of the filtration will increase the colour saturation of the ground without affecting the lettering noticeably;

but you will have to increase the exposure slightly, or the ground will be too pale and the effect will be largely lost.

Another way of obtaining coloured letters is to soak the processed transparency in photo-tint. Yellow is the most suitable, as it gives bright yellow lettering and darkens the ground. If you photograph black lettering on a white ground through a light red filter and develop to a negative, the result will be white on a dark cyan ground. If you soak this transparency in yellow photo-tint, it will come out as yellow lettering on a dark green ground.

Negative pictures

If you process a colour transparency of a painting in the conventional way, that is, to a positive, you often find that the blues and violets are somewhat disappointing. However, the blues and violets that you get in a colour dianegative are much better. So that gives the clue to the last technique we will deal with: the production of a whole picture as a colour negative. Such a picture is likely to take some care in working out beforehand. Remember that in a colour negative both lightness and hue are reversed. All your blacks will come out white and your whites black, but colours are rather more complicated. Saturation is unchanged: a dull colour will remain dull on a colour negative, and a bright one will come out bright, even though the hue is reversed. The table below shows how the most common colours emerge:

red	cyan
green	magenta
blue	yellow
violet	lime-green
brown	grey-green
orange	ultramarine
pink	dark green
black	white
grey	grey

This technique works best with paper cut-out pictures, giving high colour saturation and brilliant blues, purples and greens. You can get a range of excellent blues and greens from fluorescent paper, which is obtainable in red, orange, pink, yellow and lime-green.

Rather surprisingly, this paper gives disappointing results when you use it for conventional colour diapositives; but it gives very intense colours in the colour dianegative process.

When you use colour reversal film such as Ektachrome for dia-negatives in this way, the speed is considerably uprated. A film of speed 64 ASA/ISO should be rerated as about 400. The Wratten 80D filter has a factor of about 1½.

Processing the film yourself avoids having to wait a week or more before you see the results of your tests. To this we might add that if you do your own processing you can expose just one or two frames, process them, and see what the result is like, rather than possibly wasting a whole film. Kodak supply kits for processing Ektachrome films in the conventional way; and they also supply kits for proces-sing Kodacolor and Vericolor film. It is this that you can use for your dianegatives. Other manufacturers also make kits for developing colour negatives, and at least one make is also suitable for colour-print processing. If you buy one of these, make quite sure that it is suitable for the colour film you are using. Colour-negative processing differs slightly from one make to another, but all methods have basically three steps: colour development, bleach and fix. The last two steps may be combined, and there may be further steps for hardening and stabilizing the image. You need the same basic equipment as you do for reversal processing: a developing tank, a measuring beaker, a thermometer, a timing clock and a supply of warm water. You have to be meticulous about your times and temperatures in conventional transparency processing, especially the first developer. With colour-negative processing there is rather more latitude in development time and temperature, but you should still be as exact as you can.

Superimposed titles

One of the most successful kinds of title is the title that appears superimposed on a pictorial background. This type of title is not at all difficult to do, though it does take a little time and care. There are several ways of going about it. These fall into three categories — artwork on a colour print; montage of two transparencies; and double-exposure techniques.

The first is the simplest. It is similar to the graphics discussed earlier,

except that instead of applying your lettering to a plain white card you put it on a colour print. Use a glossy print if you can, one that is composed so that there is enough space to include a full-size title without causing crowding. If you are going to use black, red, green or blue lettering, the space where you put the title should be much lighter than the letters, say white, yellow or pale blue. It should also be either central or over to the left side, rather than to the right. A large piece of fairly blank sky makes a good background. On the other hand, light titles against a dark background are somewhat more arresting; and if you have the appropriate shot with a large dark area near the centre top, or on the left side, you can superimpose your title in white or yellow lettering.

Your colour print need not fill the frame completely. You can make your title shot very effective by putting your print on a coloured ground, and having your title on the ground instead of the colour print; or you can print your title in a bubble, and lay it across a corner of the print.

As a variant of this, you can make your title part of the picture when you actually take it. There are plenty of pictorial possibilities. You can use an existing sign, such as a town name with its coat-of-arms on a board; or you can paint your own on the bonnet of a car (in water-soluble paint, of course!); chalked on a board, nailed to a tree, picked out in pebbles, held up by a pretty girl — whatever may be appropriate to the theme.

The second method is to make a separate slide of the title alone and mount this together with the transparency of the scene. This is suitable only for dark titles on a light background. Draw up your titles on white card, positioning your lettering in the appropriate place. For black-and-white results work on Agfa Dia-Direct film,which is a monochrome-reversal material giving direct positive transparencies. For coloured lettering, use colour film, but overexpose by ½ to 1 stop, so as to get a completely transparent background.

You can also use the 'picture-frame' method mentioned on p. 106 to give you white or coloured titles outside the picture area itself. This is how you go about it. Get a piece of A4 size card, and draw the outline of your 'picture frame' on it. Fill in the space inside the frame completely with black poster paint, Indian ink or black paper. Add your title in black lettering. Now photograph the frame on

lith film. It will come out as a black frame, clear inside, with clear lettering which you can colour yellow or any other bright colour. Mount the frame in the same holder with the picture. You may have to cut away the part of the picture that lies over the title if it is very dark, but this will not matter as it is outside the frame anyway; and if you use a glass-and-plastic mount the picture will not slip down.

Your surround need not be black. If you copy your 'frame' on Ektachrome and develop it to a negative, you can have it deep blue or green, or, indeed, any colour you like, depending on the filter you employ.

The third method is perhaps the best, but it involves a little more trouble as far as the photography is concerned; and you can do it satisfactorily only if you have a single-lens reflex camera. It is the technique of double exposure; and it produces white or light-coloured lettering on a darker ground. The basic principle is that you photograph whatever is to be your background, and then, without advancing the film, photograph the title, which you have made in the form of a high-contrast negative. You will need a slide-copying jig for this (see pp. 97-101).

The first step is to make a negative slide of your title on lith film, with the lettering in the position that you want it to be in on the finished slide. Next, photograph the scene that is to be your background, preferably underexposed by about half a stop. Now, without advancing the film, make a second exposure on your title set up in the slide copier. Your exposure for this is the same as you give for your 'standard' slide (see pp. 98-100).

Most cameras do not have the facility for making double exposures, as the film wind and shutter setting device are operated by the same lever. To set the shutter without winding the film, first take up the slack on the film rewind knob and hold it firmly. Depress the film rewind button, and, holding it depressed, operate the shutter setting lever.

When you have made a double exposure in this manner, it is best to waste the next exposure by operating the shutter with the lens cap on, and winding on. This is because you have disconnected the measuring sprocket, and if it does not reset in exactly the correct place the next time you wind on, you may get an overlapping frame.

An alternative method, where you have a number of titles of this type to make, is to take all your backgrounds in one go, then rewind the film and take all the titles. If you use this method you will not waste any frames, but you need some method of making sure all your second exposures are in register with the first ones. This is simple enough if you mark the film when you first load it into the camera. Make a mark with a wax pencil at the perforation on the uppermost tooth of the film measuring sprocket, and use this as your guide when you reload the film.

Sometimes a title stands out a little better if the background is slightly out of focus. In this case it is better to use a slide of your scene rather than the scene itself, and to copy this with the slide copier, where you can control the degree of de-focus as you wish. Of course, your background need not be a landscape. In fact, such a subject could often be quite inappropriate. It can even be an unrecognizable picture. Textures such as crumpled velvet, grained wood or sackcloth can be very effective as background to titles; and there is no need to insist on accurate colour: you can have any colour you like by using filters. You can use a filter for the title too; and with this method you are not confined to yellow, as the title will stand out from the background in almost any colour. It is of no consequence, by the way, whether you expose the background or the title first.

If you cannot use this method, either because you do not have a slide-copying jig or because your camera does not focus close enough, you can use white or yellow lettering on black card for your title exposure, instead of making a negative slide. You will not get such good contrast this way, and your titles will not stand out quite so effectively, but the result is still attractive. Alternatively, if you can get hold of two projectors, you can project the background and the title superimposed, and photograph the result. This sounds a little involved, but it does work surprisingly well. It also has the advantage that you can do your composition on the spot: if the title is too big, or too far to the left, you can make the necessary adjustments there and then. If you adopt this method, assess the exposure by pointing your meter at the projected picture, just as if you were taking a reading of an actual scene. Remember that projectors use tungsten lamps, so you will need your blue tungsten filter.

If you have the use of two projectors, you can add titles and other text during the show itself. This kind of presentation is discussed later (see pp. 168-9). The technique is part of a more ambitious kind of presentation called a slide-sound show, and you can find out more about this in a later chapter.

Finishing, Mounting, Storage and Filing of Slides

In theory, you can retouch a transparency in exactly the same way as a colour print. In practice, though, it is not particularly easy: you need a steady hand, good eyesight, and the ability to use a watchmaker's eyeglass (or a bench magnifier). Spotting out pinholes on a lith negative is not very difficult: you can do this with one of the fine fibre-tipped pens sold by educational stationers for overhead projector work. Use short diagonal strokes, holding the pen rather flat and drawing it towards you. Don't dab the pen; if you do, you will get a ring rather than a dot, and it will not be completely opaque. You can also add coloured arrows and other marks with overhead projector pens. Use the water-based kinds, the finest you can get, and work on the base (shiny) side of the transparency, so that you can wipe off any errors. The colours that show up best are green, blue and violet, and the background needs to be light-coloured. Use a ruler, and as you come to the end of your line, raise the pen while you are still moving it, otherwise your line may have a blobby end.

Retouching transparencies needs a good deal more skill than spotting lith negatives or drawing arrows. If you have a valuable transparency that is marred by pinholes or a scratch, have a couple of duplicates made first, and practise on these. If the duplicates are good enough in quality, and your retouching is satisfactory, use one of them and leave the original as it is. Certainly, do not attempt to work on the original if the scratch has completely removed the gelatin. The bare patch will not take dye; if you try to fill it up, the edges of the scratch will take up the retouching dye, and you will finish up with a dark line on either side of the scratch, making it look worse than ever.

Kodak make cyan, magenta and yellow dyes specially for Ektachrome transparencies and Ektaprint colour paper; but they are also perfectly satisfactory for other makes of film. You can also use any make of water-based photo-tint in these three hues. Use a

clean saucer as a palette. Put a large blob of each hue so that they form the corners of a triangle about 3 cm across. Now carefully spread the colours so that they intermingle to give the intermediate hues, and, at the centre, black. Allow the dye to dry out completely. To do your retouching you will need a watchmaker's eyeglass or a powerful bench magnifier. You will also need at least one really good spotting brush. Go to a reputable stockist of artists' materials for this. You want a No. 000 squirrel-hair watercolour brush. You may have to examine ten or more before you find a really good specimen with finely tapered hairs and a rounded end, and when you do find it, it won't be the cheapest. Any reputable dealer will allow you to test the brush with a little water. Dip your brush in the water, shake off the surplus, then draw the brush across a piece of paper with a rolling action. The hairs should form a fine point with no odd hairs sticking out, and no tendency to divide into two. Reject any brush that has a single hair that is longer than the others. If you can, buy two or three; they should last you a lifetime.

You will also need a retouching desk for transparencies. These are expensive and not always easy to find. However, it is easy to build your own. You need two pieces of 6 mm plywood about 20 x 25 cm in size to act as baseboard and desk surface, and two stays about 1 x 1 cm and 10 cm long to support the desk at the end farthest from you. You will also need a piece of thin plywood about 10 x 20 cm to act as a light shade, two stiff hinges, and a piece of opal glass or acrylic sheet 5 x 5 cm.

Cut a hole slightly smaller than the size of your opal sheet, near the far end of the desk, and recess the edges to take the opal sheet. Paint the baseboard on its upper surface matt white and paint the light-shade black. Fix this with the hinges just above the opal sheet so that it can prevent direct light from falling on the surface of the transparency. Fix the nearer edge of the desk to the baseboard and fix the spacers at the far edge, so that light can be reflected off the baseboard through the transparency.

If you are right-handed, you may find it an advantage to offset your opal sheet to the left, so that you have more room to rest your hand. Unless you are able to adopt a really firm and comfortable position, you cannot hold the brush steady enough.

Work in a window in full daylight. Tape down the transparency with

masking tape, emulsion side uppermost, and if you are using a bench magnifier, tape that to the desk as well, so that it will not slide down. To apply the colour, moisten the brush (don't overdo it), take up a little dye of the right hue, twirl and draw the brush across a clean part of your palette, and apply the colour very lightly to the spot, building it up gradually. If the spot is very small, it is not important to get the hue exactly correct; the most important thing is to ensure no colour goes over the edges of the spot, and to stop as soon as the density of your colour is sufficient. Work along long scratches very slowly, with a stippling action. This will simulate the granular structure of the image. If you try to draw your brush along the scratch you will probably go over the edges. You may be able to fill in scratches in greyish regions with a glass-writing graphite pencil sharpened to a very fine point, working on the base side rather than the emulsion, again with a stippling action. The advantage of using graphite is that any mistakes can simply be wiped off with a handkerchief.

If the spot you are working on has a different colour from the surround (perhaps because the upper layer of the emulsion was damaged), you must choose the spotting colour carefully. For example, if you have a cyan spot in a patch of green grass, you need to retouch it with yellow dye, not green. Above all, *don't hurry*. If you begin to feel bored, or your eyes become tired, or if your fingers begin to tremble, leave the work, and come back to it later. Never smoke while you are working: it will interfere with your concentration, and may make your fingers unsteady.

Assembling montages

We saw earlier that it is possible to obtain some interesting effects by mounting more than one transparency in the same slide. You may, for example, want to produce some special framing effect such as a 'field-glasses' or 'keyhole' impression, or to show two pictures side by side for comparison. It is important to ensure your mount will take two thicknesses of film: you may need to remove the metal masks if the mount has these. Make sure the mount will stay closed with two transparencies in position.

If your montage is simply a picture in a fancy black or deep blue

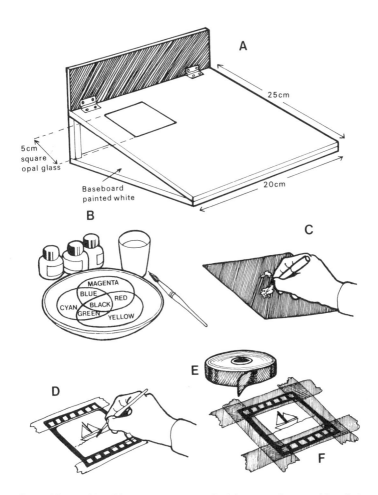

Retouching and masking a transparency. A, A home-made retouching desk from 6 mm plywood. Note offset opal glass (right-handed people). B, Use retouching dyes in cyan, magenta and yellow, blended on a saucer to give intermediate hues. C, To spot out transparent specks in lith negatives lay a black spot across the speck with either a No. 0 watercolour brush or a fibre-tipped pen. D, Fix transparency to opal glass with cellulose tape. Work in full daylight, using bench magnifier or watchmaker's eyeglass, building up colour gradually. E, F, Use slide binding strips to mask down transparency as necessary, working on base side. Trim with scissors before mounting.

frame (the method described on p. 112), all you have to do is to mount the 'picture' transparency and the 'frame' transparency in the same mount, having taken the precautions above. If you want to display several pictures side by side in a double frame (which you can make from lith film by the same method), cut your transparencies a little oversize and fix them to the lith negative so that they are correctly framed. The most suitable adhesive for this is rubber gum — as used by graphic artists. Apply it just round the extreme edges of the pieces of transparency. Do not use glassless mounts for this type of montage, as it needs protection.

Another method of side-by-side display is simply to butt-join the two pictures. This has the advantage of having only one thickness of film in the mount. If you are showing separate views, you will have to compose them for a vertical format of proportions 3:4. If you are showing the same picture, say, to show the effect of different lighting on the same subject, you may prefer to use the full format, cut each picture in half diagonally, and mount the result butt-joined, so that you have the complete picture, but one half is with one kind of lighting and the other half is with the other kind. Tape down the two transparencies, emulsion up, and cut through both of them along the required line, using a sharp scalpel or a single-edged razor blade. Take a black fine-pointed overhead projector pen and run it along both cut edges. Now mount the two halves in close contact in a mount that has glass protection for the transparencies. If your montage consists of several irregularly shaped compositions, join the separate pieces with narrow black separators cut from black gummed slide binding strip (see p. 126). You will need to use a mount with glasses for this type, too, as it is mechanically weak, and needs support.

Mounting a slide

A transparency is a delicate thing; and without adequate protection it may easily become damaged or even destroyed. There are various types of mounting. The cheapest — at least in initial outlay — is the one the processing house does for nothing. The main advantage of card mounts, apart from their cheapness (you can buy them for mounting home-processed transparencies) is that they are

very thin, and you can store a lot of slides in a small space. However, as we shall see later, this may not be a very good idea. Another undoubted advantage is that you can drop a heap of card-mounted slides onto a stone floor without any damage to them. There is very little else to say in favour of card mounts. Their thinness can be a disadvantage when you project them. With some makes of projector they sit loosely in the gate, causing focusing problems, and sometimes they can slip past the withdrawing mechanism: the slide stays partly in the gate, and the next slide is pushed up against it, jamming the projector and damaging both slides. In the end you may even have to dismantle the projector in order to extricate your chewed-up transparencies. Some makes of projectors are particularly likely to damage slides in this way when the projector is tilted to raise the picture. The magazine least likely to cause damage to card slides is the rotary horizontal ('carousel') type of magazine, as the slides drop into the gate by gravity; but a warped or dog-eared mount can prevent the slide from dropping fully into the gate.

A less serious but still irritating trouble with card mounts is that as the transparency warms up in the heat of the projector beam, the emulsion side expands more than the base side, with the result that after a few seconds in the gate the curvature of the film flips from concave to convex, and the projected image snaps out of focus. Some projectors preheat the slide waiting to be projected, minimizing this problem.

Most important of all the disadvantages of simple card mounts is that the delicate image is completely unprotected from fingermarks and abrasions. True, there are only two surfaces to gather dust, and your transparencies will never steam up; but you need touch the emulsion with your fingers only once to mark it for life. Even if you take it out of the mount at once and treat it with grease solvent and water, you may not succeed in removing the fingermark entirely; and in attempting to clean it you may cause even more damage. A method that has been suggested for giving protection is to sandwich the slide between two thin slide cover glasses (see p. 125), but this results in a somewhat unwieldy slide which may be too thick to go into the magazines of some projectors. In general, you are better advised to remount the transparency in a more efficient type of mount.

Plastic mounts are rather better. They are thicker and may be more robust. Also, some types let you take out the transparency and put it back again without destroying the mount; simply push on the locking lugs with a ballpoint pen and the mount pops open. You will need to do this if the transparency needs masking down. Mounts of this type usually hold the transparency in place by studs or ridges moulded into the frame, but you can usually move the transparency a little if it needs aligning, something you cannot do with card mounts. If you have to do this, put a clean handkerchief or paper tissue over your fingers before handling the transparency surfaces.

You can buy plastic mounts quite cheaply; and if you remount your transparencies in them, you will have a slide tough enough to defeat the most voracious projector. However, a simple plastic mount still gives no protection to the emulsion; and unless you have been careful to ensure the projecting lugs or ribs of the two halves are well interlocked, the slide may come partly open in the projector gate, with dire results. Some commercial plastic mounts take a great deal of force to close fully. A carpenter's bench vice is probably the best way of ensuring the mount is completely closed. A number of manufacturers make plastic mounts that include an integral cover-glass to protect the transparency. These vary considerably both in price and quality. The most expensive are not necessarily the best, either. With some makes you can save a good deal by buying large quantities at a time. Glass-in-plastic mounts are made to take all the standard formats, from 40 x 40 mm down to 110 size; and you can also get the larger size (70 x 70 mm) for cameras taking 12 or 16 pictures on 120 film.

The glasses in these mounts are prepolished, and the only treatment you need to give them is a dust-off with a lens brush or a No. 9 squirrel-hair water-colour brush. Try not to touch the glass with your fingers. If you do touch it, wipe any fingermark off with a clean paper tissue, and remove any paper fibres with your brush. Before you insert the transparency, brush that too, on both sides; and ensure the transparency is properly seated on the registration lugs (if any) before you attempt to close the mount.

Most makes of glass-in-plastic mount contain an integral mask, usually about 1 mm smaller than the dimensions of the transparency.

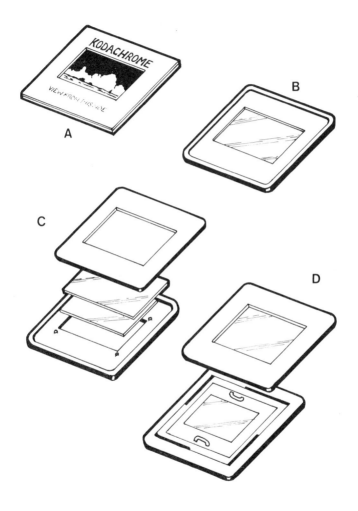

Types of ready-mount. A, Simple mount of folded card. B, Plastic clip-together mount. C, Clip-together mount with two pressure glasses. D, Mount with integral metal masks.

If you need further masking down, or if you are mounting two transparencies in one mount, make sure you get a type of mount that does not spring open under the pressure of the extra thickness; You may, as suggested earlier, have to remove the integral mask, if it can be removed.

Some glass-in-plastic mounts are constructed very crudely and cheaply — simply two glasses sitting in recesses in plastic frames. The transparency is held flat by the pressure between the glasses when the frame is closed. Avoid this type of mount. There is no air gap between the film and the glasses when the frame is closed, and the emulsion cannot take up or lose any moisture. So, unless you have mounted the transparency under absolutely dry conditions, the emulsion will eventually stick to the glass. If this happens the dyes will deteriorate rapidly, in patches, and the transparency will be ruined.

Another unfortunate effect caused by contact between the film and the glass — the base side of the film rather than the emulsion — is known as Newton's rings, an effect first described by Sir Isaac Newton. It happens when two nearly flat surfaces are almost, but not quite, touching. In a slide it takes the form of an irregular dark patch surrounded by coloured lines rather like the contour lines of a map. The dark patch is where the film base is pressed hard against the glass. Usually, the shape of the patch changes as the slide warms up in the projector beam, and the dark patch becomes steadily larger and more obtrusive. At the same time, the coloured contours ripple outwards as the film expands. It looks very nasty indeed; but in fact, the effect is purely optical, and does no physical harm to the transparency.

One solution to the Newton's rings problem, and one which works reasonably well, is to use specially treated cover-glasses. These are given a coating which has a low reflectance and is slightly rough. This means that the transparency is in contact with it at a large number of very tiny points, and any contour pattern there may be is too small to be visible. This treatment, unfortunately, approximately doubles the cost of manufacture, so that these mounts tend to be rather expensive. The other method is to ensure the transparency does not touch the glass surface at all, by using a metal mask on both sides of the film, so that it is held by the edges only.

This adds to the cost of the mount, too; and, because of the added thickness of the mask, the cover-glasses have to be made very thin and fragile. However, the presence of an airspace does mean that the transparency has the opportunity to 'breathe'; which, as we shall see later, is an important factor in determining its lifespan. So, taking all factors into account, this is probably the best kind of mount to buy.

Mounting between cover-glasses

In the days of the 3¼ x 3¼ inch slide, mounting could be a pretty laborious business. You started with your transparency (which was a glass plate), a 3¼ x 3¼ inch cover-glass, a length of black gummed paper strip and a piece of black paper for the mask. You cut this mask with a razor blade — not an easy task, particularly if you wanted the then popular circular or oval shape — and you then bound the whole lot together with the gummed paper strip. A special technique for dealing with corners of the slide was to fold the strip somewhat like the blankets at the corners of a hospital bed. It was time-consuming and messy, and took a good deal of skill to do neatly.

Until the mid-1950s, in fact, there were no really satisfactory glass-in-plastic mounts; and at that time a number of manufacturers marketed ready-cut masks, binding strips and prepolished cover-glasses. With the arrival of better quality plastic mounts, the market for traditional mounting materials declined.

This method of mounting between cover-glasses has a good deal to recommend it. Each mounted slide costs a good deal less than would an equally effective plastic mount. You can make your mask any shape you like, juxtapose, and superimpose, to your heart's content. The risk of Newton's rings is low, especially if you have given the film plenty of time to dry out thoroughly before mounting; and because the slide is bound with paper tape and masked with card, your transparency can 'breathe' much more effectively than it can when sealed into an almost airtight plastic mount.

What do you need to mount slides in this way? The first thing is a box of 50 x 50 mm cover-glasses. You also need a packet of masks the right size for your camera format, a packet of binding strips,

a lens brush, a pad of plastic sponge material about 20 x 20 cm and 1 cm thick and a pair of pocket scissors. The masks are in the form of a sandwich, the upper layer being black paper gummed on the underside and the lower layer white card. The two layers are joined along one edge. The binding strips come ready-cut in packets of 400, that is, 300 black and 100 bearing a white strip for the title. You can also get rolls of uncut black or black-and-white strip, and these work out a little cheaper. Do not be tempted to buy self-adhesive binding strips: the sticky edges pick up dust and fluff, and sometimes the adhesive 'creeps' in the heat of the projector beam, so that your slide falls to pieces in the gate. Use only the gummed paper type, which never peels off or creeps.

Put your transparency, base side up, on a clean handkerchief. Polish the base side, breathing gently on it as you do. Do not wipe the emulsion side: you can easily scratch it. Now place the transparency between the two layers of the mask. If you choose the white side to go with the film-base side ('right way round') your slide will absorb less heat from the projector beam, but not look quite so neat.

The inner surface of the mask is gummed; but *don't* stick it down. If you do, your transparency cannot expand and contract, and if it distorts and touches the glass, you get Newton's rings. If you want to mask the transparency down, cut the black gummed paper diagonally across the format so that it comes apart into two L-shaped pieces. Move the free piece around until the rectangle is the shape you need, then wet the edges and stick it back onto the fixed 'L'. Cut off the surplus black strip at the side.

Next, take two cover-glasses and clean the side of each that is going to go inside. Use the handkerchief, breathing gently on the glasses. Take the transparency in its mask and remove any dust from both sides with the lens brush. Place the sandwich between the glasses.

You are now ready to begin the binding operation. This should be done carefully, though after you have done three or four slides you should find it easy enough. Take three black binding strips and one black-and-white one and lay them, gummed side up, on the foam pad. Wet them thoroughly. Now pick up the transparency in the cover glasses, right way up and right way round. Turn it through 90° so that the bottom edge becomes vertical. Now, holding the

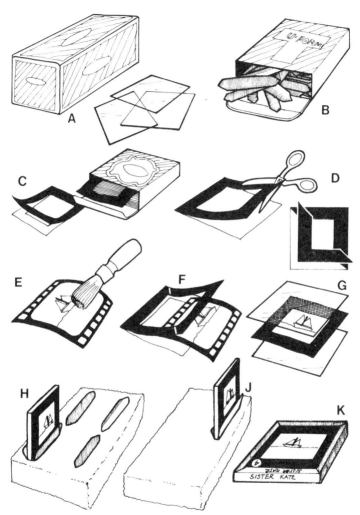

Mounting transparencies between cover glasses. Materials required: A, cover glasses; B, binding strips; C, masks. Mounting a transparency: D, cut mask as necessary to reduce size; E, remove dust with lens brush; F, insert transparency in mask; G, place between two cover glasses; H, wet four binding strips (one with white title strip), place on foam plastic pad and press down glass sandwich on each in turn, finishing J, with white strip at bottom front edge. K, Finished slide titled at lower front and edge, and the bottom left corner identified by a spot.

whole sandwich very firmly between the fingers and thumbs of both hands, locate it over the centre line of a black strip and press down hard. The foam pad will close round it and seal it to the faces of the cover-glasses. Still holding the glass sandwich firmly, rotate it so that the top edge is downwards, and press it down on a second black strip. Rotate the sandwich again so that the other side is downwards, and press down on the third black strip. Now press the bottom edge of the slide onto the black-and-white strip with the white edge at the front of the slide. Finally, rub down all the gummed strips with your finger, and the mounting is complete. Set the slide aside for an hour or so, to allow the gum to dry out thoroughly, and then clean any fingermarks and traces of gum from the outer faces of the cover-glasses.

Spotting and titling

When you have completed mounting your slide, whether between cover-glasses or simply in a ready-mount, there are still two tasks left: spotting and titling. There are eight possible ways of putting a slide in a projector, and only one of them is the right one. The agreed international standard is that there should be a spot in the lower left-hand corner when the slide is viewed right way up and right way round. Now, when you put a slide into the projector, you put it in right way round (looking through the slide at the screen), but upside down. So if you are standing behind the projector the spot will be at the top right.

You can buy small self-adhesive spots in various colours from office stationers. Or you can make little discs out of gummed labels using a paper punch. You can get numbered spots from photographic suppliers, and these are useful if you are filing a large number of slides with an index.

Whether you have the numbers upright or inverted is a matter for your own choice — if you have them inverted and store the slides inverted too, they will be ready to load into the projector that way up, and many people prefer this method.

Write your titles neatly in pencil on the mount, or the binding strip if you have used cover-glasses.

Slide storage

Once you have completed a series of slides, you need to file them so that you can find any of them individually or as a set, without difficulty; and store them with the least possible risk of deterioration. Slides need to be kept cool, dry and in the dark. The recommended temperature is below 21°C (70°F) and above 10°C (50°F); and at a relative humidity of between 15% and 60% (ideally 30%). This is the humidity that you typically get in a centrally heated house, and the temperature is about what you might expect in a partially heated bedroom. If you have open fires, the best storage place is probably the coolest corner of your sitting room.

There are four main methods of storing slides for ready access: envelopes, boxes, cabinets and projector magazines. Which you choose depends on factors such as the number of slides you want to store, how often you want to show them, and how easily you want to be able to examine them.

Slide storage envelopes are made to hold a standard number of slides (usually 24 in the case of 35 mm and other small-format slides). They are made of transparent PVC or similar material. The better types have ridges inside the pockets to allow air to circulate freely around the slide and prevent humidity building up. Some types of envelopes have reinforced holes to fit ring binders; and others are intended for suspending in a standard filing cabinet.

Which type you decide on depends on your ambitions. The filing-cabinet type is mainly intended for resource centres in schools and colleges, and the holder can include a separate pocket for instruction manuals or audiocassettes. If you already own a filing cabinet, and have some spare storage space in it, you might well decide on this method, as it is very easy to find the slide you want provided you have a good index; and you can examine any slide without taking it out of its pocket. This method of storage lends itself particularly well to self-contained 'packages'. Storage in an album may be more suitable for you if your collection is growing comparatively slowly; and slide albums for the amateur may store a rather more smaller number per page. Some firms make pages which fit their format for negative albums, so that if you wish you can keep colour negatives and colour transparencies in the same

cover. This can be useful where you have covered a particular subject partly in slides and partly in negative.

You may prefer to store your slides in boxes. There are dozens of types of slide box on the market. The simplest, of course, and the cheapest, are those your processed slides are returned in. Unfortunately, these boxes are far from ideal, as the slides are not separated; and the boxes themselves are more or less airtight, with the result that very little air gets to the emulsion. The remaining traces of chemicals and solvents cannot evaporate away, and the risk of chemical fading is high. In the relatively high local humidity you may even get mould growing: this appears as dark grey patches which eat away the gelatin and completely destroy the colour. Plastic containers which store your slides in blocks of ten or more are little better; and they may well be worse if you pack the slides tightly in order to save space. If you do use them, leave the slides plenty of room, and make a point of leaving the containers open in a dry atmosphere for an hour or two at least once every six months. The best type of container is a wooden or compressed cardboard box with spacers that separate the slides by at least 1 mm, thus allowing free circulation of air.

One of the difficulties about box storage of slides is that they all have their lids at the top (indeed, it is hard to visualize how else the lids could be attached!), so that no matter how you stack them, you cannot get at the contents of any one box without disturbing several others. This does not matter when you collection has not gone beyond about three boxes, but with most enthusiasts it is not long before the three boxes have become six, then twelve, and so on, until finding a particular slide becomes a nightmare involving great heaps of boxes, all to be put back again afterwards. If you stow the boxes on edge like books you need only bring out one at a time, of course; but you will probably run out of space before long, as this method takes up twice as much room as storing them one on top of the other.

The best way of avoiding this problem, if you intend making a lot of slides, is to use slide-storage cabinets. These are fairly expensive to buy, but they avoid all the disadvantages of the other methods. They allow free air circulation; they keep your slides in the dark; you can find any slide quickly; and the cabinets themselves are

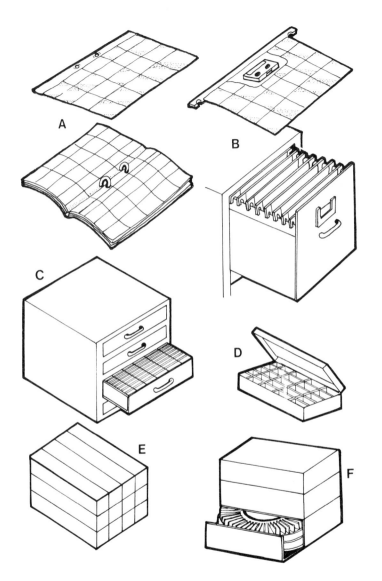

Slide storage. A, Slide wallets to fit ring binders. B, Envelopes for standard filing cabinets. C, Wooden storage cabinets. D, Stackable boxes. E, Straight magazines. F, Rotary magazines.

stackable, so that as your collection grows you can add further units. What is more, they are pleasant to look at, which may be important if you have to store your slides in the living-room. If you are a bit of a handyman, you can design your own cabinets to fit in with your furniture, perhaps matching your bookshelves or record cabinets. Make the main structure from veneered chipboard and the 'innards' from good-quality plywood. The spacers are the main problem. If you have a small power saw with a groove-cutting jig you can produce slots 3 mm wide and 2 mm apart all the way along your spacers. If you use 9 mm ply for the spacers the slots should be about 3 mm deep. If you do not have this kind of tool you will have to get your local carpenter or joiner to do the job. Apart from the spacers, the construction of this type of cabinet is exactly the same as that of any cabinet of drawers: whether you use dowels, dovetails or just screws and glue depends on your enthusiasm as a handyman.

When you have assembled the cabinet, and any adhesive is thoroughly dry, give it two coats of polyurethane varnish on the outside only. Before you use it for slide storage give the cabinet and all the drawers two weeks in a warm dry room so that all the solvents can evaporate completely. You can if you wish fit out part of the top drawer as a card-index as described in the later part of this chapter, if you are anticipating a large enough collection.

It was suggested earlier that filing-cabinet-sized transparent envelopes were a good way of storing slides as sets. Another way you might consider, if your collection is comparatively small, is to store such sequences in the magazines you are going to show them from. This way you can simply select the magazine you want to show, and it is ready for use, without the time and trouble of having to load it. It sounds a bit wasteful; but in fact it is not much more costly than buying a cabinet, and a lot less trouble than making one. You can get several shorter sequences into one magazine, and save space this way. Most magazines are designed to be stackable; and your collection will take up little more room than it would in a cabinet. Rotary magazines are best for this type of storage, as you can store them on edge, in their boxes, much as you would box-files, with labels to identify them. As with envelope storage, this method is common in schools and colleges. However, you cannot examine the slides individually without removing

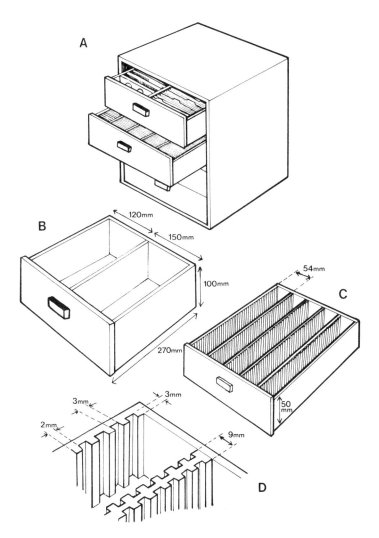

Making your own slide storage box. Construct this box preferably from 9 mm plywood, using standard do-it-yourself construction techniques for cabinet and drawers. A, Completed box showing top drawer for card-index and cassette tapes. B, Top drawer showing approximate dimensions. C, Slide drawer. Each drawer should accommodate about 250 slides. D, Detail of slide drawer.

133

them from the magazines; and you will need separate storage for any tape cassettes that go with the slides.

Filing

When you first start your slide collection, you tend to store your slides more or less in the order you took them. For a while, this is as good a way as any; if you have printed your titles on the slides so that you can read them with the slides still in their boxes or envelopes, you can find the slide you want easily enough. If you also identify your slides with numbers, you will be able to start an index as the collection grows larger. After a while, though, you begin to find that there are too many slides for this simple system, and that it takes quite a long time searching through your index to find the slide you want; and eventually it becomes almost impossible to find any slide within a reasonable time. At this point you realize that you must have some sort of order in the collection. What you need is some form of filing system, and a properly organized index.

There are five commonly used methods of filing:

1. Chronological.
2. Alphabetical.
3. Subject or topic.
4. Geographical.
5. Numerical.

You need not keep to just one of these for your entire classification system: in fact the more efficient system will probably be a mixed one. For instance, you might have the main sections arranged geographically, the subsections according to subject matter, and the individual slides within the subject areas chronologically. Let us look at the five methods in turn, and see the types of slide collection each might fit.

Chronological filing is the obvious method of starting, where there are only a small number of slides. With more, though, it becomes unwieldy and is appropriate only where a group of slides all have the same title, and can be distinguished only by the dates they were taken.

Alphabetical filing is suitable for collections under a broad subject

heading. A collection of, say, cacti and succulents would have the species arranged alphabetically, with the individual slides (not indexed separately) arranged chronologically. Your index would begin with *Agave* and run through the alphabet to *Zygocactus,* the subspecies and variety being alphabetical under each heading. You would file the individual slides of each variety either chronologically or in a logical order for showing, such as a progression from general view to extreme close-up. Alphabetical filing occasionally raises difficulties, especially where names are involved. Do you put 'de la Rue' under D or R? Where do you put 20th Century? There are rules for handling these and other awkward words; and the best way of finding out is to examine your telephone directory. (Actually, de la Rue is filed under D, and Twentieth Century is written out in full and filed under T.)

Themes themselves are best filed alphabetically according to subject matter or topic. Thus your Cacti and Succulents might be between Cabinet Making and Canal Folk. Of course, you will need these larger sections only if you are intending to cover a wide variety of topics rather than concentrating on just one or two subject areas.

The geographical system is appropriate for slides concerned with localities rather than subject matter. This is probably the best way of filing holiday slides. If you visit the same district regularly, you can file the separate holidays chronologically. The main headings could be the continents (if you travel that widely!), the subheadings the states or countries, in alphabetical order, and the places broken down into localities. You can then file the individual slides either chronologically or grouped according to subject matter; or you may prefer to arrange them as sequences, to be shown as a set. If so, you can identify these sets by putting them together in a block and drawing a diagonal line across the top of the entire block with a fibre-tipped pen. This will form a useful check that the slides are in the proper order for showing.

That leaves us with numerical (or alphanumerical) filing. The general idea of this method, which you can use in conjunction with any of the others, is that each subject has its own identifying number (or letter and number), so that if your overall system is geographical, you give B1 to Bavaria, B2 to Belgium, and so on. Within each country, each district will have a number, so that

Brussels might be B2.1, the Ardennes B2.2, etc. — not necessarily in alphabetical order as there would not be sufficient subdivisions to make this necessary. The individual slides are numbered 001, 002, etc., so that a particular slide would bear the number, say, 2.1.004, the fourth slide in that block. So that you can find any slide easily, you would have an alphabetical index, and the examples above would appear as

 B2 BELGIUM
 1 Brussels
 001-3 Grand'Place
 004 Palais de Justice

 etc.

There are several different kinds of numerical filing system, and you can find them described in any textbook of office practice. Perhaps the best known is the Dewey Decimal system, which is widely used in libraries. You can use it for slides, too, as it can include every conceivable subject, no matter how outlandish or obscure; but it does require a very large number of figures for the more specialized topics. A simple straightforward system such as suggested here is probably best.

Filing, of course, is not simply the way you store the slides in their boxes, drawers or envelopes: it also includes preparing and maintaining an index. With a small collection you can simply enter your slides up in a book, with, say, a page to each subject or country; but eventually a page gets filled up, and you are faced with either rewriting the whole thing or sticking an extra page in. Using a ring-binder with loose sheets helps to avoid this to some extent, and you only need to rewrite one page at any time. But in a growing collection of slides the best way is undoubtedly to start a card-index. You can add to this easily, and change it around as you wish to suit your changing needs. If you have separate cards for, say, Maine and Miami, and then you take a trip to Massachusetts, you simply insert your new card between the two, instead of perhaps having to rewrite a whole section. Card-indexes are nearly always arranged alphabetically; and if they grow large enough, you can indicate the letters with tabbed cards.

If you have a slide that you can file under either of two categories

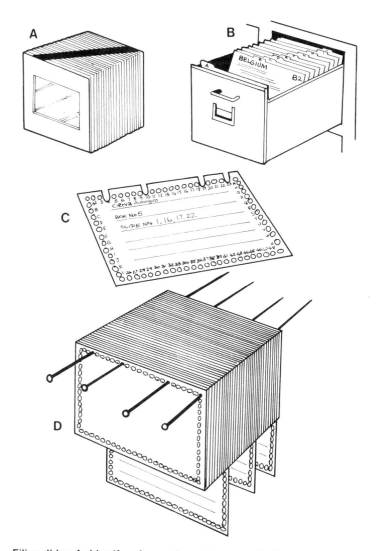

Filing slides. A, Identify a frequently used sequence by drawing a diagonal line across the block of slides with a fibre-tipped pen. B, A card-index helps to find slides of any given subject. C, Edge-punched card with identification slots. D, Finding cards on a given subject, using steel knitting needles and edge-punched cards.

— say, a cactus that you photographed while on holiday in Spain — you will need to do what is called 'cross-indexing'. That is, if you decide that it properly belongs under 'Spain' you will still need a card under 'cacti' as well. File the slide itself in whichever position you think is appropriate; if you expect to show it most often as part of a series about Spain, keep it there. If you later decide that it would be more convenient to keep it amongst the other cacti, you simply amend the file card. Good cross-referencing is a vital part of any index.

However, even with the best possible index, it may sometimes be difficult to find exactly what you want. For example, unless your cross-indexing is very comprehensive, you may find it difficult to find all the slides on a particular subject if your filing is geographically based. There is, however, a special type of card-index made to deal with just this problem. It is known as the 'edge-punched' system. Using this method you can find all the slides dealing with a particular topic immediately, no matter where their cards may be in the index.

You can get edge-punched cards in a variety of shapes and sizes from office stationers; the only other items you need to operate them are three or four steel knitting needles. The cards are like ordinary index cards, except that each card has a row of holes along all four edges. Each one of these will correspond to a particular attribute of the subject matter your collection covers.

To see how it works, let us take an example needing 24 holes. Suppose part of your collection is of old aircraft. This can be subdivided into a number of categories:

Pre-1914	British	Monoplanes	Single-engined
1914-1918	French	Biplanes	Twin-engined
1919-1925	German	Triplanes	Fighters
1926-1935	Italian	Land aircraft	Bombers
1936-1940	American	Water aircraft	Transport
1941-1945	Japanese	Rotating-wing	Private

Each one of the 24 holes represents one of these categories; you have a key card with them written or typed opposite the appropriate holes.

Now, each of your slides will fall into several of these categories.

To identify these, you take the card for each slide and cut a V-shaped slot from the hole concerned in each case to the outer edge of the card. Now, suppose you want to extract from your collection all the German triplanes of 1914-1918, all you have to do is to push your knitting needles through the appropriate holes in the whole stack of cards, lift the stack and shake it. The cards that fall out are the ones you want. If you want French triplanes as well, repeat the operation with a needle in 'French' instead of 'German'. Using this system you can be as broad or as narrow in your selection as you like. If your choice is very broad, say World War I, you will get a lot of cards. If it is narrow, say Italian private rotating-wing aircraft of 1926-1935, you may only get one. The advantage of this system is that you *will* find exactly what you are looking for, quickly; what is more, it is of no consequence what order your cards are in.

Showing Your Slides to Your Friends

You have the beginnings of a fine collection of pictorial slides, and naturally enough you want to see what your friends think of them. So you invite a few of them round to see some slides. You weed out all the shots that are not quite sharp, load up all the rest, and wait for your friends to arrive. Once the pleasantries are over, you settle them on the settee and various odd chairs, switch on the projector, and off you go. At least, that is the way a good many people seem to do it.

If you organize your slide shows that way, and they turn out successful, you should consider yourself very lucky. Of course, it may be because you have friends who are exceptionally tolerant. The slides may have happened to be on a topic that interested them. It is possible that your friends were all sitting where they had a good view of the screen. You may have managed to select exactly the right number of slides, so that nobody was either bored or unsatisfied. You may have managed to get through the whole evening without the projector jamming, the lamp blowing, finding you have loaded a whole magazine upside-down, or having one of your friends trip over a cable, spill his drink, or set fire to the carpet. You may not always be so lucky. So we are going to look at all the things that can contribute to making your slide show the success you would like it to be.

How to select the material

Perhaps the first thing you should do is to examine your motives for showing the slides to anyone else at all! Be honest! If, in your heart of hearts, you know that you only want a captive audience to admire your photographs, then the slides have got to be show-stoppers, every one. If you really only want to boast about your holiday, you had better choose your audience very carefully

indeed. Otherwise, they will find excuses for not coming on any subsequent occasion, so that your first slide show will have been your last.

So let us begin again with a different point of view. A better question might be — what are the interests of my friends? Before you begin inviting people along, make sure they are going to be interested in what you propose to show them. So we must qualify the question and ask — what are the *common* interests of my friends? If you are thinking of inviting more than two or three, you may very well find that their common interests are not sufficient to give enough pictures to make it worthwhile getting the projector out. It would be better to ask only one or two at a time, and show them all the slides you know will interest *them*.

The next most important question is — how long a show, and how many slides, is it reasonable to expect them to tolerate? The answer will certainly be a shorter time, and fewer slides, than you yourself would like, especially if the subject matter is a bit limited. Leave them still wanting more, and they will come back again. Thirty to forty minutes of slides is enough for anybody. In that time you probably will get through less than a hundred slides, particularly if your friends want to discuss the pictures too — which they certainly will, if you have chosen the slides carefully.

Begin by putting out all the slides that have a direct bearing both on your story and on your friends' interests. When you have done this, start arranging the slides in an order that unfolds the story logically. Try if you can to organize the arrangement so that as far as possible, the pictures tell their own story, so that you yourself will have less explaining to do. After all, your friends are coming to see your pictures, not to hear you talking about them.

Now go through the slides very carefully, reducing them to the ones that are essential in telling your story. You will probably have to do some fairly ruthless pruning. Start by taking out all near-repeat shots, inessentials and any poor quality slides (unless they are so important that their defects will just have to be overlooked). Repeat this operation as many times as you need in order to get the total down to a reasonable number — certainly fewer than 100 and perhaps not more than 50. Put all the slides you removed from the set in order, in a spare magazine, just in case someone asks to

see something you left out, or wants to see more of some aspect of your subject matter. Make a list of them as you do so, so that if necessary you can find the slide you want quickly.

Now have a final check of your selection. Lurking among them will almost certainly be one or two that are there only for self-indulgence, such as shots of your car or your family. Harden your heart, take them out, and put them back in the box. Load the magazine, and record the order of your slides.

You should prepare some notes before the show, and not be afraid to use them; Your friends will appreciate your having gone to the trouble. It is disrupting to the whole show if you forget what you were going to say about a particular slide until it has gone, especially if you turn back to the slide to say it. A good set of notes will ensure your commentary is complete and to the point, but brief. When making the notes, project the pictures at the same time. You will find this a great help in preparing them; and at the same time you will be able to see if there are any gaps to be filled with graphics or continuity material. If you took the advice given in the chapters on preparation and planning of sequences, no doubt you *will* have some.

Arranging a sequence

It is easy enough to say 'arrange your slides in a logical sequence' — what *is* a logical sequence? It depends very much on your subject matter, of course. But there are some good general guidelines to work along, to provide a smooth logical development of your theme, both overall and within small groups of slides. Some of them were discussed earlier in the planning of photography around a theme.

The simplest way of sequencing your slides is temporally, that is, related to the time the photograph was taken. For a touring holiday, a mountain climb or a carnival procession, you can show the slides in more or less chronological order; and you would use a similar arrangement for more extended sequences such as building an extension to your house. Of course, you need not arrange the slides in precisely the order you took them; and you can often vary the strictly chronological approach by using a 'flashback'

arrangement. For example, your house extension sequence could begin with the completed extension, and each stage could be preceded by a shot of that stage completed. Do not overdo this approach, though, as too much of it can become confusing.

A second type of logical sequence is through space rather than time. This is suitable for holiday sequences, where you have visited a number of different places from a central point. Sort out your slides according to locality first. Stack them in their approximate geographical positions (on the map, if you like), with any 'continuity' slides in between, and any titles on top of the piles. You should then be able to select a fairly sensible sequence of locations. It would be logical, for example, to begin with your central location and to work outwards, if possible keeping the most exciting scenes towards the end.

Within your framework, always try to move from the general to the particular, as suggested in an earlier chapter. Set the scene, then move in for the close-ups. For instance, let us suppose you had a holiday in Ibiza, and one of your subsidiary themes is the old town of Ibiza and its cathedral. You could set the scene with a shot from the harbour of the old city, the cathedral and walls towering over the old houses. The next scene would be the gate in the city wall, then the cathedral from below. You could then put in a shot from the old ramparts of the harbour, to tie in with your first shot; then the interior of the cathedral, a close-up of some of its detail, and perhaps one of its valuable relics. If the theme was to be, say, the fruit market, you could start with a view of the whole market, then a single stall, and finally a close-up of the fruit itself, or of the vendor holding out a particularly fine melon.

Nearer home, you might be presenting a slide show of flowers from a greenhouse. You would start with the whole greenhouse, then a group of plants, then one plant alone. As you show each plant you begin with the whole plant, then the flower, then perhaps a close-up of the flower. In this case the approach also helps your audience to get a better grasp of the scale of the pictures. Without the scene-setting, a slide of a close-up of a tiny flower enlarged to a metre or more across can be almost meaningless.

Try to arrange your slides so that, even without any commentary from you at all, the sequence still makes sense. This does not mean

putting explanatory titles before every group of slides, like some silent movie. The main purpose is to avoid your show appearing to jump from one subject to another without any sort of continuity or lead-in, so that you have to do an excessive amount of talking in between slides. Or, worse, you have to introduce a new subject while the old one is still on the screen. You do not want to be talking about a visit to a bodega while your friends are still looking at the interior of the cathedral.

There are several ways of achieving smooth continuity. Perhaps the simplest, and certainly one of the most effective, is a 'travelling on' shot. One such might be a shot taken through the windscreen of a coach, showing the road ahead and the silhouette of the driver, followed perhaps by another of the entrance to the town, with its name prominently displayed on a sign, or a coat-of-arms. Another good continuity shot is a slide of a sketch map, or an actual map with a 'you are here' indicator. If you enjoy graphics work, you can show a little hand-drawn cartoon, say, of your caravan or car, with a road sign, or of yourself with rucksack, depending on the way you choose to travel.

A simple improvised method of going from one theme to another, where you have no continuity and have to rely on your own linking commentary, is to use a completely plain slide. If you ever have one or two exposures left over and nothing to photograph, make some of these; they can be very useful. Simply photograph a plain sheet of pastel-coloured background paper or card with about two stops underexposure, using a fairly large aperture and the focus set on infinity to ensure no dark specks are in focus.

Plain slides may not be an ideal form of continuity, as they contain no information, and thus force you to do the introduction verbally, but they have other uses. They force people to concentrate on what you are saying, simply because there is momentarily nothing to look at; so if you have something important to say, a completely blank slide can actually help to emphasize it. You can also put such slides in at points where you feel there is going to be a discussion, and there is no particular reason for leaving the previous slide in. A slide should not outstay its welcome; and in any case it does your transparency no good to be left slowly cooking in the projector gate while you are discussing something more or less irrelevant.

Linking or continuity shots lead your slide show smoothly from one subejct to the next, so that you need not start talking about the new subject while the previous slide is still showing. You can use shots of the road, town boundary signs, hand-drawn or actual maps, cartoon figures or even a plain slide.

If it turns out that there is no discussion after all, just pass on to the next slide. If you are using a single-slide rather than a magazine projector, you can keep a plain slide ready to put in as necessary.

There is no particular insistence on having the slide absolutely plain, of course. You can equally well use textured material such as velvet, or slightly out-of-focus sacking or canvas.

Plain slides are also useful for separating totally unconnected sequences, or at the end of a magazine, to avoid the sudden glare of a blank screen.

Finally, never underestimate the effect of a little humour. If you think of something amusing to say, then say it. If there is something humorous connected with one of your pictures, make a note of it: there is nothing more infuriating than to have forgotten to tell a good story at the appropriate point, especially as you are not likely to have another opportunity. Sometimes the picture itself may have an amusing point to make. But it may not amuse everyone. *You* may think a slide of your children making faces absolutely hilarious, but do not expect it to convulse your friends. When in doubt, play safe, and leave it out.

Projector types

Although you still find single-slide projectors in schools and colleges, where they also double as filmstrip projectors, almost all amateur projectors nowadays use magazines. Unfortunately, there is little standardization in magazine design. Although a few makes of magazine will fit more than one type of projector, many do not. There are three basic configurations of magazine: straight, vertical rotary and horizontal rotary.

The straight magazine usually holds 36, 40 or 50 slides. It is perfectly satisfactory for home showing, of course. However, for exhibitions, where the projector is in continuous operation with a time-switch, only the rotary type is suitable. The main advantage of the straight magazine is that it is cheaper and takes up less room than the rotary type.

Many modern projectors are designed to take either straight or rotary magazines. The latter are usually operated vertically, and fit in the same recess. The main advantage of the rotary magazine is

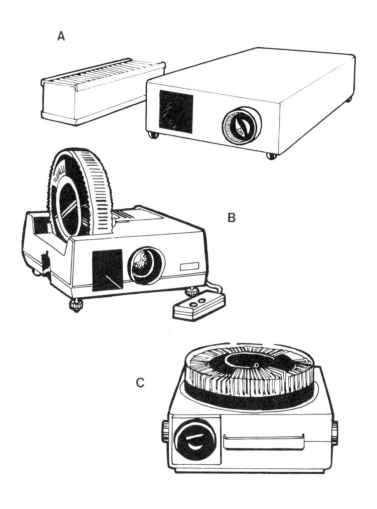

Types of magazine projector. A, Straight magazines only. B, Vertical rotary magazine. This type of projector will usually also take straight magazines. C, Horizontal rotary magazine, carousel or Ektagraphic type projector.

that it holds more slides than the straight type, usually 80 to 100. Some magazines are available for 120 slides, but with these it is not always possible to fit the thicker kind of slide mount. Rotary magazines are always used in automatic projection setups at exhibitions, because when the slides have gone round once the series simply starts again from the beginning, without any need to reload. A few of the cheapest slide projectors have a hand-operated slide-changing mechanism; but the great majority are operated by a push switch on the projector body. Most also have a remote control, so that you do not have to stand by the projector all the time.

The third type of magazine is also rotary, but sits flat on top of the projector. The slide is positioned above the film gate, and drops into it by gravity. Unlike the vertically oriented magazine, where the slide is pushed sideways into the gate, this type requires a metal base to prevent the slides from falling out when you fit the magazine. The base has a slot in it, and remains stationary while the magazine is advanced, so that each slide in turn comes over the slot and can drop into the gate. As you might expect, this extra complexity means that such magazines are more expensive than simple moulded ones; but they do have the advantage of quick changing (less than 1 second) and freedom from jamming and the slides never fall out of the magazine. This system is standard on the Kodak carousel series of projectors.

Choosing a projector

If you are planning to buy a projector for your slides, the first question you are likely to ask is — How much should I pay for it? This is a bit like buying an enlarger, in that it rather depends on how much you paid for your camera. In both cases the optical system of the cheapest equipment may be so poor that your results are no better than you would have got from a very cheap camera. There are certain minimum requirements: for example, you *do* want a sharp, bright and evenly illuminated picture, and you do *not* want the illumination system to be so hot that it damages your slides. Once you have paid for the basic necessities of a projector, anything more you pay will be reflected in improvements in optical quality and mechanical reliability, up to a certain

point. Once you reach this point you find that paying 50% more for your projector gives you only about 5% improvement in quality. If your present camera is a comparatively cheap one, you should still get the best projector you can afford: it is in the projection that most image quality gets lost. In any case, you do not want to upgrade your projector when you upgrade your camera. If you own an expensive high-quality camera, you may expect to pay 60% to 75% of its cost for a projector of comparable optical quality.

However much you spend on your projector, there are some basic essentials to look for. And you will not always find all of them, even in fairly expensive equipment. Of course, by far the most important thing is the quality of the optics. You probably cannot check this in the shop, though if you go to a reputable dealer, he will be able to advise you; if the projector does prove unsatisfactory he will certainly take it back and change it. The main points to look for when buying a projector are:

1. No play in lens mount or slide gate.
2. Good heat-absorbing glass at least 3 mm thick between lamp and gate.
3. Lamp and reflector adjustable.

You also need to check that the lamp cooling system is adequate and not too noisy. Most projectors nowadays use quartz-halogen lamps which have a compact filament, a long working life and a brighter, whiter beam than the old-type lamps with large glass envelopes. They will still burn out quickly if they are not adequately cooled, and they are expensive to replace.

It is worth paying more for a projector with remote control and focusing. Most remote slide changers can go either forwards or backwards, and the remote focus control makes accurate focusing very easy. Once you have set up the focus roughly you can go right up to the screen and get it absolutely accurate. You can also make quick adjustments to the focus if one of your slides is in a different type of mount from the others. Remote control is essential if you anticipate coupling a tape-cassette player to the projector for slide-sound sequences (see pp. 203-4), or an automatic timer to change slides at predetermined intervals.

Once you have paid for the essentials in a projector, you are likely to find that any extra you pay goes as much into extra gadgetry

as into better optics and mechanical quality. Such additions may or may not be worth having, depending on the use you put the projector to. Some projectors have the option of several lenses of different focal lengths, and some have 'zoom' lenses as options. If you have to set up the projector in a variety of places, it is a great convenience to be able to fill the screen from either a short or a long distance, but do not buy a zoom lens unless you need it. Although zoom lenses for projection cost very much less than their counterparts for cameras, they produce an image which is markedly inferior to that given by a conventional lens.

Some of the top-price projectors have built-in interval timers, and others have a sensor which adjusts the focus automatically for slides of different thicknesses. There are even projectors with twin optical systems and fade and dissolve facilities built in. Most of these very sophisticated designs hardly justify their very high cost, however; and every extra addition to the complexity of a projector is just one other thing that can go wrong.

Checking projector optics

A projector has two separate optical systems. The objective or imaging lens is the one that actually produces the image on your screen; and, of course, the better it is, the better your pictures will be. But the other one, the illumination system, is just as important. In fact, you cannot even begin to check the quality of your imaging lens until you have the condenser system correctly aligned. This is how you go about aligning the condenser system of a projector. You need a piece of thick cardboard 50 x 50 mm, as thick as an average slide, with a small hole, about 3.5 mm diameter, punched accurately in the centre. Switch on the projector lamp, feed the card into the slide gate, and focus the small disc on a distant wall. Now hold a piece of tracing paper over the front of the imaging lens, or fit the lens cap if it is white polythene. You will see two images of the lamp filament on it, near the centre of the lens. If the lamp filament is a 'W' shape, it should be interlaced with its inverted image; if it is a flat coil, one image should be directly above the other so that the two images form a square block of light. If the alignment of the components is correct, the

Aligning the optics of a projector system. A, Optical components: 1, spherical reflector; 2, lamp at centre of curvature of reflector; 3, heat-absorbing glass; 4, condenser lenses; 5, slide; 6, imaging lens; 7, screen; 8, test slide of thick card with hole in centre. B, Image of compact filament lamp seen on white polythene lens cap when test slide is in position. C, Image of coiled-coil filament (both correctly aligned). D, Reflector too high. E, Reflector too low. F, Lamp horizontally displaced. G, System set for lens of different focal length. H, Inadequate coverage of 40 x 40 mm format. J, Test slide for imaging lens: a lith negative of this pattern is best. This negative can be used for identification of all normal lens faults.

images should both be quite sharp, with approximately the same intensity, and precisely centred in the lens.

If both images are unsharp, the condenser is incorrectly set for the lens you are using. Some of the better quality projectors have different settings for the condenser system for different focal lenses; and some even have different condenser systems. Check with the instruction booklet.

If only one image is sharp, the distance between the lamp and reflector is incorrect, and needs adjusting until both images are equally sharp. If both images are sharp but not in the centre of the lens, the lamp and reflector are off-axis, and need moving until the images are properly centred. If the filament images do not overlap accurately, the lamp and reflector are out of alignment, and need moving relative to one another until alignment is correct.

Now remove the tracing paper or lens cap, and the cardboard square from the gate, and examine the illumination on the wall for evenness. If one of the edges of the patch of light is discoloured (yellowish or bluish), you have centred the illumination incorrectly, and you should do it again. If the disc of light is bluish or yellowish evenly all round the edges, the lamp and reflector are at the wrong distance from the condenser lens. Try moving them a few millimetres along the axis, and see if the fringe disappears. If it does, go back to your card, and check that the remaining alignments are still correct.

When the illumination is as uniform as you can get it, put an empty slide mount into the projector and use an exposure meter to check the illumination all over the area. The variation between the centre and the corners should not be more than about 15%, or about a quarter of a stop. Be sure to use a mask size for the largest transparencies you intend to show. Some 35 mm projectors simply will not cover a 40 x 40 mm format; and if you intend to use this or a 28 x 40 mm size, make sure the illumination goes right to the corners. If it does not, you will either have to get the projector changed for a different model, or resign yourself to having your compositions marred by having their corners cut off.

Now you need to test the sharpness of the optical image. You can buy test transparencies for the purpose, or you can make your own. The most generally useful is a lith negative of a grid of fine lines.

If you want to go about it scientifically, and try to identify the particular lens aberrations that are present, you will have to use one of the lens test charts made for the purpose, and read up the method from the leaflet that goes with the chart. On the other hand, you can identify most optical faults from a simple design of lines radial from the centre of the pattern, with concentric circles and rectangles centred on the same spot. The exact analysis is beyond the scope of this book; but the faults you should look for (and hope not to find!) are as follows:

1. Any unsharpness that gets worse from the centre towards the edges.
2. Inability to bring edges and centre into focus at the same time.
3. Coloured edges to outermost circles.
4. Curved sides to outermost rectangles.
5. Inability to bring outer parts of radial lines and circles into focus at the same time.

The first three of these are the most serious; should you find these on any but the very cheapest projectors, you have strong grounds for complaint.

As a final test, put a 50 x 50 mm piece of dark grey cardboard into the projector gate, switch on the projector, and leave it for ten minutes. When you take the card out, it should be no more than slightly warm.

Types of screen

A white wall in the right place makes an ideal screen in a well-blacked-out room. It is as large as you like, vertical, flat, and no one can trip over it or knock it over. Comparatively few homes do have a white wall in exactly the right place, so it is fairly likely that you will need some sort of projection screen.

If you can find the space to store it, and can get your room fairly dark, the best screen to use is simply a large piece of hardboard painted white and hung at an appropriate height from a picture rail or pelmet. Paint the rough side of the material, using a brilliant-white emulsion paint. Some liquid paints produce a still better white if you add a tablespoonful per half-litre of a blue-white detergent washing powder made into a paste with water. This

should not be tried with non-drip paint, you will destroy its non-drip properties.

The big advantage of a matt screen is that whatever angle you view it from, the image is equally bright. The disadvantage is that a lot of light gets wasted above and below the screen, where there is nobody watching, as well as right round at the sides. Some of this light can come back from the walls and ceiling, too, degrading the image tones. What would be preferable would be to have a screen reflecting light mainly in a horizontal direction, and out to only about 30° each side from the centre. Such a screen should give an image up to ten times brighter than a matt screen, and would be much less sensitive to stray light. Stray light falling on a matt screen from any direction tends to degrade the image, causing loss of contrast, particularly in the shadows. On the other hand, stray light falling on a directional screen is not reflected in the same way, and has less effect on the image.

The simplest kind of directional screen is an aluminized surface. Aerosol aluminium paint over white emulsion paint on hardboard is quite effective, giving about double the brightness of a matt white screen, and less degradation from stray light. However, some people find its 'coldness' unpleasant; and some makes of paint, especially if applied too thickly, have reflective qualities that cause 'hot spots' from direct reflection of the projector beam.

If you want to try making your own aluminized screen, do it with the prepared surface flat on the ground. Use aerosol paint of the kind sold for touching-up car bodies, and work about two feet away from the board. Using wide sweeps, start spraying before you get to the board, and finish after you leave it. Do not worry about thin patches. After ten minutes, give a second coat at right angles to the first, then after another ten minutes, a third coat along the direction of the first. This should give you a perfectly uniform surface, with no 'puddles' to cause hot spots.

Commercially available matt screens are usually made with a folding frame, with the screen rolling up into a long box intended to stand on a table; or they may pull up from a cylindrical container fixed to a metal stand similar to a studio floodlamp stand. One snag with roll-away types of screen is that the screen material eventually stretches, resulting in an uneven surface. Also, the tripod stands

are often unstable, so that the screen itself easily falls over if you accidentally kick it. Even a good draught can sometimes blow it down. However, it is portable, and that can be a big advantage. Most commercial matt screens are made from textured material with a slightly glossy surface, so that they reflect rather more light than emulsion paint; but they are susceptible to the effects of stray light, so unless you have a good black-out you still need to wait until after dark before you can show your slides. This does not matter too much in the winter, but it can be a nuisance in the summer.

Lenticular screens avoid the stray-light problem to some extent. They carry a pattern of fine vertical embossed plastic cylindrical lenses, and reflect light fairly uniformly over a horizontal angle of about 30° each side. They give roughly double the brightness of a matt screen; and stray light from the sides has little effect on the image quality. You can get a perfectly good picture with a lenticular screen on a summer evening with the curtains drawn, and enough stray light to read by.

A 'beaded' screen also gives a highly directional image. Tiny glass beads cover the screen and act like cat's-eyes, reflecting the light almost straight back along the projector axis. This kind of screen gives an image about four times as bright as a matt screen; but the angle of good visibility is restricted to about 20° either side of the projector. Most screens sold as 'daylight' are beaded screens; and you can obtain special paint containing glass beads, for coating your own screens, from specialist shops.

There are two other types of screen, used mainly for exhibitions and other places with a large or unpredictable amount of stray light. One is the Kodak 'Ektalite' screen, which uses a curved sheet of specially treated material. The other is the back or rear-projection screen. This is a translucent screen, usually operated via a combination of mirrors, with the projector beam coming from behind the screen. These are discussed in the chapter on exhibitions.

Setting up

The first thing to do is to ensure that the stray light around is insufficient to affect the tone quality of your pictures. Of course,

there is not much point in setting up your screen in the optimum place at ten in the morning for a show at six in the evening, by which time the sun may be shining directly at your screen. So do it a day or two beforehand, at the appropriate time of day. Your exposure meter will be a great help in the exercise. First, black out the room as best you can. Then take the meter round the room, preferably with an incident-light attachment on it, and pointing to where the projector would have to be for that position. If you do not have an incident-light attachment, hold a piece of white card where you would be putting the screen, and take readings on that. Choose a position where the ambient light is as low as possible, but where the screen position would still allow a reasonable seating arrangement. Set up the screen and projector, put an empty slide mount in the projector gate, and compare the (direct) meter readings with the projector lamp on and with it off. If the ratio of the two readings is about eight to one (three stops) your picture will be slightly degraded unless you are using a reflective screen; but if you can get it as large as thirty to one (five stops) you need have no worries with any type of screen. The best screen position in a poorly blacked out room is with the stray light coming from behind or to the side rather than from in front of the screen. Only the projector light should come from there!

Once you have decided where the screen needs to go, it is worth taking a little trouble to get the projector set up correctly. The optimum distance for viewing projected slides is about three or four times the width of the screen. Thus, if your screen is about 1 x 1 metre (39 x 39 inches), the average distance of the seating needs to be about three to four metres (10 to 13 feet) from the screen. With most projector lenses this will also be the approximate distance to the projector.

Most people seem to prefer a projection screen to be centred a little higher than a television screen; and this may be helpful if you have more than about six friends watching, as those in the rear seats will be able to see better. As a general rule, for home viewing, the centre of the screen should be about 1.4 metres (4½ feet) from the floor. This is within the range of adjustments for a tripod stand; and if you have a table screen, the height of a coffee table is about right. Check that the screen is vertical, and that it will not

Angle of good illumination for various screen types. The heavy lines indicate the angle of negligible fall-off in illumination, the pecked lines 50% fall-off. The arrows indicate the minimum angle from which stray light has negligible effect. A, Matt screen. B, Aluminized. C, Lenticular. D, Beaded. The figures are only approximate, as screens vary from one manufacturer to another.

be blown over if someone opens the door suddenly, or knocked over by a clumsy gesture.

Now set up the projector. You may be surprised to find how high it has to be in order to give a picture completely free from 'keystone' distortion (diverging verticals). Get a good firm stand — a kitchen stepladder with a platform preferably not less than 1.3 metres (4 feet) high is ideal. If your stand is less than this height you should raise the level with a wooden box. Never use cushions or anything soft, as you may obstruct the cooling fan air intake (which is often on the underside of the projector body), with dire results for the lamp, the slide and any nylon gearing inside the projector.

Switch on the projector, and adjust its distance from the screen until the picture just fills it. If the projector is still not quite high enough, you may need to tilt it up slightly using the height adjustment, but do not overdo this or you will get keystoning, and you may not be able to get the top and bottom of the picture in focus at the same time.

As suggested above, a good viewing distance is from about 3 to 4 screen-widths away. Also, the angle of viewing should not exceed 30° out from the projector, or the view will be unacceptably foreshortened. Put the seating along a curve with its centre at the screen. The projector should be just behind the row of seats, or between the rows if you need two rows. If any of your slides are in a vertical format, make sure they fit on the screen, and that nobody's head will get in the way. If your projector has remote control, sit at the edge yourself, so that you can stand up to attend to anything without interrupting the projector beam.

Safety precautions

Slide shows can be a bad time for household accidents. People cannot see round the room very well, and their attention is diverted from the things that are lying around, so that they stumble over coffee tables, spill drinks and knock ashtrays onto the carpet. A little commonsense will help you to reduce the possibility of this kind of mishap. Use heavy-based tumblers for drinks (or mugs for coffee or tea) and place them and any ashtrays on metal trays.

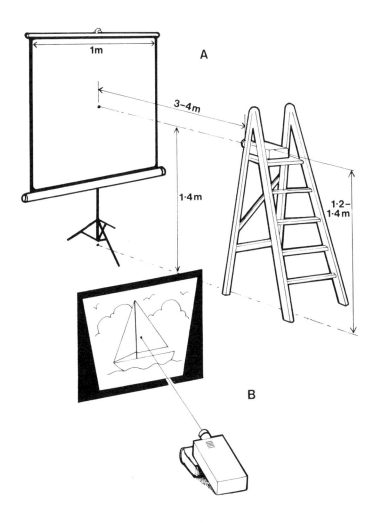

Setting up the projector and screen. A, Set the screen high enough for every-one to see (not less than 1.4 metres to the centre of the screen from the floor) and the projector not less than 20 cm lower. B, Tilting the projector distorts the picture and you may not be able to get the top and bottom in focus at the same time. At worst the slides may jam in the gate.

Try to avoid the need for anyone but yourself to get up during the show; but if they must, stop the show and put the light on. Tie the power cable to the foot of the projector stand, so that if anyone trips over it they will not pull the projector over. Better still, put a pull-out plug and socket into the cable about halfway along its length. Make sure that nobody can get tangled up in your remote-control cable.

One particular menace is the person who jumps to his feet and rushes over to the screen in order to point out something during a discussion. If he manages not to knock over the screen he is still likely to dislodge some ornament as he stumbles back to his seat. A long heavy coffee table in front of the seats will discourage him to some extent, especially if you provide a pointer for him to use. You can make an excellent pointer from a narrow strip of pale-coloured acrylic sheet about 60 cm (24 inches) long, which you can get from any shopfitter. Show your audience how to use it, by holding it in the projector beam so that its shadow does the indicating: otherwise someone will probably poke it through the screen. Then leave the pointer on the coffee table. You can find instructions for making a rather more sophisticated version of this pointer on pp. 200-1).

Always keep a spare projector bulb handy. If one blows during the show, leave the fan running, put the lights on, and wait for at least five minutes before you disconnect (not just switch off) the projector and attempt to change the bulb. Even then it may be very hot, and you will probably need to protect your fingers with a handkerchief. If the bulb is the quartz-halogen type, you must avoid touching the quartz envelope with your fingers when installing it. Use the polythene or card wrapper provided. This is very important, as the sweat from your fingers can damage the surface of the quartz, and the lamp may shatter without warning. If you do accidentally touch the bulb with your fingers, wipe it carefully with a paper tissue before you switch on. Make sure the new bulb is fully home, otherwise the condenser optics will be out of alignment. You should in any case recheck the alignment at the first opportunity.

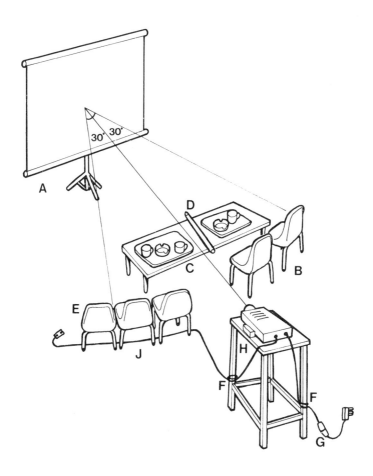

Arranging your show for good vision and safety. A, Ensure screen is stable and unlikely to be knocked over. B, Best viewing position is within an angle of $30°$ from the projector axis and 3 to 4 screen widths away. C, Heavy coffee table with metal trays. Use heavy ashtrays and broad-based tumblers for drinks. D, Provide a pointer for indicating details. E, Your seat should be at the edge, so that you can get up without disturbing anyone. F, Tie cables to foot of projector stand. G, Pull-out plug and socket in mains cable. H, Spare bulb. J, Run remote-control cable under rear of seats.

Your commentary

Unless your friends are rather peculiar people, they are not going to expect a full-blown lecture to go with the slides. On the other hand, they certainly will expect you to give them the story behind the slides; and in a coherent form, not just a selection of rambling anecdotes. So make a good set of notes, your friends will appreciate the trouble you have taken. While you are making the notes, bear in mind the particular interests of your friends, and concentrate on these rather than on your own. Unless they are fanatical photographers they will soon get bored with details of *f* numbers, polarizing filters or fill-in flash. If they want to know exposure details they will ask for them. They will be much more interested to hear the the hotel in the background is the same one that was taken over by rebels last week, or that the unobtrusive character in the doorway holding a camera is Lord Snowdon.

Try to be complete, but brief. No slide should ever need more than sixty seconds of commentary. Try to keep to an average of something like twenty seconds. Your friends will probably want to say something, too, and there are more of them than there are of you. So give them the chance, but try to head off red herrings.

There are one or two things to watch in your commentary. Make sure your notes really are notes — if they are in narrative form there is a tendency to read from them, and you will sound formal and prosy. Just take a look at the notes before you put a slide up, and talk naturally. However, speaking 'off the cuff' carries the danger of getting caught up in your own favourite catchwords or phrases. Listen to yourself; and if you realize you have used a word like 'splendid' no fewer than five times in as many minutes, avoid using it again.

Making notes will save you from one cardinal error in slide presentation, namely taking your cues from the slides themselves. The most tedious kind of commentary is the sort where the presenter puts up a slide, peers at it, then says 'This is a picture of . . .' and then goes on to describe what his audience can see perfectly well for themselves. Let your picture and your commentary complement one another. Do not say, for instance, 'This is one of the best examples of apses of the Decorated period . . .' etc., as though you were an official guide. Your friends

are either interested in Gothic architecture or not. If they are, they will probably wish to comment themselves; if not, they will not want to know. Say 'There's an interesting story about this part of the church . . .' and tell it. If there is no story, just tell them what and where it is, and let them do the talking. One of them will probably be delighted to have the opportunity to tell you that it is one of the best examples, etc. I was once showing some slides of Bavaria to some acquaintances, without having checked their backgrounds very thoroughly. Worried because my pictures of the interior of the church at Wies did not seem to be making much impression on one of them, I continued eulogizing about the rococo splendour of the interior, and in particular of the beautiful organ. Eventually one of my guests said, wearily, 'I know. I used to play that organ'.

Summary of common errors

1. Too much on a single theme. Prune your slides down to the smallest number that will put the theme across.
2. Inclusion of substandard material. Do not include unsharp, incorrectly exposed or badly composed shots unless they are vital to the story; and, in any case, try to replace them as soon as you can with better quality material.
3. Slides up too long. Nobody wants to look at a alide, however beautiful, for more than a minute. Twenty seconds should be long enough for most.
4. Talking too much. Again, if you talk about any slide for more than a minute, you are in danger of becoming a bore.
5. Variations in colour quality. Successive slides taken under widely different lighting conditions, or on different makes of film, may have marked colour differences, and this will spoil the visual continuity.
6. Variation in mounts. If you mix a number of different types of mount you will have to keep refocusing the projector, which is distracting to your audience and forfeits much of the impact of your pictures.
7. Poor (or no) masking. There are few subjects that fit a particular format exactly. In general, at least three slides out of four can have their composition improved by masking. Masks should

be clean-cut and accurate: ragged edges and obtuse angles display your carelessness for everyone to see.

8. Frequent changes of picture orientation. Avoid switching backwards and forwards between horizontal and vertical format, it is very unsettling. If you have to show both, try to keep each format in groups of two or more.

9. Slides popping out of focus. Some card-mounted slides are particularly prone to this trouble. Mount your slides between glasses, and you will not only cure this problem but also protect your transparencies from damage by careless handling.

10. Newton's rings. These only occur with glass mounts. Make sure your transparencies are thoroughly dry before mounting, and use either mounts with metal masks which separate the film surface from the glass, or the traditional mask-and-coverglass method.

11. Slide incorrectly oriented. This should not happen if you spot your slides correctly (bottom left corner of mount) and insert them in the magazine with the spot at the top right, as seen from the rear of the projector.

12. Dirt and fingermarks on slides. Always check that your slides are clean and free from dust when you load them. Keep your fingers off glass surfaces, and under no circumstances touch the emulsion side of a transparency.

13. Uneven illumination of the screen. Check the alignment of the condenser optics every time you use the projector.

14. Vertical-format picture partially off screen. Always check both orientations before the show.

15. Keystone distortion of vertical or horizontal lines. The line joining the centre of the screen to the projector lens should be as nearly perpendicular to the screen as you can get it. If nothing you do can raise the projector high enough, use the height adjustment on the projector body and tilt the screen slightly forward.

16. Projector tilted too far. If the raising mechanism is fully extended and the picture is still too low, raise the projector or lower the screen. Never put books under the front of the projector: you may cause the slides to jam in the gate.

17. Insufficient room ventilation. If your audience falls asleep it

may not be from boredom, it may be from lack of oxygen. A room with all the curtains drawn and the windows closed quickly gets stuffy. If you cannot open a window without the curtains blowing about, try opening a door instead.

Music and sound effects

If you are a little more ambitious, you might like to try the effect of introducing some music or sound effects into your show. A little introductory music is a good way of setting the mood. Do not be embarrassed about introducing your show like this, and spoil the effect by excuses or weak jokes: do it boldly, and you will be surprised how effective it is. There will be no raised eyebrows. Your friends will appreciate the trouble you have taken for their benefit. If you are showing pictures of your holiday in foreign parts, and you have brought back a record or a tape cassette of local music, now is the time to use it.

You may also feel that a little background music would help during the actual show. This depends very much on the tastes of your friends. Some people find background music relaxing, others find it irritating. You may like to introduce sound effects, too. There are records available with every conceivable kind of sound effect, from the song of a goldcrest to the roar of a Saturn rocket. Most of these records do not require permission to use for amateur performances, even if you borrow them from a library; but it is, strictly speaking, illegal to copy an ordinary record onto tape. Of course, if you actually own the record there is no reason why you should not play it to friends; and you would not be prosecuted for putting some of your own records onto tape for convenience at your own private slide show, as long as it was in your own house, and was erased as soon as you had finished with it.

It is certainly easier to use tape rather than records, especially if you are sitting in near-total darkness!

Slide-Sound Sequences

It is only a small step from a slide show with commentary and occasional musical background to a fully integrated slide-sound sequence. This particular medium is one of the most recent to appear on the aesthetic scene. It was originally developed as a method of instruction whereby a single student or group of students could listen, watch and learn about some subject such as statistical analysis, fire prevention or first aid in motor accidents. Enthusiastic amateur photographers quickly realized that they could use the medium in a creative and entertaining way. The slide-sound sequence depends on a combination of visual and aural effects produced with slides and magnetic tape. The tape can have pulses put on a channel not used for sound, and these can be used to provide signals which change the slide at the correct point. Interest in the medium is growing fast, and with the coming of fade-and-dissolve projection and even multiple screens some quite exceptionally exciting creative work is appearing, much of it aspiring towards a kind of one-man Son-et-Lumière. Such complexity, however, is for experts only. Here the aim is more modest.

Planning a suitable sequence

There are several types of theme which lend themselves well to slide-sound treatment. The relative contributions of vision and sound vary a good deal. At one extreme there is the sort of theme where the pictures are purely incidental to the sound. You might, for example, supply pictures to complement a recording of evocative music such as Tchaikovsky's *Nutcracker Suite* (remember Disney's *Fantasia*?). For this you might choose a great variety of pictures — perhaps mainly based on woodland scenes in various moods — that would match the 'feel' of the music, though not necessarily bearing any direct relationship to it.

A little more closely linked might be pictures as a direct illustration of the music, for example Respighi's *Fountains of Rome*. Here your choice of material is bound to be more limited. In fact, you will almost certainly have to plan your photography to match the mood of the music with appropriate angles (and, of course, the right fountains). This type of production also lends itself well to poetry readings, especially to pastoral poetry such as that by the Lakeland poets.

At the opposite extreme to illustrated music or poetry themes is the sequence where the pictures tell the whole story, and the music simply provides an appropriate background. With this type of sequence it is important to change your sound backgrounds smoothly. If you have the facility on your tape recorder, cross-fading is best. Sometimes a sudden change may be effective, for example, where you might be emphasizing the contrasts in London life, to switch suddenly from Pall Mall (with Elgar) to Carnaby Street (with hard rock). But too much of this can be irritating. In this type of presentation the music should always be subservient to the pictorial content.

These, then, are the opposite poles of slide-sound: a wholly visual theme supported by sound, and a wholly sonic theme illuminated with pictorial matter. In between these extremes are themes where the visual and sound elements are fully integrated; and these are perhaps the most satisfactory. Possibly the simplest kind of sequence to compose is the one that tells a story. This can be a factual story. Some of the themes we mentioned earlier, such as the life of a birch tree or the building of a water-garden, lend themselves well to the slide-sound treatment. You have plenty of scope for putting music, snatches of conversation, poetry and natural sounds, as well as your own narrative. For such subjects the medium is ideal, much better than movies, because the subject matter is essentially static; and, of course, the picture quality is incomparably better. There is always a tendency in filming to introduce some artificial kind of movement into static subjects, by panning and zooming; and this often succeeds in being merely distracting. That is not to say that you cannot convey the impression of action with slides. A quick succession of stills, projected as fast as possible, can give a vivid impression of action: in fact this trick

has often been employed in the cinema itself, and in television presentations.

Dual projection

Ideally, a slide-sound sequence should use two projectors, cross-fading between them so as to avoid a gap between slides. Professional apparatus can have all sorts of complicated facilities such as slow or rapid fades, wipes, snap changes and superimposition; but you can do well enough it you can simply borrow a second projector (preferably of the same kind as yours) from a friend. There are a number of visual mixers on the market, the cost varying with the complexity, and several designs of dual-optics projector. All these items are very expensive, and certainly not worthwhile unless you are going to take the medium very seriously indeed. You can also obtain (much more cheaply) iris diaphragms which fit over the projector lens, so that you can produce fades and dissolves manually.

Once you can do this you will find the potential of slide-sound increases vastly, as you can change rapidly or slowly from one slide to the next, move forward or back, alternate two slides, and superimpose titles. You can move gradually from far distance to close-up through a series of dissolves; cross-fade from daylight to sunset, dusk and night on the same scene; or show a flower opening. If you can use a motor-driven camera, you can produce splendid action sequences of show-jumping, diving or gymnastics though to do really quick changes takes a fair amount of skill and practice, as you need someone to operate the slide changers while you look after the cross-fading. The possibilities in dual projection are endless, and once you have tried them you will probably never be satisfied with single projection again! If you want to know more about dual projection, and about slide-sound sequences in general, consult *The Focalguide to Slide-tape*, by Brian Duncalf (Focal Press, 1978), or *Slide Tape and Dual Projection*, by R. Beaumont-Craggs (Focal Press, 1975).

Once you have tried your hand at a few sequences you may like to try making up your own stories to amuse your children (and your friends' children, too). Get them to pose for your illustrations.

Avoid overdoing the dressing up, though. If your story is about kings and queens, or wicked fairies and frogs, you cannot hope to be ultra-realistic. Make your costumes symbolic rather than realistic. A paper crown and a purple bed-cover are quite enough to represent royalty! You can use all the techniques already discussed, keeping to the principle of general-to-particular, and long shot to medium close-up.

Music and sound effects

So far we have confined ourselves to the visual element; and this is not far removed from the slide sequences discussed earlier. But now we have to look at the part that sound plays in the presentation, and, more particularly, how to make your sound tape. Perhaps the best way to start on slide-sound is to take a sequence you already have, and add a suitable sound background. Although the very best slide-sound presentations are always designed with both the visual and aural elements taken into account at each point, it is surprising how much you can do with an existing visual sequence.

You will certainly want to mix and cross-fade different sounds. For example, to accompany a sequence on an old railway you would want train sound effects, animal and bird sounds, commentary and appropriate music. There are plenty of train pieces available, such as Honegger's *Pacific 231* or Duke Ellington's *Daybreak Express*. You will want cross-fades from sound effects to music and back again, and probably commentary over both.

It is best to use an open-reel stereo tape recorder. It need not be the ultimate in hi-fi; but you will find editing much easier if it will operate at 190 mm (7½ inches) per second. You also need a microphone (quite a cheap one will do), a tape-splicing bench and a roll of splicing tape for editing. How to edit tape is explained later. The reason for choosing an open-reel (rather than a cassette) recorder is that cassette is totally enclosed and is therefore extremely difficult to edit, and its slow speed, 47.5 (1⅞ inches) per second, makes accuracy in locating a particular sound very difficult. However, if you possess a cassette

recorder and can borrow or hire a suitable open-reel machine, you can transfer the whole sound programme to a cassette when it is finished, and use your own machine for the presentation.

Although it is very easy to record music and sound effects by putting a microphone in front of a loudspeaker, the quality is often poor. Most record player amplifiers have an output labelled 'tape'; and a connecting cable from this to the 'aux' input of your tape recorder will transfer the sound from disc without distorting it. some systems have a 5-pin DIN socket labelled 'tape monitor'; this incorporates connections for both record and replay.

Microphone technique

Producing really first-class sound recordings is a skilled business, and needs a complete book on its own. However, by following a few straightforward instructions you can produce good sound without a lot of costly equipment or a specially designed acoustic room.

First, set up the tape recorder, preferably on a carpeted floor, or else on a fairly thick pad on a table. Make sure the pad does not block any ventilation inlets. Set up the microphone on a cushion on a separate table. The purpose of the pad and cushion is to prevent vibration being transferred from the tape recorder to the microphone ('acoustic feedback') and causing a background rumble. The cushion under the microphone also helps to minimize reflection of sound from the table, which interferes with the directly transmitted sound and causes a hollow, unnatural sound. Now switch on the recorder, and talk in an ordinary voice to the microphone from a distance of about 30 cm (12 inches). Check the input level meter as you do this. The needle should hover about the −3 dB mark while you are talking, and should flick up to 0 dB or a little higher, but it must not *stay* in the red + region.

Rewind and replay your test, listening carefully to the sound quality. If your voice sounds hollow, there is too much room resonance. If the effect is slight, drawing the curtains may be sufficient. Speaking a little more quietly and rather closer to the

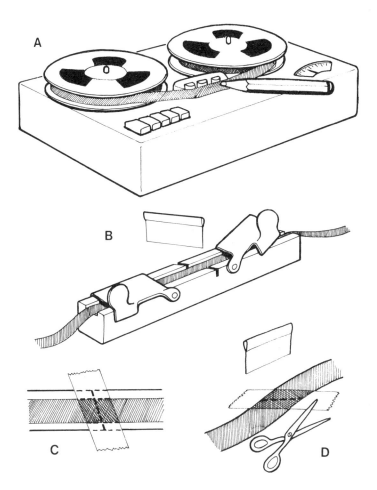

Editing tape. A, Operate pause button; rotate spools by hand until you locate start of piece to be removed. Mark this point with white or yellow wax pencil at replay head. Move to end of passage and mark similarly. Always mark at start of a sound. B, Using tape splicing bench, cut across each mark in turn with a razor blade or scalpel. Discard intervening tape. C, Cut off about 2 cm splicing tape from roll, lay across butted join, and press down. D, Remove from splicing bench, burnish with fingernail, and trim with razor blade or non-magnetic scissors. Do not under-trim.

microphone may also help. Failing this, you will have to move into a smaller room.

If, on the other hand, your voice sounds dead, there is insufficient resonance. If, in addition, consonants such as 'P', 'B', 'T', and 'D' produce a scratchy or popping sound, you are too close to the microphone. Moving farther away and speaking a little louder should do the trick.

If you plan to use several voices you must make sure the microphone you use is the type described as omnidirectional. Most of the cheaper models are of this type. Even so, all your speakers should be within about $60°$ from the axis of the microphone if the sound ambience is to be the same for all voices.

You may also want to produce special sound qualities in your voice. For example, you can simulate a vast echoing cavern by using a large room without any draperies and talking rather slowly from the opposite end of the room to the microphone, with the gain control turned well up. You can simulate a voice over the telephone by talking into a tumbler. To give the impression of whispering directly into someone's ear, you do just that — to the microphone. Turn the gain control up as necessary, and whisper sideways across the microphone grille. You can produce the effect of intimate conversation by following the same procedure, but talking very quietly instead of whispering. If you keep testing and playing back, you will eventually be able to produce any effect you want to order. This kind of skill is well worth acquiring if you want to be a storyteller.

One word of warning — never tap your finger on a microphone or blow into it to see if it is working. You may cause irreparable damage to either the microphone or your reproduction equipment. And the more expensive these things are, the more liable they are to damage from this sort of treatment.

The right kind of script

Most people, when they first attempt to write a script, write it the way they might have written an essay at school. They take a lot of trouble to get the 'grammar' right, and use expressions like 'it is' and 'to whom'. If you speak a script written in this kind of

language, it always sounds very stilted and unnatural. It takes a good deal of practice to write real 'spoken' language; but it is well worth persevering. As you write each sentence, say to yourself, 'Would I *say* it like that?' Mostly, you will find that you would actually have used many more words. When talking we tend not to use relative pronouns like 'who' and 'which' very often, but repeat the subject, as if we were starting a new sentence. We rarely use passive constructions, either, nor inversions. Consider saying 'While walking down the street John was hit by a car'. We are more likely to say something like 'D'you know, John was just walking down the street yesterday, and this car ran into him', or more formally, 'John got knocked over by a car while he was walking down the street'.

There is no short cut to writing good 'spoken' material. It *is* difficult, make no mistake about it. The best way to get the feel of it is to listen very carefully to discussions on the radio. Except for the obviously impromptu interviews, almost all of these are scripted. The late A.J. Alan, who presented so many of his tales on the radio, was a master of 'speech' writing. He wrote in every 'um' and 'er', every unfinished sentence, every stammer; and he pasted his typescript to cardboard so that it would not rustle. You may not need to go to those lengths; but it is worth a good deal of trouble to have your script sounding completely natural.

Editing speech and music

As we said earlier, you can do successful editing only with an open-reel tape recorder. It is easiest if you use your fastest speed, 190 mm (7½ inches) per second, and avoid very thin (double- or triple-play) tape. The best way to edit tape is by cutting and splicing. You can manage to edit tape, after a fashion, by using the rewind and pause controls while recording from one tape recorder to another, but it is not easy, and you nearly always finish up with odd pops and clicks from the switching, or bits of overlapping sound. When your original is on cassettes and you do not have access to an open-reel recorder you may have to do your editing this way, but it probably will not be very successful. With really good editing the seams should be undetectable.

The standard method is just to cut out the bits you do not want, and stick the pieces back together. You need a wax pencil to mark the exact points on the tape, a scalpel or single-edged razor blade, an editing block, and some splicing tape. Use the 'pause' or 'reel motors off' control on your recorder, and move the reels by hand while you listen to the sound. Mark the portions you want to cut out with the wax pencil after you have identified their exact positions by moving the tape backwards and forwards several times. Always work to the *beginning* of a sound, as this is much easier to identify than the end of one. When you have identified the exact pieces you want to cut out, use the slots on the editing block as cutting guides; then join the ends with splicing tape and trim off the surplus.

Mixing

There are three ways of mixing two different sound sources. The first, and simplest, is to use a microphone and mix the sounds manually from equipment using loudspeakers. For example, you might be composing the sequence mentioned earlier, on old steam trains. You have a commentary script, tapes of train sounds, and records of 'train' type music. You have a cued script, and as you talk you get a friend to operate a record player and a tape recorder at the appropriate moment, fading up train noises or train music or bird song, then fading it down again at your signal, just before you start your commentary once more. Provided you take a fair amount of care to set up the speakers and microphone, and to eliminate all extraneous noises, this method works quite well.

The second method is to use a mixer input. This is worth consideration only if you have a fairly bottomless purse. There are two types of mixer, called respectively passive and active. The passive type simply feeds the inputs into some kind of matching network. It can do little more than add several inputs together. The active type contains amplification circuitry. It can manage crossfades, background sounds, and combinations of a number of inputs with variable degree of loudness and sound quality. An active mixer can cost as much as a good open-reel tape recorder.

The third method is to use a stereo tape recorder. The microphone

input for your spoken commentary is connected to the left channel to begin with. Start by recording the commentary complete, with timed pauses for music or sound effects. Once you have the commentary right, with any editing complete, feed any music or sound effects into the right channel direct from the record player or another tape recorder, fading up or down as your require. You can revise either track independently, of course.

By this method you can combine any two sound sources. However, if you want to combine more than two, you will need a second tape player. Set it on 'mono', put your two-channel tape on it, and transfer the combined signal to your original recorder, left channel only. The left channel will now contain the combined recording, and you can add further sound to the right channel as before. You can do this about three times before the continued rerecording causes the quality to fall noticeably.

Some of the better open-reel recorders have a 'sound-on-sound' facility — they can copy the signal from the left channel on top of any signal that is already on the right channel without erasing it. By this means you can record as many times as you like on the left channel, transferring the signal each time on top of whatever you already have on the right channel. You can also record sound-on-sound with any tape recorder if you blank off the 'erase' head with several layers of PVC insulating tape; but make sure there are no bits left sticking to the head afterwards.

If you want to make instructional slide-sound sequences, you can read about these on pp. 203-4. This was the way tape-slide packages began, and they still fill a very useful niche in education and training. Nowadays they almost always use cassette tapes, with pulses to operate automatic slide-change mechanisms; and slide-sound sequences intended for competitions are usually cued in this way, too.

One last warning: if you intend showing your slide-sound sequence anywhere other than your own home, you would be well advised to read the chapter on copyright.

Slides For Exhibition

Most exhibitions, whether they are on the scale of the Science Museum in Kensington or in the local village hall, feature projected slides. Sometimes they tell a story, perhaps some industrial process, or of the ancestry of Man. Sometimes they are a display of material appropriate to the exhibition but not available within the hall: sculpture; porcelain locked away in distant museums; views of historic buildings in the locality. The set-up may range from a highly sophisticated system with automatic projection and a tape-loop commentary to a simple single-slide projector which the viewer operates himself.

If you get involved in helping to organize an exhibition you can probably do a good deal towards its success. In any case, it will be pleasant to have the opportunity of showing your work to a wider public.

Let us assume, then, that you have been left 'holding the baby', and that you have the responsibility of hiring the equipment and setting it up in the hall. At once you run up against two problems. Firstly, there is going to be a good deal of light in the hall. Your display will have to be more or less in full light, so there is no possibility of using an ordinary matt white screen. Secondly, the projector will have to be left to run unattended for long periods of time, so it will need to have some kind of automatic slide-changing system. You will also have to decide to what extent the people attending the exhibition should be allowed to operate the projector themselves; this may depend on the terms of the insurance.

The projector

Clearly, you need a projector that is thoroughly reliable, and has a rotary magazine. There are several good heavy-duty projectors available with rotary magazines, some of them taking as many as

120 slides; but the clear favourite for this type of work seems to be the Kodak carousel (or its close relative the Ektagraphic). This has a rotary magazine which sits flat on top of the projector. The standard magazine holds 80 slides, or 81 if you use the 'zero' slot.

There are a number of models of the carousel, but all of them have the basic functions needed: remote operation, selection of any slide while operating, and a selection of lenses. You would be well advised to specify the zoom lens (this is often standard on projectors for hire) as it enables you to adjust the picture size to fill the screen regardless of the projector distance. If the funds run to it, you can hire a twin-carousel set-up with automatic dissolve-changing, but you then have to find 160 slides!

One gadget that is essential is an automatic timer. This is a small accessory which plugs into the remote-control socket, and changes the slide at predetermined intervals. You can set it for any interval from about three seconds to well over a minute between changes.

Screens

If you are lucky enough to find a position in the hall where no direct light falls or the screen, you may find that a lenticular or beaded screen gives quite a reasonable picture. However, there is a screen especially made for these conditions; and if you use it you will find a quite startling improvement in image quality under these conditions. It is manufactured by Kodak, and is called the Ektalite screen. It is expensive compared with other types of screen, and the surface is very delicate; but the improvement in brightness and colour quality far outweigh these considerations.

The Ektalite screen is made of fibreglass, and the surface is a thin sheet of aluminium with a specially treated surface. It is rigid and slightly concave. The picture area is 1 x 1 metre (39 x 39 inches). It is supplied either with a frame for hanging on a wall, or on its own stand. Most of the light is reflected back horizontally, with a horizontal spread of about 60^o; and the image brightness is about eight times that given by a matt screen. Because of its directionality it needs to be aligned fairly carefully, The radius of curvature of the screen is 4.5 metres (14 feet), and as it is so highly reflective, it

acts somewhat like a concave mirror. This means that there is an optimum distance for viewing. As a guide, the following table may be useful.

Projector distance (metres)	Viewing distance (metres)
2.5	18
3	9
4.5	4.5

If you can fix a hood about 45 cm (18 inches) deep, made of black-painted hardboard over the top and sides of the screen, this should cut out practically all the stray light. To see whether the ambient illumination is low enough, carry out the exposure-meter test as described on p. 156. Take your readings direct from the screen, *not* by the incident-light method. The main thing to avoid with this screen is illumination coming from within the angle of view given above, that is, 30° to either side of the projector axis, and about 15° above or below.

Sometimes, however, there is just too much light everywhere for a reflection screen to give an adequate picture; and sometimes there is not enough space for one. The answer to this is back (or rear) projection. In this system of projection the projector beam comes towards you from behind the screen. The screen itself is translucent, and is made of specially coated glass or acrylic material. The whole system is enclosed in a tunnel, with the projector at one end and the screen at the other. In practice the optical path is 'folded' one or more times by means of mirrors, and adjustable 'doors' and a hood prevent stray light from falling directly on the screen.

Back-projection systems give a brighter picture than any front-projection system, with the possible exception of a well-hooded Ektalite screen. The price to pay for this is a rather small picture — about 50 x 50 cm (20 x 20 inches) — and a very narrow viewing angle, so that only a few people can see properly at one time. On the other hand, a well-designed back-projector takes up very little space: the whole set-up can usually be stood on a small table. Within its limitations it does work very well; and it is often

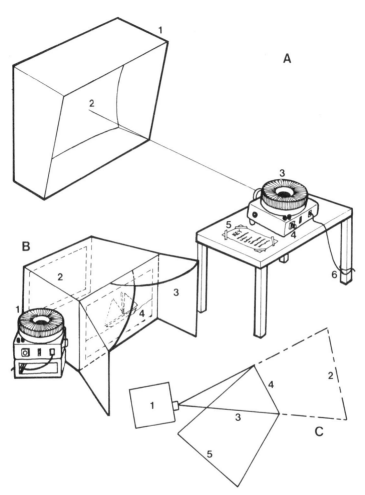

Front- and back-projection systems for exhibitions. A, Ektalite screen. 1, Hardboard shield, painted matt black inside. 2, Screen, tilted slightly down towards projector axis. 3, Projector tilted slightly upwards. 4, Interval timer. 5, Key sheet for slides, with instructions for operating projector. 6, Lead tied for safety. B, Back-projection cabinet. 1, Projector. 2, Mirror. 3, Hooded doors. 4, Translucent screen. C, Using a folded template in designing a cabinet. 1, Position of projector. 2, Paper templates cut to shape of projector beam. 3, Paper template folded. 4, Position of mirror. 5, Position of screen.

the only way to produce a satisfactory image under exhibition-hall conditions.

There are several models of back-projection housing on the market, some of them folding down to the size of a small suitcase. Not all of them are entirely satisfactory; and if your exhibition is going to be a regular event it may be better to consider making your own housing from 9 mm plywood or from chipboard. The mirror needs to be first-quality plate glass, and as thin as possible. In order to avoid a 'ghost' reflection from the front surface, and to keep the size of the mirror as small as possible, it should not be set at a steep angle to the beam.

The best way to arrive at the correct position and angle of the mirror is to draw out a replica of the projector beam as a thin triangle with the correct 'spread', terminating at a width of 50 cm (20 inches). It is best to draw this from an actual trial, using an empty slide frame in the projector gate, and measuring the distance of the screen from the projector lens when the image is 50 cm across. This is safer than trying to work out the angle from the focal length of the lens. When you have made the triangle, draw the outline of the projector (plan form) and fit the triangle to it. Now fold the triangle back so that its base comes roughly alongside the projector outline. The fold line is precisely where your mirror is to go. You can build the box any shape you like as long as it encloses the entire beam. You will need a stand for the projector, which needs to be at a height of 25 cm (10 inches) above the table, measured to the centre of the lens.

The screen material is fairly important. Do not use ground glass: it is quite unsuitable, as is any 'opal' material. Use one of the materials specially made for the purpose. These vary according to the angle of viewing required, as well as other factors such as amount of ambient light and intensity of the projector lamp. Your nearest professional photographic supplier will be able to advise you, and to get the correct material. If you have a problem, ordinary draughtsman's tracing paper is as good as anything; but it does not last long. You can get a very good pamphlet from Kodak (Pamphlet S-29, *Self-contained projection cabinets*) which shows a number of different configurations of projector, screen and one or more

mirrors. It also contains a design for a cabinet for a carousel projector, complete with all dimensions and a cutting layout for a plywood sheet and suggested designs for a cabinet using front projection onto a cut-down Ektalite screen. This is claimed to give a better picture than back projection, though with a small amount of distortion.

Subject matter

You would not be well-advised to try to present a fully developed, coherent story for an exhibition in the matter suggested for slide shows. Even at one slide every 15 seconds, a carousel magazine will take 20 minutes to go right round. Most people at an exhibition do not have that kind of time to spare; and in any case they are more likely to come in halfway through than at the beginning. So keep your structure at a fairly low level. Instead of a continuously developing theme, have the presentation broken up into subthemes, each of equal importance. For example, if your general topic is European ceramic figurines, set them out under sections for Meissen, Dresden, Sèvres, etc. Let each section begin with a group of figurines, followed by close-ups of each in turn. If the theme is your home town, divide it into a dozen or so topics, such as old buildings, churches, schools, the market place, the shopping precinct, and so on, with six or so slides on each topic. Then people do not need to watch the entire sequence just for the few pictures they are interested in. In fact, provided the terms of your insurance allow it, there is no reason why they should not be allowed to find and project the slides they want themselves, by overriding the timer.

Information and instruction cards

As there will probably be no one around to answer questions about the slides, you need to have a key-sheet giving information about the pictures. This will enable anyone watching to identify the slide being shown from the number on the magazine. Your key-sheet should contain the slide number, title, and a brief description of the contents for each slide. It will be easier to read if you separate the various sub-themes under their own headings. Fix the sheet

firmly to the projector table or cabinet. Make sure it *is* firmly fixed — your carefully selected slides will lose a good deal of their effect if nobody can tell what they are watching.

If you are going to allow visitors to select their own slide numbers, as suggested above, you will also need an instruction sheet telling them how to select a different part of the sequence, or go back one slide if it has changed too quickly for them. Make sure these instructions are brief, simple and unambiguous. (Try them out on several people who have never operated the projector before). Fix these down firmly, too, as near to the projector as you can. Add a large notice asking anybody who sees that the projector has stopped working to contact a committee member at once; and ask the committee, if possible, to detail someone to check the projector not less than once every 15 minutes to see if it is overheating or needs refocusing.

Tape control

It is possible to control the slide-changing system by tape. For this you need a cassette recorder which will put slide-changing pulses on the tape; and you can probably hire one from the same place as you hire the projector and screen. This system is intended for a set of slides where a spoken commentary is necessary. You record the commentary on one channel, and put the pulses on the other by operating a push switch at the appropriate points. To work the system you connect the pulse output terminals to the remote-control socket on the projector via a cable supplied with the tape recorder. However, if you use this system you have to prevent people from operating the projector themselves; and someone will have to rewind the tape and reset the projector magazine at the end of each showing. In general, you would be better advised to try to construct a show where the slides can be allowed to speak for themselves.

You may feel, after all this, that showing slides at exhibitions is a lot of work for very little return — this is not so. There are many things that slides can show that nothing else can put across so well. They can supply visual material that could never otherwise have been shown in the exhibition. In a way of speaking, they can bring

the whole world into the exhibition hall. They are good publicity, too: at an exhibition, practically everybody at some time stops to watch the slides, especially if you can find room for a few seats. You can couple slides with a print show, too, and arrange the stands so as to help cut down stray light. The prints should be of similar subject material, and, of course, you can caption them in much more detail than you have room for on your key-sheet for the slides.

Formal Presentations and Lectures

In a lesson or lecture, the role of the slides is to add the missing visual element to your spoken words — to illuminate them. The type of slide you need depends very much on your subject matter; but it also depends on the degree of formality appropriate to your situation. For example, you may be giving an informal talk to a club or society you belong to, possibly a photographic club. The atmosphere may be very little different from that of a totally informal presentation to your friends at home, except that your audience is somewhat larger. You may have more problems to sort out with the projector, black-out and safety precautions than you would at home; but most of the points made in the chapter on showing your slides to your friends still apply. Or you may have been invited to give a talk to, say, the local youth club or Women's Institute about your special interest — which may be anything from the Yellowstone National Park to climbing the Old Man of Hoy, making boomerangs, or walking across Iceland. The atmosphere may be somewhat more formal (you may well find yourself standing on a podium), but your general approach would be similar, with the pictorial element uppermost. Your slides will probably be mostly photographs of scenery or objects, perhaps with the occasional graphics slide to help clear up an odd point; and no doubt you will have a suitable supply of non-projected material to show as well.

You may, on the other hand, be involved in formal teaching. This, too, is an area where good slide illustrations can be of immense help in the learning process. Yet the medium is in practice the most abused of all visual aids. It seems extraordinary that, with such a powerful aid at his elbow, the average lecturer can ignore it entirely; or, if he tries to use it, make such a dismal mess of the whole thing. Most of us at some time have experienced lectures of this type. The lecturer drones on interminably, and when it finally becomes

clear to him that auditory communication just is not enough, all you get from him is a hasty scrawl on a greasy blackboard with a microscopic bit of dark purple chalk. The few who do bring slides have to spend most of the time apologising for their quality, or taking them out of the projector so that they can put them back in the right way round. What an inefficient business it all is! Yet a few well-chosen slides can enliven the dullest subject. And slides can be much more than just a diagram to help out where words have failed, or a pictorial element introduced to relieve the tedium of a long lecture. To get the full benefit of this powerful medium you need to *integrate* your slide illustrations into the material concerned. This means thinking quite hard about what you are trying to put across, and about where — and how — a slide will help you to do it more effectively.

What can slides do?

There is a whole range of audiovisual equipment available to the lecturer, from the simple chalkboard to closed-circuit television. Each has its own special area, where it can do its partiular job better than any of the others. What is it, then, that a slide projector can do? Well, of all visual aids, the projected slide carries the most impact: a large, sharp, high-contrast image in brilliant colour. The slide is one of the most versatile aids, too. Let us look at some of the ways you can use slides in a lecture or a lesson.

Firstly, you can use a slide to clarify a concept that is difficult or even impossible to put across entirely in words. This tends to happen most often in scientific and technical subjects, and in certain branches of mathematics. For example, in elementary topology we come across a very peculiar object called a Klein bottle. It is peculiar because it is a closed surface that has only one side. Certainly such an object defies verbal description. It would be very difficult to make a model of one. But there are no problems about illustrating it as a slide. You can even show the stages in building it up from a flat surface. One picture here is worth far more than the traditional thousand words.

Secondly, a slide can be used as a verbal or pictorial summary, to go at the end of a lecture or one of its sections. The verbal type

would summarize the main points in the section using short phrases or keywords, whereas the pictorial type might 'recap' on a series of operations. As an example of this, let us suppose you are teaching the principles of internal combustion engines. At the end of the session you want to summarize what you have been saying about the four-stroke cycle. You may have used a two-dimensional model for this during the body of your lesson; but when you come to your final summary you need to show all the stages of the cycle together. This is where a slide comes in useful: you can make a drawing based on the model you have used, showing the four stages, colour it with poster paint, and copy it on colour film as described in the chapter on copying.

Thirdly, slides can be used for their considerable visual impact required to hammer home pictorially a point you are making verbally. A slide showing a wrecked motorcycle, a polluted river, or to look on the brighter side a group of black and white children playing happily together, can add a telling effect to your spoken words. Even in the more formal areas such as business studies or economics, something as simple and totally visual as a 'pie' diagram can help to reinforce your point about, say, the effect of investment on long-term research on immediate profits. In a less formal situation you can use slides of this type to start people discussing the ideas you are presenting — to form a jumping-off point for debate.

Fourthly, the slide can be used to provide a record of something otherwise unavailable. It might be something very small and delicate like a tiny, short-lived flower; something large or inaccessible, such as a building or other large structure, or a geological feature; or an event that cannot be repeated to order, such as an eclipse of the sun. A slide is a permanent record, too: you cannot take a group of horticultural students out to examine annual weed seedlings in the middle of January, but you *can* show them the slides you took last July, and at a scale that everyone can see.

Finally, you can use a slide as a substitute for some other visual aid, such as a large chart or a chalkboard diagram. It may not be quite as satisfactory, but there are times when portability overrides other considerations; and there are rooms where dust-producers such as the chalkboard are forbidden.

Constructive thinking about illustration

Before we can start designing a slide, we need to know the limitations of camera and projector lenses, of films, and of people's eyesight: otherwise we will not know whether they are going to be able to decipher what we are showing them; and we shall deal with that aspect in due course. But first we have to try to create a visual idea that the audience will *want* to look at. After all, it will not help your message to get across if your illustrations are too complicated, or cluttered up with unnecessary information, or are just plain ugly. You may finish up worse off than if you had shown no slides at all. You need to start thinking about making your slides attractive as well as readily understandable. There are three important qualities to keep in mind when you're designing a slide illustration, and each depends to some extent on the others.

The first is *relevance.* The only things to appear in your slide should be matter that contributes to the point it is there to make. Get rid of everything else. This is one good reason for not using textbook illustrations (there are others, as we shall see later). They hardly ever contain precisely what you need, and nothing more, in order to put your point across. Often, all you need to do by way of simplification is to take a tracing (see p. 60) as a basis for your drawing. If the diagram is very small, and you have the use of an episcope, you can project the diagram onto a sheet of card, trace the outline in pencil, and use this as the basis for your drawing. Failing this, you can use the squared-paper method as described on p. 60.

The second quality is *simplicity.* Your slide is intended to convey a message. You must ensure the method you choose for conveying it is the most straightforward possible. Do not show a table of figures where a bar chart would be clearer, nor even a bar chart if a line graph would give the same information. Do not use words where a picture would do the job. And make quite sure the method you choose is one all your audience are familiar with. For example, if you do decide to use a bar chart, it will not be very helpful if the people you are showing it to have never seen this method of presenting statistics.

The third quality is *impact.* As we saw earlier, your slide may have

one of a number of functions. It may inform; it may elucidate; it may exemplify, emphasize or summarize. But whatever its nature, it must arrive with a *punch.*

Of course, once you have decided on the simplest and most straightforward way of putting your point across, and then looked fairly hard at what you need (and do not need) in the slide, you will probably find the impact is already there, and that perhaps all you need to do is to add a little colour. Sometimes a touch of humour may help, too, but on no account must it be allowed to get in the way of the message.

There are five basic categories of slide material for illustrations: actual photographs, copies of photographs or 'realistic' artwork such as painting; cartoons and drawings; diagrams, graphs and data displays; and words only. The question is — which should you use at any particular time?

The answer often becomes clear as soon as you have sorted out exactly what the illustration needs to do. If, for example, you are talking about pests and diseases of the potato, you need (among other things) genuine photographs of potato plants affected by blight and other diseases, and of Colorado beetles, eelworm and other pests. If you cannot find the genuine article a copy of a printed photograph will do, though it can lack both the visual and psychological impact of a photograph of the real thing that you have taken yourself. Nevertheless, it will help you to achieve the immediate objective, namely that the class should be able to recognize the particular pest or disease; and at the end of the lesson you can use the slides again to test that this objective has indeed been achieved.

At a less formal level, you might be describing something your audience has probably never seen, such as traditional pottery-making in the Middle East; and here again, no visual aid is more vivid than a colour slide of the real thing. In fact, no matter what your subject, an appropriate photograph will always bring home the connection with reality. You may often have to make do with a copy from a poster or a periodical, of course; but if the original is a good one, and your copying technique is up to scratch, the result will be fairly convincing.

Quite often you can obtain the effect you need from a painting or

an artist's impression, particularly with tricky subjects such as birds, wild flowers or even certain types of architecture.

Cartoons and drawings are often useful to emphasize a point. Make sure they are appropriate — even if you have to draw or re-draw them yourself. Teachers often build up a collection of cartoons relevant to their subject; and it is a good idea to have a set of slides of them. However, remember that cartoons are subject to the laws of copyright, and don't use them without permission; and remember to acknowledge the artist and the publication.

Line diagrams, of course, can be immensely useful. And they need not be a dreary black and white, either. Use the techniques described on pp. 104-13 to produce coloured grounds, or coloured lines on a black ground. And remember the rule about relevance. Leave out even the title if you don't need it. The proper place for a title is on the mount, not in the picture area.

Often you can use an actual photograph and a diagram to complement one another. For example, you might be giving a talk on Ancient Greek pottery, and to illustrate the design of, say, a particular frieze pattern, you could follow a photograph of the urn showing it with a line diagram of the pattern, before returning to the urn. This kind of illustration can be very effective if you have a twin-projector system, as you can fade up the diagram (as a line negative) superimposed on the slide of the urn itself; or cross-fade from urn to diagram, then back to the urn.

If you need to display data to back up what you are saying, always try to select whatever is the most 'visual' way of doing it. In this way you achieve the greatest impact. Words and figures alone are almost invariably the least visual, so keep them to the minimum if you cannot eliminate them altogether. In a visual illustration it is relationships that are important. Ask yourself — what will show the relationship best? It could be a histogram; a pie diagram; a graph; or a pictorial chart. It is beyond the scope of this book to discuss *all* the ways of presenting data (there are hundreds); but you can find any number of examples of different types in books on graphic design. Remember: keep the message simple and straightforward. There may be mathematical objections to showing a set of simple values in the form of a continuous curve, for example; but the clarity of the message must have first priority, and if it *is*

clearer presented like that, then that is the way to do it. Similarly, it may seem like cheating to take a straight-line graph and convert it into a steeply sloping curve by using a logarithmic scale along the horizontal axis; but it may be justified, provided you do it to emphasize a perfectly valid point, and provided it is clear that the scale *is* logarithmic.

Legibility of words and detail

We discussed lettering to some extent in the graphics section. It is worth remembering that average (6/6) vision is the norm, but many people see considerably less well. With 6/6 vision, you can see a 12 mm high capital letter quite easily at 6 m. In practice, 24 mm lettering (capitals) at 6 m is a good standard to aim for (see pp. 47-8).

Do-it-yourself graphics for lectures

In this section we will look more at the techniques that are most appropriate for certain kinds of illustration rather than the general techniques that were discussed earlier.

Black line drawings and lettering on a white ground are suitable for any graphical information or verbal summary. However, straight photography of such material is dull and lacking in impact; and a white ground is glaring and unpleasant. Hand-coloured line negatives (pp. 104-6) are usually preferable, or coloured slides made by using a filter with colour film and developing to either a positive (pp. 102-4) or a negative (pp. 106-10).

Paper cut-outs are appropriate for pie diagrams, histograms and other kinds of pictorial statistics. Choose brightly contrasting colours. If your slide is of copies of rather dull, flat photographs or monochrome originals, you can usually make your slide more attractive by cutting out the pictures in cloud or bubble shapes (p. 44) and laying them on brightly coloured background paper on the copying stand.

Felt-tipped pen drawings are suitable for graphical and statistical material, and for 'rough' hand-lettering where unevenness of tone is not important. Remember, though, that the colour is a dye, not

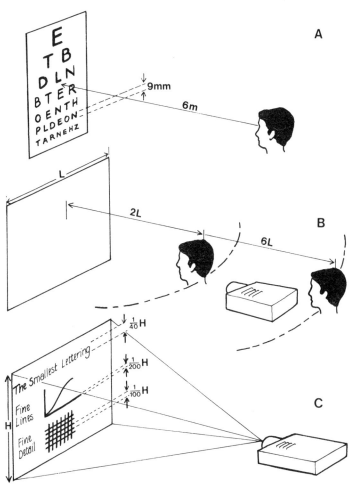

Minimum sizes of projected lettering and lines. A, At one time, statistically
'normal' vision was 6 mm detail (12 mm letters) at 6 metres distance. Nowa-
days it is 4.5 mm (9 mm high letters). B, Minimum and maximum distances
for good viewing are 2 and 6 screen widths respectively. B, Because of varia-
tions in people's eyesight and the conditions of viewing, we use a more
pessimistic criterion for standardizing minimum sizes of lettering, lines and
detail. In this diagram the height is taken as that of a projected 35 mm slide
(horizontal format).

a pigment, and therefore the lines are always darker than the background.

Poster paint (p. 64) is the best medium to use for pictorial work, or for properly drawn lettering where the tone needs to be uniform; or for anywhere you might want the lines or letters to appear lighter than the background. Poster paints are opaque pigments, and you can apply them over any ground, no matter how dark. You can also get a very attractive effect by using artists' pastels on black or dark blue card. This effect is particularly good with graphs. To get your lines thin enough, sharpen the stick on an old carpenter's file, to a chisel point. You can, if necessary, use ordinary coloured blackboard chalk. Draw the guidelines in pencil first.

Collages and montages of photographs and verbal material cut from catalogues and periodicals are used in such fields as general studies, and business and commerce courses. In practice these usually take the form of posters; but you can photograph the poster; and your projected picture will be much larger, and often more effective, than a poster. The same applies to reproductions of paintings, where the only alternative is the episcope.

Drawings direct on 'Ektagraphic' slides (p. 58) are possible if you have a very steady hand; but as a rule, this is only an emergency method for ad hoc sketches where you have neither a chalkboard nor an overhead projector.

Specialist slide projectors for educational purposes

Many educational establishments use ordinary 50 x 50 mm slide projectors designed for the amateur market; and, of course, these are often perfectly adequate. However, they do not always stand up to continuous use and rough handling; and, although it may be more expensive, there is much to be said in favour of buying optical equipment designed specifically for educational purposes. It is not only more robust than amateur equipment, but usually more powerful. Almost all such projectors use compact-source quartz-halogen lighting, and many have a 'half-power' (actually more like 95% power) setting which gives the lamp a greatly extended life. All the major manufacturers produce a heavy-duty, high-power 35 mm projector, but, as in the field of exhibitions and

professional slide presentations, the Kodak carousel and Ekta-graphic projectors lead in the popularity stakes. This is partly due to their ruggedness, and partly to the very large range of accessories and ancillary equipment available. This includes provision for remote slide changing, random access to any slide, plug-in tape commentary with slide-change cues, and a whole range of fade-dissolve capabilities for a two-projector system.

If you want to show only a few slides, a single-slide projector avoids the nuisance of having to load up a magazine. Some single-slide projectors have an alternative holder for filmstrips, the whole lens assembly being rotatable through 90° for filmstrips in half-frame format. However, this facility is not always essential, as many teachers and lecturers prefer to cut up filmstrips and mount them as slides, for the extra versatility this gives.

There are also dual-purpose overhead projectors with a facility for projecting slides. The simpler models are just an add-on lens and slide-holder. More sophisticated models have the slide-holder below the platen. A large image of the slide is projected onto the Fresnel screen of the overhead projector, and from that point the normal optics of the projector take over. The image quality of both these designs is, of course, no better than the usual image given by an overhead projector; and as the equipment costs roughly the same as that of a separate overhead and slide projector together, there seems to be little advantage except in the saving of space and possibly time.

There have been a number of attempts to solve the technological problems involved in integrating tape and slides in one machine. One such machine has been produced using a slide mount surrounded by a ring of magnetic oxide on which the lecturer prerecords a short commentary. This is automatically played back during the showing of the slide. Projectors with built-in cassette recorder and playback facilities are becoming available. However, any survey of this rapidly developing field would quickly become obsolete, and for the latest developments you should refer to the specialist periodicals on audiovisual technology.

The ideal lecture theatre

From the point of view of projecting slides, the ideal lecture theatre is such a rarity that you might think it a waste of time to try to describe it. However, once you know what the 'ideal' is, you may be able to rearrange the real thing so that the positions of the projector and screen, and the arrangement of the seating, lighting, etc., are fairly near to it.

People concerned with research in audiovisual media have done quite a lot of experimental work to try to find out exactly what is the best layout for showing projected pictures. We will summarize the findings briefly. The farthest away that anyone should be from the screen is about six times the horizontal width of the screen. This is roughly the distance most people view a TV picture from. If anyone is farther away, the screen will occupy a smaller angle of view than one normally has when looking at a picture. In a photograph with normal perspective, people would probably have difficulty in distinguishing fine details; and in a slide or print they would not be able to read the words readily.

There is also a minimum distance for viewing, about two to two-and-a-half screen widths. If nearer than this to the screen you cannot 'take in' a picture at one go; and you will probably have to move your head in order to read a line of print. Also, the image may be too high, so that your neck muscles get tired.

The sideways limit for good visibility is about 30° out from the projector axis. Even at this fairly small angle you do get quite a lot of foreshortening of the image, and lettering will be 'condensed' by up to 25%.

Of course, arranging the seating to conform to these conditions can be very wasteful of space in a square room like the average classroom, lecture theatre or hall; and if your lecture is likely to be well attended, or if you are a teacher with a full classroom, you can save a lot of space by fitting your 'ideal' viewing space diagonally within the room, with the screen across one corner of it. In a room where the seating area is roughly square, almost everyone will be within the 30° angle and the distance limits; and because the arrangement 'staggers' the seating with respect to the screen, people at the back have less obstruction from other people's heads. *You* will be at the front, to one side of the screen, and you will

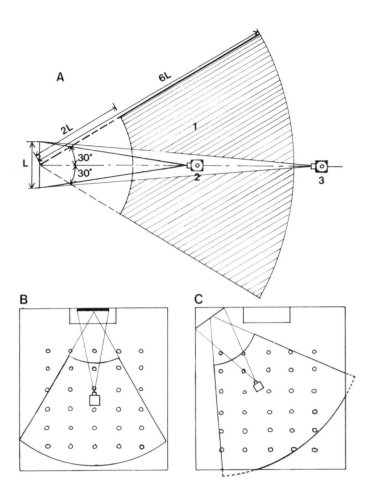

Ideal and actual lecture rooms. A, The layout of the ideal lecture theatre for slide showing. 1, Area of good viewing. 2, Projector with 100 mm lens. 3, Projector with 200 mm lens. B, Normal classroom layout. Nine out of thirty students are outside good viewing area, and three more are in projector beam. In addition, the screen obscures the chalkboard and there is nowhere for the lecturer to stand. C, Screen moved to corner. Now only three students are outside good viewing area and only one in the projector beam. Only four need to move instead of twelve; the lecturer is in his usual place and the board is unobscured.

need a light for your notes. You may be lucky enough to have a properly designed lectern with its own illumination; but if you have to organize your own light, try to get a fully hooded table lamp so that none of its light reaches the screen. You may not find this easy; and if you are giving a formal lecture with a lot of slides you would be wise to allow yourself time beforehand to fix up extra shading should it prove necessary.

You saw earlier (p. 158) how important it is to have the projector lens axis truly perpendicular to the screen, and that it is bad policy to prop up the front of the projector with books. The screen should be at a height such that the bottom edge is level with the eyes of the front row, and the projector should be at the height of the centre of the screen. In a lecture theatre with tiered seating this is usually fairly easy; but in a room such as a classroom or hall, with all the seating at the same level, you may have to have the screen somewhat higher. In this case you may need to tilt the projector using its height adjustment, and to tilt the screen forward until it is again perpendicular to the lens axis.

If the projector has alternative lenses, or a zoom lens, choose a long focal length (say 200 mm), so that your projector is at the rear of the room instead of the middle. In a room with a flat floor raise the projector high enough for the beam to be well clear of heads, or leave a gangway in the middle. This rear position also has the advantage that any tilt of the projector will be less pronounced than it would have to be with the projector nearer the screen.

Room lighting

Assuming for the moment that you have a good black-out, how about the lighting? Should you keep some of the lighting on all the time? Or should you insist on displaying the slides to their best advantage by showing them in total darkness? The answer will depend on a number of things. If your slides are line diagrams or verbal material rather than actual photographs, there is little advantage in a total black-out. A little ambient light makes it easier for people to take notes; and it makes *you* visible too. You may, if you are very lucky, have the use of a lecture theatre with a

control panel where you can operate the blinds, and have the room lighting at any level you like. If so, you can leave a little light on for most of the time, and darken the room completely only for your pictorial slides. However, if you have only normal light switches, do not keep snapping them on and off every few minutes, especially if they are fluorescent lights; it is distracting. In such cases, if you need a short gap between slides, put in a plain slide (see p. 144). This will leave enough light for note-taking, and does not destroy the continuity. If your lecture is more or less a continuous series of slides, it is a good idea to have one of these plain slides wherever you are going to talk for some time about something you do not want a slide for. If you leave the previous slide showing it will simply prove a distraction. There is another, rather different use for a plain slide, too. If you have been showing a continuous series of slides, and you suddenly put up a plain one, your audience will momentarily be forced to concentrate on what you are saying — because of the sudden disappearance of the visual stimulus. This is useful if you need at some point to say something very important.

If you are a teacher in a school or college, and have your own classroom, you may be able to have a dimmer switch fitted in place of the usual one. These devices are electronically controlled, and have recently become readily available. However, before attempting to 'do-it-yourself' make sure the wattage is right. Add up all the wattages of the lamps the dimmer is to control; and get the next higher wattage. And make sure, if you have fluorescent lighting, that the dimmer is suitable for it.

Liaison with technicians

If you have to give a formal lecture in a college, and you want to show slides — or, indeed, any other audiovisual aids — you may find there is a technician to fit up the equipment for you. He may also help with the projection. You can make everything much easier for him, and yourself, by contacting him well in advance, and listing the equipment you are going to need. If you intend to use other media in addition to slides, for example, sound recordings

or film, prepare a cued script, so that he can switch on the right things at the right time. It goes without saying that your slides should be numbered, titled and spotted correctly (see pp. 128-9). You may also find it helpful to arrange a signal system, say a small light invisible to the audience. Shouting 'Next slide, please!' or banging a pointer on the floor is amateurish and distracting.

If you have someone to help with the slide projection, and the projector is of the carousel type, you can if you wish reveal your 'summary' slides a line at a time. Cut a T-shaped piece of card with the vertical bar 50 mm (2 inches) wide, and drop it into the magazine immediately behind the slide, in the same slot. The depth of the vertical bar should be just enough for the top line of the slide to be visible when the slide and card drop into the projector gate (remember that the 'top' line will be at the bottom of the slide in the gate). As you progress, your helper raises the card to reveal the slide line by line. This is more effective if your slide is a lith negative. With other types of projector you can get a similar effect by holding a piece of black card some 50 cm (18 inches) in front of the projector, and slowly lowering it; but this takes a certain amount of practice.

Pointers and indicators

Sooner or later you will want to point out some feature on one of your slides. If you simply grab a chalkboard pointer, or the broken billiard-cue or metre rule that usually serves for one, you will have little success. What will happen will be that your picture will be projected onto the pointer, so that nobody can see it. If that is the only kind of pointer available, the only satisfactory way to use it is to hold it some distance away from the screen, and let its shadow do the indicating. Explain to your audience that they should watch the shadow, otherwise they will try to follow what you are pointing at with the pointer, and simply get confused.

You can get special focusing torches from educational suppliers. These have an arrow-shaped filament, and are somewhat more effective than the usual opaque pointer. But they are not very bright, so that they work really well only with lith negative slides. Also, you have to stand well away from the screen to operate them;

A, T-shaped piece of card can be used with a carousel magazine for revealing slides of text line by line. B, A luminous pointer made from 6 mm fluorescent Perspex. 1, Polish lower end to a lens shape with metal polish. Polish upper end flat. 2, Metal tube hammered to box end to take pointer and torch. 3, Hole to take pen torch clip. 4, Pen torch with rotary or push switch at lower end.

and they are merciless at showing up an unsteady hand. Lecturers who use this type of indicator quickly learn to hold it with both hands, with the base of the torch firmly against their chest.

Probably the best type of pointer is a scaled-up version of the transparent Perspex pointer so useful for overhead-projector transparencies. With this, you simply lay the pointer on the transparency. If it is a pale colour rather than clear, the pointer is somewhat easier to see, and you can still see the image through it. The scaled-up pointer for slides needs to be about 80 cm (32 inches) long, tapering in width from about 18 mm (¾ inch) to 9 mm (³/₈ inch). The best material is 6 mm (¼ inch) thick acrylic sheet, fluorescent orange or fluorescent green. You can get this material from shopfitters: they will usually be prepared to cut the material accurately to size for you.

You can use this pointer just as you would use an ordinary pointer on a map or chalkboard; but for slides it has the advantage over an opaque pointer that the light goes through it. You can see the pointer because of its colour; and it does not cause an ugly black shadow. If you cannot reach the screen, or if it is a treated-surface screen that must not be touched, hold the pointer away from the screen, and do the indicating with the pointer's shadow.

With a little extra effort you can make the pointer self-luminous. This is particularly handy for lith negative slides, where the pointer would otherwise be invisible. Round the broader end of the pointer to a lens shape, using a smooth file followed by successively finer grades of glasspaper, finishing with the finest emery ('Crocus') paper. Then polish the end with metal-polish wadding Treat the other end similarly, but finish it absolutely flat instead of lens-shaped. You now need a hollow handle to take a pen torch. You can make this from mild steel, copper or duralumin tube of suitable diameter, hammered at one end to a rectangular box shape to take the pointer. The pen torch should be the type that has a rotary or button switch at the opposite end to the bulb, and it needs to be a fairly tight fit so that it does not fall out in use. You will need to polish the sawn edges of the acrylic sheet in such a way that the illumination is uniform along its length. Smooth it with No. 0 glasspaper first, then with successively finer grades down towards the handle, finishing with metal polish at the handle end.

Finally, cover the handle with PVC electrical sleeving, and you will have a really professional-looking pointer your colleagues will envy. If you have taken care to get the tip highly polished and absolutely flat, you will get quite a good beam of light emerging, and you can use this as an additional indication aid.

A word of warning about pointers. If you have little or no blackout, so that you need to use a screen with a prepared surface, such as a beaded or lenticular screen, take particular care not to scratch the surface of the screen with your pointer. If your room is equipped with an Ektalite screen (see pp. 177-8), you should under no circumstances touch its surface with either a pointer or your fingers. Use the 'shadow' method described above.

Slide-sound instructional sequences (tape-slide packages)

One very useful product of educational technology is the instructional slide-sound sequence. This is a self-contained learning package, and is usually called a tape-slide package. Most commonly it takes the form of a short (10-30 minutes) lecture on cassette tape, with slide illustrations.

Many of these packages are available from educational publishers, and others have been marketed by educational establishments. By no means all of them are first rate. Sometimes the technical quality of the transparencies is poor. Sometimes the photography itself is bad. Often the script itself is not irreproachable, either, and the presentation is not always as enthusiastic as it could be. So, before you decide to use any educational tape-slide package, play it through, and make sure it is going to do its job. A tape-slide package resembles a film in that once you start it off, it takes over your teaching from you; and if it does it badly it will not be a satisfactory learning aid.

However, some commercial tape-slide packages *are* very good; but even these may not cover your subject to exactly the right depth, or with just the emphasis you want. So why not try making your own?

Let us consider first where tape-slide packages fit into the learning business. It is quite important to start by doing this, because you will not want to go to a lot of trouble to produce a tape-slide

package when a simple printed text would do equally well. Do not consider whether it would be a change for the students to have a tape-slide package instead of listening to you; nor whether it will save you from having to give the same old talk time after time. Consider rather whether there is a learning problem, and whether a tape-slide package is going to be the best way to solve it. The essentials of the package are (a) sound, and (b) still pictures of high quality; it is a self-contained piece of instruction which can be used by either a single student or a group of students; and it is self-pacing: that is, a single student using the package can stop and start it as he or she pleases.

Having considered your problem, you have to decide which of the media available to you is the best. It may well be something quite different. Does it need to be self-contained? Does it need slides? Does it need recorded sound? Would some simpler method (e.g. a couple of textbooks and a study guide) be equally effective?

Quite often, the answer will turn out to be that a tape-slide package *is* the best way of getting over a learning problem. Probably the most common use of the medium is for remedial teaching, where perhaps one or two students are lacking in the background they need for a certain course, or have missed attending through illness, or need extra tuition. Tape-slide packages are also useful for background material and for case studies.

The simplest and most common type of package is the illustrated lecture. If you have a regular lecture to give on a subject such as, say, fire prevention or safety in the office, and you use a lot of slide illustrations, it is a good idea to put the whole lecture on tape so that anyone who unavoidably misses it can still go through it later. And if you cannot be present yourself at a time the lecture is needed, someone else can introduce it and play the tape for you.

The second type is where you need both pictures and sounds that you cannot reproduce 'live'. A suitable example might be bird recognition, with slides showing the birds, commentary pointing out the distinguishing features, and recorded sounds of their calls. You could also use a tape-slide package to explain the problems of after-care of patients suffering from, say, multiple disseminated sclerosis, with the recorded voice of the patient describing how he copes, and the help he needs, along with slides of the patient

himself and the mechanical aids he uses. If you were teaching architectural history you might be lucky enough to tape a radio interview with one of the protagonists of, say, the Bauhaus School, edit it as appropriate (see pp. 173-4) and illustrate it with slides of the buildings themselves (but make sure you do not infringe copyright). Or if your subject is music, you could produce an analysis of a movement of a string quartet, using diagrams to show the structure, parts of the score, and recorded extracts of the sound, along with commentary and all on one tape cassette. In this case, of course, it *is* possible to have the sound 'live' (or at least on records) but is is very often difficult to find an exact groove on an LP record. And, of course, once you have these packages available, anybody can borrow them for further study.

A third type of package is the programmed instructional course. Here, the tape-slide element may be a self-contained package, or it may be part of a larger package containing worksheets, raw materials and question papers for self-assessment. This kind of training method is sometimes called a 'multi-media package', and if you intend producing one of these you will have to put a great deal of work into designing and validating it.

We can talk only fairly generally about equipment for operating tape-slide packages, as new models are continually coming on the market and older ones disappearing. Any slide projector with a remote-control socket will do, of course, but you need a cassette tape recorder that will put slide-changing pulses on the tape, and replay them, changing the slides as it does so. Most European pulsed tape cassette recorders are designed so that they record the sound (mono or stereo) on the lower half of the tape, and the pulses go on the uppermost quarter of it. The pulse that changes the slide is a 1000 Hz 'bleep'. Some cassettes also have a 200 Hz signal which switches the projector on and off, though not all projectors have this facility. The pulse signal is completely independent of the sound, and you can add the signals either at the time you make the recording or at any time later. You can also erase and rerecord either signals or sound independently.

Nearly all commercially available tape-slide packages use this system, with mono sound. However, one or two makes of cassette recorder have been designed to record the sound on the lowest

quarter of the tape only, with the pulses on the second quarter-track. This system does have the advantage that you can use both sides of the tape cassette. However, if you try to play back a commercially produced tape on a machine of this type, the pulse-detector head will be picking up commentary instead of pulses. So unless you switch off the automatic change and operate the slide changer manually, the slides will change at random, depending on the pitch of the speaker's voice! To eliminate this unfortunate effect, you need to run the tape through the machine with the pulse control set to 'erase', which will wipe off the second quarter-track. You can then put your own pulses on. You will still be able to operate with a European-standard machine, of course, if you need to.

As electronic circuits become tinier and tinier, it becomes possible to combine both tape player and slide projector in one housing, and models are already available. It seems likely that this may become a standard item of equipment in the future. The tape-slide package fills an important niche in educational technology, and forms a very effective way of aiding both collective and individual learning.

Copyright

The phrase 'infringement of copyright' has already turned up several times in this book. What does copyright mean, and how do you know if you are infringing it?

The present UK law on copyright stems from the 1956 Copyright Act, with one or two later additions. Copyright law in other English-speaking countries are similar. The position in the United States has been simplified by the new law (following closely the Berne Union copyright principles) which came into operation on 1st January, 1978. Copyright legislation is designed to protect authors, composers and artists in visual media from having their work exploited by other people without adequate remuneration. If you create anything in a tangible form, such as written words, manuscript music, drawings or photographs, you automatically own the copyright; and anybody who wishes to perform your play, read your book to an audience, play your music in public or make a replica of your work by photography or a duplicating process must pay a fee for doing so. If they do so without obtaining permission or making adequate payment, they are breaking the law. The law is beneficial to the author or composer who, after all, has to make a living. But it can be a serious obstacle to people who want to make tapes of music or photograph copies of pictures for their own private purposes, or for teaching. Sometimes it is very difficult to tell what is and what is not permitted. For example, are you breaking the law if you make a slide-sound sequence containing sound effects, live and recorded music, copies of cartoon characters, maps, printed material and drawings? According to the letter of the law, the answer is *yes* to all these things. But in these days, where most families possess a tape recorder, where radio sets with built-in cassette recording are commonplace, and where every library has its own document copier, the law has in many cases become almost impossible to enforce.

The UK Copyright Act and most others do, in fact, recognize the need for certain classes of people such as students and literary critics to make copies of copyright material in the course of their work, and makes a number of exemptions from its requirements under the heading of 'fair dealing' or 'fair use'.

Let us look first at what you *can* do. First, you can quote (in speech or writing) small sections. Provided you need it for research, private study or critical review, you can also have a photocopy made, and in this case you are allowed a rather larger proportion of a work. You may not, however, make multiple copies. For United States libraries, Congress has written in specific exemption for the preparation of archives. If you want to use the material for teaching the situation is easier. Most copyright laws allow you to copy substantial portions of material for educational purposes and many educational broadcasts have specially modified copyright protection to allow recording and reproduction.

So, what is the position regarding your slide-sound sequence? Well, provided you are not going to attempt to make any money out of it, you can use your poetry readings. Most discs and tapes of sound effects are free from copyright (but you should read the small print around the record label or on the cassette to make sure). Maps, drawings and sometimes the cartoon characters themselves, *are* copyright; and if you want to produce copies of them, you need to write to the publisher for permission. For recorded music the situation is more complicated, as both the composition and the recorded performance are protected separately. However, in the UK the Mechanical Copyright Protection Society, of Elgar House, 380 Streatham High Road, London SW16 6HR, issues an annual licence which allows you to make tape recordings for your own use of live performances of musical works owned by MCPS members provided they have at some time been issued on gramophone records. It also allows you to make tapes of records issued by member companies. This covers prctically all record companies, and most composers. However, you are *not* permitted to tape a performance of a work that has yet to be recorded, unless the composer has been dead not less than fifty years (after this time, copyright lapses).

Unfortunately, the MCPS licence is useless if you want to do

anything with your tape other than play it at home, or at a tape-recording club, or enter it for an amateur recording competition. The licence specifically excludes tape-slide and film presentations. If you want to clear the audiotape part of a slide-sound sequence you need to get permission (in respect of compositions) from the Performing Rights Society Ltd., 29/33 Berners Street, London W1P 4AA, and (in respect of records and pre-recorded tapes) from Phonographic Performances Ltd., Ganton House, 14–22 Ganton Street, London W1V 1LB. And if you want to use a tape of a live professional performance you will need to obtain permission from the Musicians' Union.

It all sounds a bit off-putting for the amateur; and there is no doubt that a great many enthusiasts, having found all these restrictions, either give up the idea of slide-sound sequences altogether, or simply ignore the law. As it stands, the law raises at least as many problems as it solves. Indeed, almost every individual who owns a tape recorder or a camera has probably unwittingly broken the law at some time or other, though in most cases it would be very difficult to bring a successful prosecution. If you were to insert a few bars of, say, Beethoven's Fifth Symphony into a slide sequence, and you then showed the sequence in public, it would be a bold lawyer who would stand up in a court of law and attempt to prove that, out of some twenty-seven current recordings, it was his client's version you had pirated. The law is plainly unsatisfactory both for the copyright owner and the user of the material; and if every enthusiast requested written permission every time he wanted to copy a drawing or tape a snatch of music, the publishers and copyright protection societies would soon be submerged in a sea of correspondence. International agreements make it very difficult for any country to attempt a drastic revision of its copyright laws; so we shall probably have to make do with the present situation for some time yet.

A simple and sensible solution would be the issue of annual (or once-for-all) licences by a central body, covering all amateur work; and, indeed, the Whitford Report (1977) has recommended a blanket licensing scheme for photocopies which, if implemented, would sweep away the anomalies, permit the copying of material without the necessity of obtaining prior permission, and at the

same time recompense the authors and artists. There is also strong support for adopting a system (as in West Germany) of a fixed levy on tape recorders, to be paid at the time of purchase, which would buy a licence to record anything at any time.

INDEX